ETCHING
an artist's guide

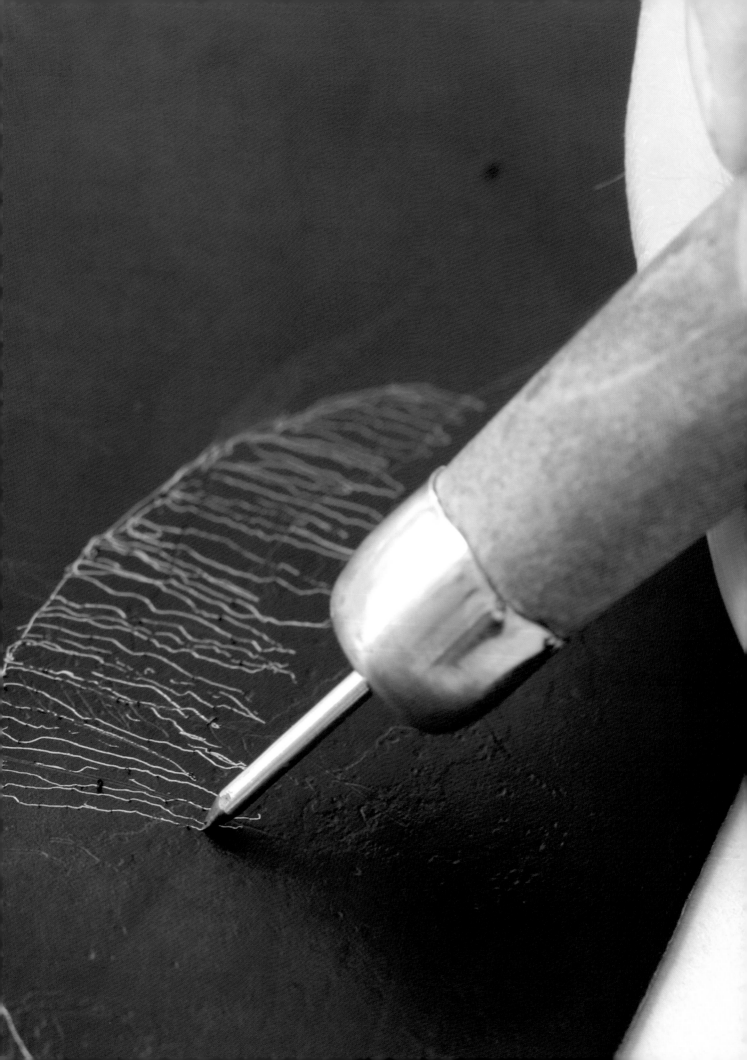

ETCHING

an artist's guide

Ann Norfield

THE CROWOOD PRESS

First published in 2019 by
The Crowood Press Ltd
Ramsbury, Marlborough
Wiltshire SN8 2HR

www.crowood.com

British Library Cataloguing-in-Publication Data
A catalogue record for this book is available from the British
Library.

ISBN 978 1 78500 615 9

Acknowledgements

I would like to thank all the contributing artists for giving their
time and for creating such fantastic prints. Also to Cora James
for her beautiful photography.

A big thank you to friends and colleagues at East London
Printmakers for their patience with the book and for helping
to make the studio such a great place to work. Special thanks
to Steve Edwards for his kind willingness to take on-the-spot
photos.

Huge thanks to Lucy, Alice and the many friends who gave
continued encouragement. Also to my parents for their
understanding.

Biggest thanks of all to Michael Taylor for his support, fortitude
and practical help whenever they were most needed.

Page design by Ian Youngs
Printed and bound in India by Parksons Graphics

CONTENTS

INTRODUCTION

Artists have been using the printed multiple image as part of their practice for over 500 years. Materials, processes and techniques may have developed over time from the simplest woodcut through to the latest digital technology, but artists have always been, and will continue to be, intrigued and challenged by each and every new technological development within print that comes along. Those that we now see as traditional were themselves once new and revolutionary, and of course those that we now see as new and revolutionary will soon become part of the tradition.

Etching has developed over this period from a simple decorative craft to a fully expressive art form, one that continues to use its history and traditions to reveal our contemporary world with fresh eyes. When we visit any gallery or museum we still see work that uses the exact same materials and techniques that Rembrandt and Dürer would recognize, but we can also see work produced with very new materials, using the most recent technologies and processes available. The great strength of printmaking in general is that it can draw on a rich and vibrant past while continuing to be relevant to the present.

In many ways, the making of an etching can be seen as a destructive and corrosive process. The acids and tools that we use are to bite, gouge and deface the surface of a smooth metal plate. Yet they produce images of such delicate beauty as Picasso's *Dove* as well as the brutal revelations of Goya's *Disasters of War*.

The starting point to any etching is quite often one of the three traditional processes of hard ground (the drawing of sharp lines through a wax and bitumen layer), soft ground (the drawing of gentler, tonal marks through a wax and tallow layer) and aquatint (the painting of washes of light and dark tones over areas of the plate using a fine resin dust as an acid resist).

The etched or incised plate can then be printed one at a time in black ink, or with multiple plates and in any number of colours. With the more recent developments of photo-etching and polymer gravure, the photographic and digital image can also be the starting point of the creative process, or may be incorporated within the more traditional mark-making techniques.

DRYPOINT 1
Ink sits both sides of incised mark

HARD GROUND
Acid bites down and sideways. Fine lines can bite

SOFT GROUND
Generally shallower bites than hard ground and with more texture

ENGRAVING
Clean sharp incisions into the plate giving clear

AQUATINT 1
Resin randomly applied to plate either by hand or in an aquatint box

AQUATINT 2
Resin is heated to melt and adhere to plate

AQUATINT 3
Acid bites between the resin to produce a fine tonal bite. How light or dark the tone is controlled by the time in the acid

AQUATINT 4
Resin is removed and the plate is then inked prior to printing

History

The art of etching is generally thought to have started with the rubbing of dark waxes into engraved and incised armour to further highlight their decoration. In order to record their designs for future replication, armourers developed ways of impressing these marks/incisions into soft absorbent material, which could hold the image separately from the metal plate into which it was engraved. A printed record was made and over time it is not difficult to see how this means of replicating an image was found to have such profound artistic possibilities.

The development of each new print technology or material has always created new possibilities for the artist. It is rare that any new development was at the instigation of the artist or was first thought of for strictly artistic expression. On the whole it is a more prosaic commercial need that initially drives print technology forward. Artists will find a use for almost anything new that comes along and simply add it to the lexicon of visual languages they already possess and that have been developed over the previous centuries. Good techniques, like good ideas, do not simply disappear after use; instead they can be added to, and new uses found for them.

The rise of the digital image and its appearance within the broad palette of visual languages available to an artist is just the latest development in the long technical history of print.

Back in the fifteenth century most people in Europe were still illiterate and visual imagery was crucial to the communication of both new ideas and those of longstanding tradition. One of the most important technological advancements of the last millennium, namely Gutenberg's invention of the printing press and its use of movable type, meant that the sharing and dissemination of new ideas was more possible and also much faster. The idea that imagery could be replicated through mechanical means was to have a profound social and political effect across all social strata. No longer was it only the literate and privileged few who were able to access fresh ideas and express opinions. The printed image helped to illuminate this new world as the printed word helped explain it. The democratization of Western Europe came about as much through the use of the 'democratic art' of print as any other.

This relationship between artistic expression and technology can be seen running all the way through the development of printmaking as a whole. As the engraved print became the dominant means by which artists circulated their work to a wider audience, it became both a means of artistic expression and a commercial necessity. More copies of any image to sell, at more affordable prices, meant a growing audience for the artist's work. In turn this created more income and, more importantly for the artist, paid for the time and means to make new work.

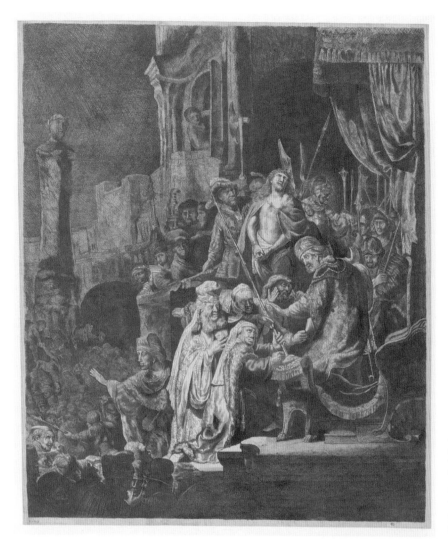

In his 1636 etching *Christ before Pilate*, Rembrandt used dense areas of darkness to give weight to the drama of the scene depicted. The image was made by hard ground drawing, built up over time by repeated reworking of the plate using this one technique. (Rijksmuseum, Amsterdam)

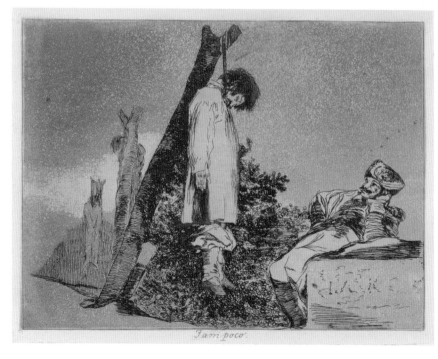

Goya also relies on dark tones to set the atmosphere for his series *Disasters of War*, including this, *Tampoco*. By the time of its making, in about 1820, he was adept at using aquatint to create tonal range and did not have to rely on line drawing alone. (Yale)

At a large international print fair, such as the IFPDA held annually in New York, the antiquarian and the modern hang side by side. Etchings through the ages share the same techniques.

As the burgeoning audience for artists' prints developed, the role of the publisher as the financier and instigator of print projects also developed and so more commercial concerns started to influence the whole development of the medium. It had been common for artists to be the primary makers of their own prints but a point was reached where the demand for new work started to outstrip supply. After this, more and more work was handed to the professional artisan engraver, who simply copied the drawings and paintings of artists.

This meant that, except in the unique hands of a few artists such as William Blake, engraving became less a personally self-expressive tool, but more a means of replicating images the artist had already made through other media. The art lay in the original drawing, the craft in its replication by the engraver.

Commercial engravers were highly skilled and at times highly paid artisans. When the development of hard ground etching came along, the artist was able to work directly onto the plate and not have their work mediated through the artisan engraver. Not only was this more commercially viable for the publishers, as it removed one very expensive stage in the whole process, it also ushered in a whole new means of expression. Artists were able to experiment with the more direct, natural drawing style that wax-based hard ground and the move from iron plates to beaten copper allowed.

The sixteenth-century French artist Jacques Callot further developed the process by mixing a harder ground, made from a varnish rather than just wax, allowing more and finer detail to be drawn which could survive the etching process. His extraordinary collection of fine etchings, *The Great Miseries of War*, revels in the new possibilities that this simple improvement in materials offered.

Such an outwardly simple development as this created the means by which artists from Rembrandt, Goya, and Picasso through to Paula Rego (and several of those included in this book) have all been able to explore etching's ability to create images of raw power and vibrant mark-making.

Soft ground, made by the simple addition of tallow fat to the hard ground mixture, was an extension of 'crayon engraving' and developed to mimic pencil drawings. As interest in artists' drawings increased (until the seventeenth century artists' drawings were rarely seen and almost never exhibited), soft ground developed as a technique that better replicated the drawn chalk and pencil mark. Although most probably developed in France, it was in England that artists really took hold of its new expressive possibilities. Artists such as Thomas Gainsborough used its light, direct quality to great effect, as did John Cotman and Joseph Cozens of the Norwich School. Soft ground has an intimacy that lends itself to the quiet and restrained. There are works by artists such as David Hockney and Celia Paul that exemplify this beautifully.

Aquatint, the etching of fine tonal areas across a plate, is also thought to have originated in France. (France had a large and sophisticated print publishing market and many of our terms used to describe prints are French in origin, such as 'BAT' and 'HC', as described in Chapter 10). To use aquatint, a fine resin dust is sprinkled over a plate, which is then melted and bitten with acid. This allows for a more tonal and painterly quality to an image, rather than the purely linear marks of hard and soft ground.

If there is one artist who most strongly represents the development of aquatint at its outset, it is Goya. If we look at Rembrandt's *Christ before Pilate* and Goya's *Tampoco* from *Disasters of War*, the raw power to evoke a strong emotional response from the viewer is apparent in both. Rembrandt's is achieved through countless reworkings of the plate, with layer upon layer of hard ground drawing. Goya's has the appearance of being achieved with a single hard ground and aquatint. This outward simplicity still achieves an extraordinary visual intensity because of the ability of the aquatint to provide a broad-brush atmospheric quality.

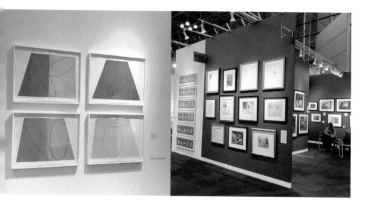

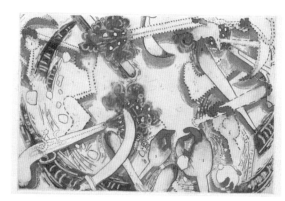

The processes of etching continue to resonate. Oona Grimes' *Bligh's Bounty Box 2* is based on hard ground, as used by Dürer and Rembrandt, and aquatint, as used by Goya.

With the arrival of the 'Modern Age', and a period of seemingly continual technological advancement, artists have been offered an almost inexhaustible range of further possibilities. Firstly, the development of the photographic image spawned photogravure and later photo etching for the printmaker. The arrival of the digital image has also opened up a wealth of creative possibilities that has led to the development of new ideas and imagery and enhanced our ability to manipulate them. The relatively recent uses found for photopolymer, a profoundly commercial material, has further added to the artist's ability to use the essentially unchanged medieval techniques of etching to express contemporary concerns. Throughout the course of the twentieth century, art moved at a dizzying pace through a myriad of changing styles, theories and 'isms'. Many of the ideas that underpinned and drove both the art and artists forward during this period can be seen in the printed, multiple image, with 'Truth to Materials', a central axiom of Modernism, revealed through many artists' prints.

Throughout this book, etching can be seen to move from one original starting point and then deviate along any number of paths as the work progresses. Some of these routes will have been tried before, whereas others may be new and can take the artist and their audience somewhere else altogether.

Technology and art have always sat side by side within printmaking. No technology that has an expressive force ever becomes redundant. New technologies are bound to offer still more possibilities in the future. Nevertheless, etching techniques that have been with us for over 500 years still provide their own unique languages that artists wish to explore. This mixing of histories and technologies is one of printmaking's greatest assets.

The democratic art

My own etching experience has been in a communal studio, and it is this experience that colours much of what I have written.

It has been commented upon many times that printmaking is the 'democratic art'. This I have always taken to mean two things: firstly, its inherent multiplicity means that access to artists' prints is not limited to an individual collector. The larger the edition, and therefore potentially the more affordable each print becomes, so the range of people buying artists' work can be expanded and broadened. Secondly, because of the very nature of most print workshops, the need to work with one eye on the needs of others in order to make a studio function well requires a sense of community. An individual artist working alone rarely needs to concern themselves with other people until they walk out of their studio door.

A communal studio also brings with it the opportunity of working with an audience of like-minded people. It is easy to initiate discussion and debate about the work being produced as there is an in-house peer group who are all experiencing the same struggles in mastering techniques while also trying to develop their ideas and visual language.

Almost any studio you attend to learn etching will be a communal space. There are communal print studios scattered all around the UK (and beyond that, the world!) where anyone can attend courses and learn printmaking techniques. A list of possible places is included at the end of this book. These studios are often set up by groups of artists who want to include print in their art practice but need to share the cost of studio space and of equipment.

On the whole, the bigger the group, the better the facilities. Sharing a communal studio can be a wonderful opportunity as it gives you the chance to learn in a nurturing and invigorating environment. The best studios can feel like art colleges, but without the stress.

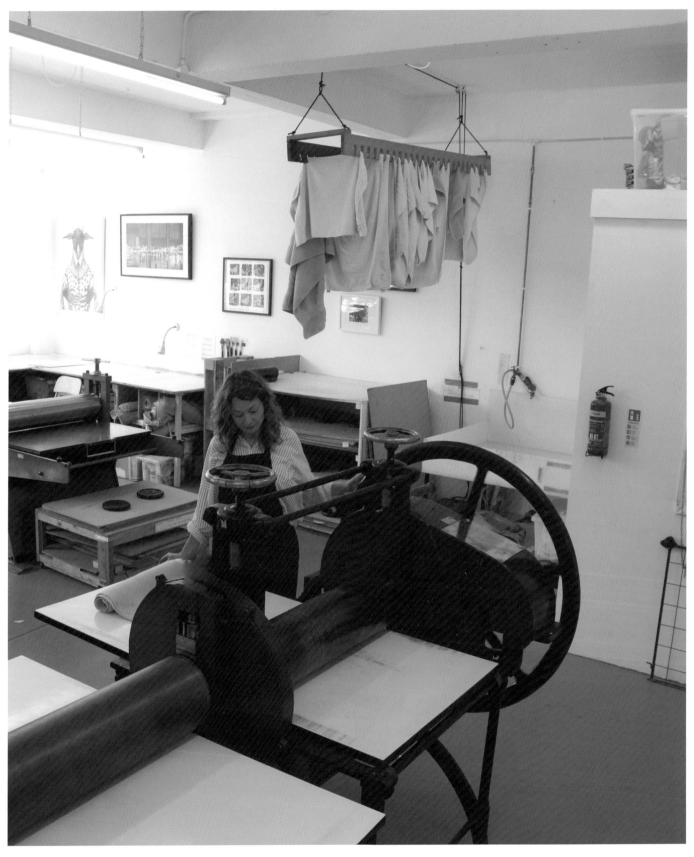

East London Printmakers Studio in Mile End is shared by fifty rent-paying keyholders. For people who want to come and learn print techniques there are courses and every week there are bookable open access sessions.

Building a community

The facilities required for etching inevitably lead printmaking artists to start their working lives in communal studios. Many artists' initial contact with printmaking is at art college and they progress to other facilities when they leave. Others come to etching via short courses at adult education or open access studios.

Personally I have made work in perhaps a dozen or so communal studios, some in art departments, some privately owned, some with charitable status and public funding. The one with which I have been most involved, in three different venues over twenty years, is East London Printmakers. This has been run as a self-funding, artist-led cooperative through two different incarnations, initially as an incorporated organization and more recently as a Community Interest Company.

Set up to keep rental costs low, many members of the early group continue to be actively involved. The rent is still much cheaper for a shared space than for an individual studio and the facilities we have collected over time are substantial. For some of us the communality is also a benefit in terms of having an inbuilt peer group but the cost factor is still a strong driving force.

If I found myself in the position of helping to set up a print studio on a tight budget, there is every chance you might too. There are a number of practical factors we found important when looking at a new space and calculating how workable it would be.

Before anything can be moved anywhere, access is crucial. Ground floor space is an easier option, both for installation of heavy presses and use of them by anyone with mobility problems.

A strong goods lift and reinforced floors broaden your options, and measuring doorways before the removal company arrives makes the need for spontaneous wall removal less likely. Internal partitions may be better built around large equipment once installed. Well-placed waste water drainage is crucial and deciding on the position of an etching sink and a paper sink (plus water supply for any other print facilities) will take some thinking through.

The placing of an acid room and a separate aquatint room is a dominant consideration because of the need for good extraction. Venting onto a used outdoor space (such as a street) is problematic in terms of environmental health. (In our own most recent move we had to compromise by changing the etching solution for zinc as nitric acid fumes venting onto a canal side – without a very expensive filter system – can harm passers by.)

It is worth spending a long time planning the studio layout. The footprint of an etching press is large as the bed extends in two directions and space around it is necessary for good printing with accurate registration. Ergonomically planned work areas make a huge difference to the pleasure of working in a space. In a small studio, movable workbenches on casters can be a fantastic and much appreciated luxury.

Like surface plumbing, electrical wiring can be adapted. Ventilation, an extraction fan, a hot plate and an exposure unit (and possibly an electrically powered fan or reversed vacuum cleaner in the aquatint cupboard) are all fixed points and an abundance of extra sockets for hair dryers, a fan heater, a kettle, laptops, printer, etc. makes a space more adaptable.

Unfortunately we are living through a period of contraction and closure in the field of higher education and printmaking departments are bearing more than their fair share. The silver lining in this cloud is that equipment is being made available and offered to communal print studios.

One of the most important aspects of most open access studios is education, through introductory short courses, open access and masters programmes. This can be a vital part of any studio's development as it increases their audience and so the range of artists using the facilities. Participants in workshop programmes and even sales at exhibitions increase in number over the years, which in turn brings in a source of revenue with which to buy new equipment and increase the facilities available.

What started with a small group of seven like-minded artists, sharing the rent in a ramshackle series of small rooms and corridor spaces, has now grown into a group of about fifty key-holding members sharing large print rooms with natural light. We are now able to pay for a part-time administrator and part time technicians. Equipment which was once found, begged and borrowed can now be saved for and bought.

Finding the time and space to make your own work as an artist is always a hard-won struggle. Most people can find a way of making a bit of work in their limited home space. What they do miss, however, is the sense of communal activity and peer group dialogue they found at college. Communal print studios offer all of this at reduced costs, with the possibility of involvement with exhibitions, shows and an audience. What more could you ask for?

An understanding of how to use a press, how to use acids, aquatints and solvents and how to be dressed appropriately is essential. Printmaking workshops will have plenty of information dotted around. Clarity about best practice and practical common sense will go a long way to making the studio as safe as any other working environment, but we also do need to know what we are dealing with. Most studios will give you a health and safety talk when you first join, as an understanding of these issues is vital, for you and your fellow practitioners.

The first rule of working in a print studio is to always to dress appropriately. Wear gloves when handling any cleaning or etching solutions, wear a mask when handling anything in powdered form, and wear working clothes that you don't mind getting covered in all manner of detritus.

Health and safety

Within every print studio, some of the materials, chemicals and machinery can be hazardous and must be treated with respect and knowledge. Without being over-dramatic, there are tools and equipment which, if badly used, can cause damage and injury, and chemicals which can be toxic and corrosive.

The acid room

It almost goes without saying, but strong acids are dangerous and need careful and expert handling.

Ventilation must be switched on whenever the room is in use. All etching solutions must stay in the acid room and be covered

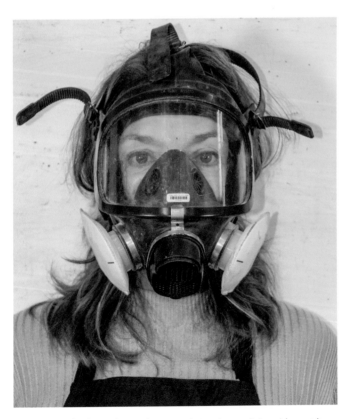

Health and safety when using aquatint resin or nitric acid must be taken seriously: goggles, gloves and a mask must be worn.

Some areas, such as the acid room sink, are bound to get dirty...

if left in the tray for any length of time. When not in use etching solutions should be decanted back into secure containers and stored in lockable storage areas. Mixing acids in their respective concentrations is a job for a trained technician. Always mix the acid to the water, as this instantly dilutes the acid.

Each etching solution will require a separate bath, as will each strength of each solution. (For instance, soft ground and aquatint are etched in a weaker solution than hard ground and there will be a separate bath for this.) Different metals give off different residues or gases during the etching process and so these will also require separate baths.

Nitric acid must be used inside a fume cupboard with good extraction. Copper sulphate requires two rinsing trays as well as trays for the etching solutions. Ferric chloride dip tanks are sometimes vertical to allow copper residue to fall away from the plate while it etches; if not, then flat trays are used.

The sink in an acid room is invariably dirty. This is inevitable as it is used to degrease and rinse etching plates, but rinsing it at the end of your session helps prevent a build up of general murky mess.

Degreasing materials will be stored near the sink. If ammonia is used it must be diluted to at least 10:1 and stored in a covered bottle. The container of pure ammonia must be kept in the lockable store. The degreasing sponges, felts or other application materials must be kept completely clean in a separate container.

Accidental spillages of unknown substances can be neutralized with sodium bicarbonate.

Eye wash kits must be available with clear instructions on what to do if an etching solution gets in your eye. Wear goggles to avoid this ever happening.

If nitric acid is used, gloves, goggles and a mask must be worn at all times.

Aquatint cupboard

Even before you enter the aquatint room it is essential to put on a well-fitting mask with new dust filters. You will need to wear your mask throughout the aquatint process until the dust is melted onto your plate and the room is clear of any residual floating dust particles.

Like any other fine, active dust, it is potentially flammable, so any naked flame used for melting the resin must be kept well away from the aquatint box.

Solvents

Finding out the method your studio recommends for cleaning up during and after etching will help you make sense of the solvents available. White spirit or turpentine substitute are the old-school favourite solvents, as they remove hard and soft grounds, inks and varnishes thoroughly and quite quickly.

Other solvents that remove hard and soft ground, inks and varnishes effectively are blends of vegetable oil and alcohol. Some of these 'green' washes also contain a detergent. These take longer to clean with but are much safer for the user and the studio environment. Whichever you use it is still essential to wear gloves, as repeated skin contact can lead to irritation and dermatitis.

If you are using acrylic grounds and varnishes these can often be removed with a mild solution of washing soda and water. If the washing soda is not strong enough the recommended alternative is a solution of caustic soda and water; however, this can be a very hazardous material. A mask and rubber gloves should be worn when handling caustic soda.

Traditional resin aquatint and straw hat varnish can only be removed with methylated spirits. Like white spirit, it is flammable and must be stored safely, preferably in a metal cupboard.

Rags soaked in solvents should be put in a metal bin with a cover after use, as should ink-heavy scrim.

Metal bins with lids provide safe storage for used rags or scrim.

An aquatint cupboard is very useful but the fine resin dust must be kept inside and a mask worn throughout the process. You can see dust on the hatch door as well as the plate.

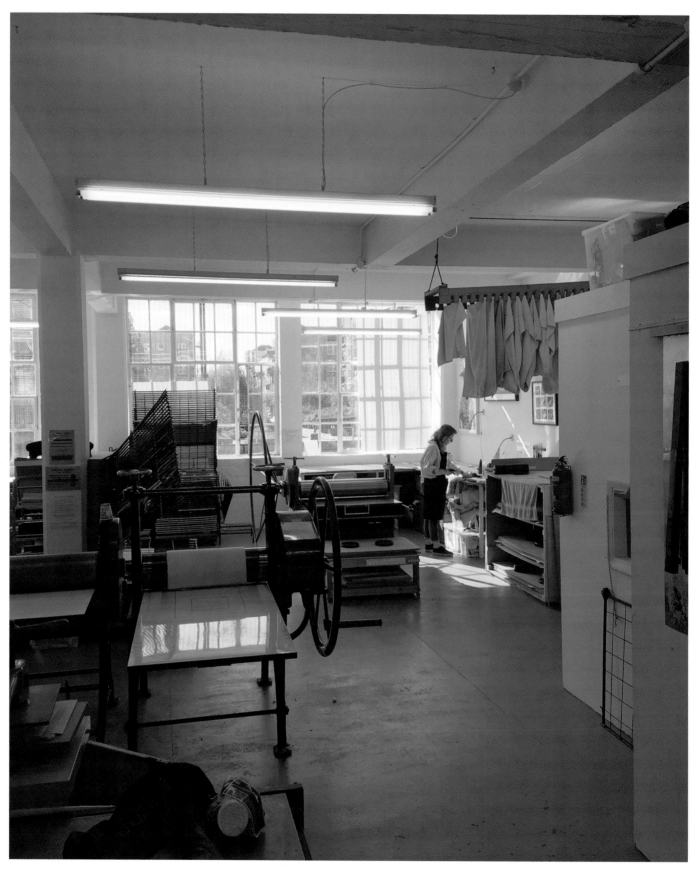

High ceilings and open windows help ventilate even without the ideal extraction system.

Room ventilation

A studio full of the acids, grounds and solvents as described above does need good ventilation. If you are lucky, there is a proper ventilation system to switch on at the beginning of the day and off at the end.

Even without this ideal provision there are steps that can be taken to optimize the air quality in your etching studio. Minimizing the amount of toxic solvents you use will help improve the air quality enormously and the basic approach of opening windows during working hours goes a long way to creating a pleasant, well-functioning work environment.

Metal guillotine

Before cutting plate on the guillotine, check which metals and thicknesses are allowed there. Heavy gauge steel, for instance, can blunt the guillotine blade and polymer may bend instead of slice if the guillotine is not set up properly. A card guillotine may be a good alternative for cutting polymer. When you cut, bear in mind that anything devised to cut heavy gauge metal can also damage you, so keep your hands well away from the blade and your back foot away from the pedal.

Hot plate

The hot plate will take a while to warm up to temperature and a while to cool down. Hard ground melts at a higher temperature than soft ground and it is important to remember that hard and soft ground each require a separate roller. The hot plate needs to be wiped clean after use, preferably when it has cooled down.

Smoking plates

For obvious reasons smoking plates with a naked flame should be done in a designated place, whether wall brackets or hand clamps are used to hold the plate upside down. The most important consideration for the etcher smoking the plate is to work out where the tapers will be extinguished after use. A metal tin with a lid may work as a place to both stub out the tapers and store them. Avoid extinguishing lit tapers in water, unless absolutely necessary, as the next user will find that the tapers spit the water onto the next plate, which can mark the ground.

Etching press

In terms of health and safety, always pay attention as you take your plate through the turning rollers and keep your hands well back, as no finger going through the press would survive unscathed. The handle must be held when turning and turned patiently, never spun uncontrollably. If space is tight it may be best to remove the handle when the press is not in use. The bed must be centred at the end of the working day so it rests evenly on the supporting rollers. Blankets should be removed and either hung to dry or rolled and stored. Nothing thicker than the average gauge of metal plate used should ever be run through, so no coins, keys or family jewels. Other details about the press will be particular to your studio so it is best to check preferred practice.

When cutting plate on a metal guillotine keep your hands well back from the shearing blade and your back foot away from the pedal.

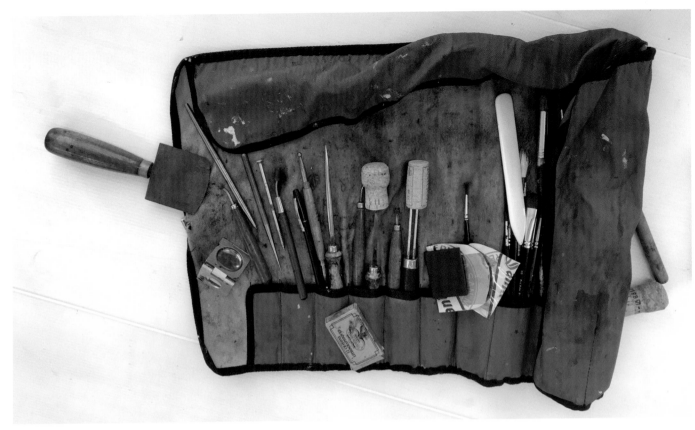

Etching tools can last a long time if carefully wrapped at the end of the day.

Etching tools

On the whole an etching tool is a benign and useful item but, as with any metal spike, accidents can happen if it is not stored or handled carefully. Etching and drypoint needles, scrapers and burnishers should all be kept and carried with protective coverings on the end – a cork will do if you have just one to carry around. Storing them in a solid box or tool roll will also help keep you safe and the functioning end sharp.

Clean area best practice

These areas must be kept absolutely clean, so no inks, solvents or liquid grounds should be left uncovered here. Cutting mats are primarily for preparing paper so must be kept free of oil, ink and dirt.

The paper sink or bath must be emptied and fully drained daily so that the water in which your paper soaks is always clean and fresh. Problems arise when the water is left to sit too long, especially in warm weather when mould and algae spread quickly across damp surfaces. Scrubbing with a dilute solution of a sterilizing fluid such as Milton should rid the paper bath of mould and unwanted aquatic life.

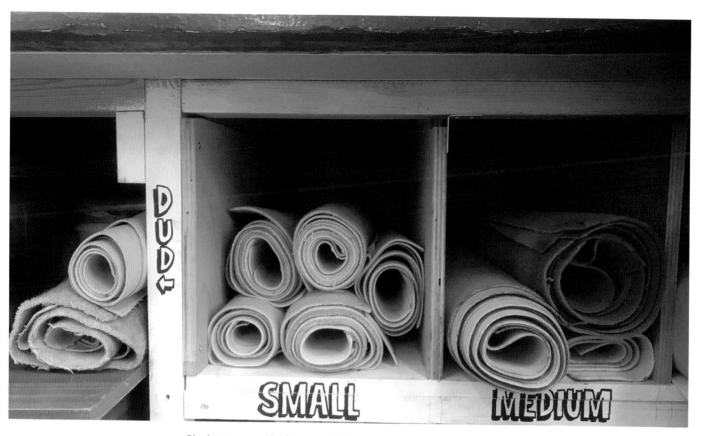

Blanket storage. 'Duds' are useful for any occasion where ink may leak.

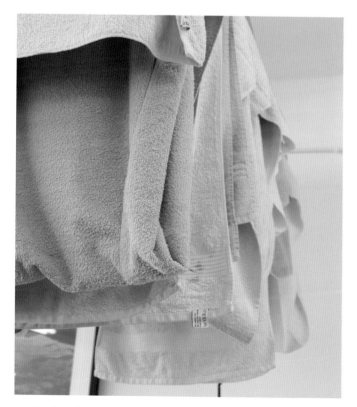

The benefit of using towels to blot is that they can be washed thoroughly and used in rotation.

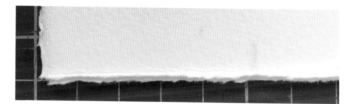

Work areas need to be kept clean when handling papers.

The paper blotting area must also be kept clean. Whether towels or blotting paper are used they must be separated and dried after use to avoid mildew and mould developing. There is often a ball rack on which to hang them.

The drying boards must be kept ink free. To ensure this happens, prints must have at least one sheet of tissue over the printed image to avoid offsetting ink onto the boards or other work.

Press blankets are expensive so protect them with tissue paper laid on top of the printing paper, each time you print. This minimizes the chance of ink spreading and paper size seeping into the felt. If you use paper grips to handle blankets while printing this keeps them fingerprint free. When the blankets do get dirty, they require a gentle wash with a small amount of Woolite or other non-biological laundry detergent and it is best if they dry either flat or hung from a ball rack.

MATERIALS AND EQUIPMENT

This chapter will cover only those materials and equipment that make up the essential elements we work with and choose from in order to make our prints. There are, of course, many others but these are covered in more detail in their own specific process chapters, or within the necessary health and safety aspects of where we work and what we do.

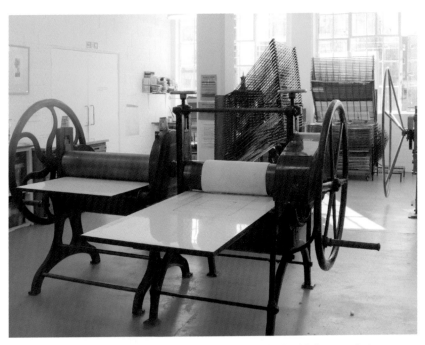

These top roller driven presses must have the bed fully extended before the blankets can be laid on the bed and wound in.

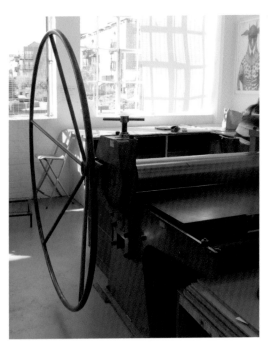

Presses that are bottom roller driven have an adjustable top roller which can be lowered onto the etching blankets.

The etching press

There are two basic designs to an etching press in terms of how the roller is put in contact with the bed. Some presses are top roller driven; this means that the top roller is always in contact with the bed and so the blankets have to be pushed in while turning the handle. The second design of press is bottom roller driven, allowing for the top roller to be lifted up above the bed, the blankets inserted and then the roller dropped back onto the blankets and put under pressure.

Bottom roller presses have the added advantage of being able to print thicker items, such as wood or lino cuts, as the roller can be held in place above the bed.

The correct setting of the pressure for printing is slightly different for each type of press. For presses that allow for the top roller to be lifted and held in place, lift the roller and put the bed and blankets evenly in the centre of the press. Drop the top roller down into contact with the blankets, and, depending on whether the press has been pre-marked for the correct pressure (often done in communal studios), engage the pressure screws either side of the press evenly to the given point, or until you can see the roller touching the blankets. Then turn the handle so that the bed and blankets move to one side of the press, lift the blankets and place a bevelled plate into the centre of the press.

Place a sheet of newsprint on the top, drop down the blankets and roll through the press as if taking a print. Lift the blankets once it has passed through and you should hopefully see some impression of the plate in the newsprint. If it is a weak impression, increase the pressure through the screws and repeat the printing process until there is a slight tearing of the newsprint evenly down the sides of the printing area. Then the press is ready to take a proof and ultimately it is only through the printing of an inked plate that you can fully judge whether the pressure is correct. Once it is printing well, it is advisable to mark the pressure screws in some way, as the pressure is usually going to be roughly the same for similar size plates of the same thickness.

With presses where the top roller sits on the bed and cannot be raised, the main difference is the placing of the blankets under the roller. In this case the bed must be wound out to a safe, full extension. Then the blankets are placed on the bed, the two thinnest fronting blankets first with the thicker swanskin placed on top. It is best to stagger them slightly so that there is about a centimetre gap between the bottom blanket leading edge and the second, and the same between the second and third blankets. This makes it easier to get the blankets under the roller as they act as a ramp to lift the roller, rather than a solid mass that can act as a barrier. Once you have the blankets lined up, turn the handle with one hand while encouraging the bed to move forward with the other. (On an older press, pushing the bed gently with your hip can help to get it moving!) The bed will move forward until all three blankets are under the top roller.

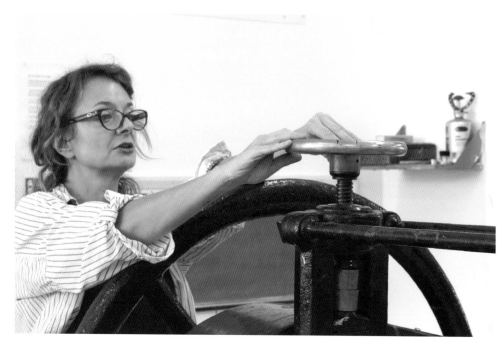

Adjusting both the pressure screws is best done before the blankets are inserted. Just a small adjustment can make all the difference to how well a plate prints.

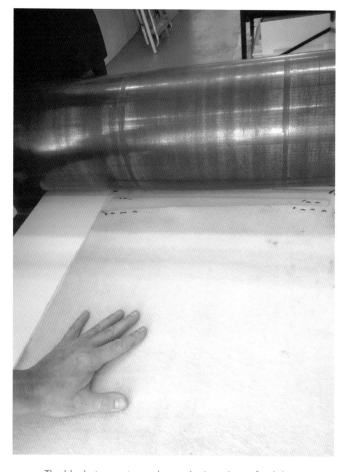

The blankets are stepped to make it easier to feed them under the roller as it turns. Take care to keep fingers away from the roller as the bed moves forward.

One swanskin/felt over two fronting/compressed blankets.

The blankets are staggered when laid on the bed to help ease of entry under the top roller if needed.

A system of pressure measurements can then take place, basically the same as mentioned above. There is a difference in that the full weight of the top roller is already on the bed and blankets, so try not to over-tighten the pressure screws before you test it with a plate.

If the embossing on the paper is uneven across the plate you will need to adjust the pressure until both sides are equal, using the pressure screws above either side of the top roller. Turning a screw handle by just a tiny fraction can make all the difference.

UV exposure units

Many print studios have an ultra-violet exposure unit, as it is useful for several different photo print processes. The light produced hardens the photo emulsion on the plate which, when developed, reveals only the drawn image areas to the action of the acid. The ideal is a machine specifically designed for exposing plates for photopolymer and photo etching. Inevitably this is not always available but alternatives can work just as well.

Preparing a photo test plate gives you the chance to work out optimal exposure times. The top of this plate was exposed in stages at intervals of fifty units.

You may find that the unit you have access to is also used for screenprinting or lithography. It is almost inevitable that the surface of the glass will be scratched from repeated high-speed removal of large and quite cumbersome screens or plates. Scratches can show as marks on your positive, but this can be alleviated a little by placing a sheet of clear acetate between the glass and the plate.

It is also possible to make your own simple exposure unit. Indeed, devising an exposure method can be as much an outlet for creativity as the artwork itself.

I have seen various configurations for UV exposure. Perhaps the most straightforward is to build a wooden box with a glass top on which to lay a plate upside down. The UV bulbs are wired into the wooden box to shine upwards against the plate on the glass and the whole is protected against daylight during exposure with blackout curtains. I have even seen tanning lights used for photopolymer exposure. If no vacuum is available the inverted plate can be compressed against the positive with a heavy sheet of wood, MDF or Perspex.

Alternatively, you can suspend UV bulbs from above and surround the exposing plate with blackout curtains. The positive can be held against the photo emulsion with a clean glass or Perspex sheet during exposure. Another way of creating compression is to use a tightly sealed transparent bag intended for compressing packed clothes. This can be used to pull the positive down against the light sensitive plate if a vacuum cleaner is attached to the bag opening.

In an extremely sunny climate daylight exposure is possible, although timing is inevitably problematic as the amount of UV light changes during the course of a day. In the UK this is difficult even in sunny weather as there is likely to be a small amount of cloud passing between the sun and the plate at some point during the exposure period.

Checking exposure times

Each exposure unit has its own optimal exposure times. However, once these timings have been established they are generally consistent for each positive exposed. Whether the image is digital or hand drawn the exposure time will be much the same.

Most studios have a written record somewhere about their UV unit and optimal timings. If none is available, you can use a 'Stouffer step wedge' to calculate optimum times. This is a small clear acetate with a range from light to dark steps of tone. By giving the plate a single exposure and developing it, you can calculate the optimum exposure by seeing what has developed, what has burnt out and what has not developed at all.

However, an easier method is a simple form of test plate similar to ones made for aquatint. Get an image you wish to use and tape it down to a test plate. Cover the whole area except the first 5cm with a sheet of completely opaque film (red masking film if available).

Expose the plate for a set time, for example 1 minute. Then, once the vacuum on the unit has released, move the opaque film back another 5cm and repeat the exposure. Do this several times, recording the timings, perhaps increasing the time to 2 minutes, or even 3, until the whole plate is done. Remove the tape to remove the photographic image from the plate, develop and proof. Hopefully this should give you an idea of optimum times for exposure. Once you have this it will tend to be the same for all similar films used, so normally this process will only need to be done once.

Plates and etching solutions

The four primary metals you will come across in an etching studio are copper, zinc, aluminium and steel. The popularity of each varies over time, partly due to price fluctuation, partly due to the changing concerns regarding the health and safety aspects of the chemicals surrounding their use and partly due to their ease, or otherwise, of use within any particular studio environment.

The variety of paper colours available is subtle but worth experimenting with.

Most printmaking papers, particularly those useful for etching, are called 'wove' papers, whereas many lighter weight book papers, especially 'oriental' papers, are what is called 'laid'. Wove papers have a very fine mesh woven through the thicker support wires in the mould, which holds the sodden paper pulp. This creates a smooth surface to the paper, which is better for printing images onto. Laid papers have a visible indentation running through the sheet. As with the wove papers, the coarser mesh provides the support for the bulk of the paper. The 'laid' line is created by a thicker wire which is woven into the finer mesh placed on top. This thicker, heavier wire is spread much wider and creates the characteristic laid ridges that can be seen clearly when the paper is held up to the light.

The term 'deckle edge' is often associated with these papers. A 'deckle' is a removable wooden frame or fence, used in manual paper making, to limit and control the size of the paper during its making. This leaves the paper fibres overhanging the mesh frame, so giving each sheet made its decorative edge. Hand-made papers have four deckle edges, as the frame is four-sided. Wove papers generally have two natural deckles and two are torn from the continuous sheet as it is made.

Either during or immediately after the sodden pulp stage, a glue binder, the 'size', is added to help bind the fibres together. Papers are often referred to as having 'internal sizing', i.e. it is added at the pulp stage so that it is contained throughout the sheet, whereas 'surface sizing' is applied after the sheet is formed and is applied only to the surface as an extra layer.

Internally sized paper is generally best for etching as the paper has to be strong enough to withstand both soaking and being rolled tightly through the press to pick up ink from deep grooves on the plate. Surface sizing is best for print processes that apply the ink in a more gentle fashion, such as lithography and silkscreen, where the image is really held only on the surface of the paper, not sunk into the sheet like an etching.

Papers also have a surface texture, which can make a difference too. Some are classed as having a textured, velvet or satin finish. Velvet is often the most popular for etching but you may find the smooth finish of satin works better for small-scale work with fine lines, and heavy textured paper may work well for strong, bold images with big areas of open bite.

Papers also have a 'grain'; this is the direction in which the long fibres lie after the mould-making process. They are called either 'short grain' or 'long grain'. Most printmaking papers are long grain, the paper fibres lying parallel to the long edge. It is most important if you are making books, as folding a page against the grain is extremely difficult. It can also be important for paper stretch and registration when multi-plate printing. It is preferable for the grain direction of the paper to move in parallel to the movement of the etching bed when printing.

It is also important that printmaking papers are 'acid free', especially if you are hoping to sell your work. As the term implies, they are essentially made of neutral pH value material, so that they do not rot or change colour over time. All cotton-based and most wood/cotton-mix papers are acid free, and many others have a neutral pH balance. Your paper supplier should be able to tell you which are suitable.

Finally, a paper's weight is something to be considered. The weight of a paper implies its thickness and generally etching papers start around 200gsm and go up as far as 500gsm. You tend to find that for most uses a weight of 250gsm to 300gsm is more than adequate. Heavier weights are reserved for larger sized papers where the extra weight gives it more stability; lighter ones are used for book papers or may have some unique colour or texture that the standard sizes and weights cannot provide.

Cotton papers are ideal for etching as they hold together well when soaked.

Cotton papers

Traditional intaglio papers are made from parts of the cotton plant discarded in textile production, often in combination with end cuttings from cotton fabric. The fibres are long, so the paper holds together well when soaked.

Cotton paper is ideal for intaglio techniques such as etching, because it moulds into all the grooves in a plate to pick up ink and can withstand the pressure of a press. Cotton paper is easy to handle when damp and stays flat when dried flat. Despite being inanimate, it is sometimes described as 'good natured' and 'well behaved'! It is durable and acid free, so will remain stable for years after printing. If you print your etchings on cotton paper all your collectors can enjoy your work long after you are gone!

Popular brands include Somerset, Arches, Fabriano, Zerkall and Hahnemühle. (All are available to order from paper suppliers listed at the end of this book.)

Cotton paper does not come in a huge range of colours, but it is worth testing the subtle differences between 'white', 'soft white' and 'radiant white', as well as such shades as 'antique', 'newsprint' and 'buff'.

Cotton/wood pulp combination papers

The mid-way option in terms of quality and price, these papers consist of a blend of cotton and wood fibres. They mould to the grooves of an etched plate better than papers made purely from wood pulp and cost less than cotton papers. Fabriano's Rosaspina is 60 per cent cotton and 40 per cent wood pulp and prints etchings well. It comes in white and in 'Avorio' – an interesting shade of pinkish off-white hard to find elsewhere. Other cotton/wood pulp blends include Magnani Acqueforti and papers by Hahnemühle. They tend not to be as strong or as subtle as pure cotton papers, but they are all good quality acid-free alternatives.

Proofing papers

Cotton-based intaglio papers are fantastic to use for printing etchings, but they can be expensive. If you are printing a test or proof of different stages in your plate making before your final print, it is possible to economize by using cheaper alternatives to cotton paper, such as wood pulp or 50 per cent wood/cotton.

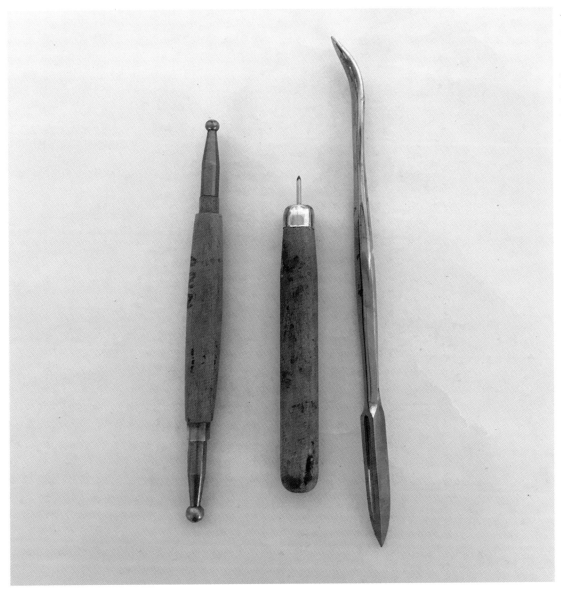

The etching needle in the middle is flanked on the left by a ball burnisher for highlighting small areas and a scraper-burnisher on the right used for changing larger etched areas. The latter is also useful for preparing the edges of a plate.

The main criterion for a proofing paper is that it can retain its shape even when damp and under pressure. It is best to use strong paper of at least 180gsm.

Wood pulp papers contain more size to hold their short fibres together. As a result they can easily fall apart as the size dissolves. This problem can be avoided with some deft handling. For instance, ordinary cartridge paper is made from wood pulp and is not intended for printing. However, it can be soaked briefly before blotting and printing. If preparing more than one sheet of wood pulp paper at a time then whisk them in and out of a paper bath after a few seconds, wrap them in polythene as described in Chapter 4, and place a weighted board on top to keep them flat.

Oriental papers

Most of these papers are made from a variety of plant fibres. They can be found made from wood, grass and rice straw as well as other tree plant fibres such as kozo, mitsumata and gampi. By comparison with Western papers, they tend to be thinner and more absorbent.

Hand tools

The main purchase you will need to make is a simple etching needle. This is quite sharp but is designed to remove hard ground without scratching the plate. Secondly, a scraper-burnisher is good for making broad plate changes, and for smoothing plate edges before editioning. Other hand tools may prove useful but these two are the only essentials you need to get going.

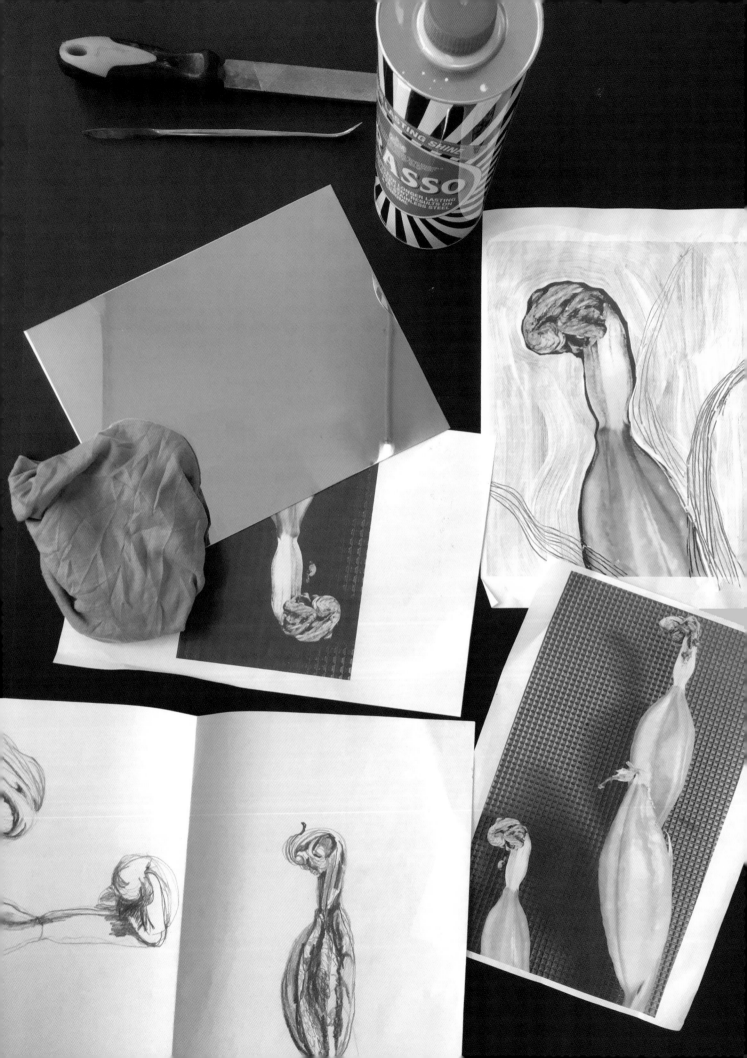

GETTING STARTED

The basic premise of etching has remained unchanged for hundreds of years so there will be elements of this preparation that may appear quite anachronistic. However, the processes described here are extremely effective and serve as a perfect start to the etching process itself.

As the book moves through the various techniques, you will find many of the processes repeated, particularly those involved in cleaning and degreasing the plate. Whenever these processes crop up and you are unsure how to proceed, refer back to this chapter to refresh your memory.

Plate preparation

In a nutshell

1. Cut the plate to size.
2. File the plate edges.
3. Polish the surface.
4. Degrease the plate.

Cutting the plate to size

Metal sheets come in only a few sizes direct from the manufacturer, although they can be bought pre-cut from specialist printmaking supply shops to a variety of commonly used sizes. They also come in a variety of thicknesses, but again most print suppliers limit this choice down to a couple of the more practical and cost effective, normally either 1mm or 1.2mm.

Cutting metal plates can be problematic and can only really be achieved accurately with the use of a metal shear guillotine, usually foot operated. Most print studios will have one of these as their basic equipment, so this should present no problems. It is, in theory, possible to hand cut a sheet of metal using a 'draw tool'. Through the action of dragging a fairly broad blade across the plate against a straight edge ruler, so creating a groove, the plate can eventually be folded and snapped. However, this can take a long time to achieve, never gives a very satisfactory cut and is something I have tried a couple of times, only to give up and seek out a guillotine.

To prepare to cut your plate, measure and mark the plate size you want with the aid of a ruler and a set square. Place your plate on the metal guillotine, pushing it sideways to sit firmly against one of the metal end blocks to stop the sheet from slipping. Holding it flat, slide the plate under the blade and blade guard. It goes without saying that a blade strong enough and sharp enough to slice through metal should be treated with respect.

Check the line you want to cut is directly aligned with the cutting edge below the blade on the guillotine. Stand well back from the foot pedal. While still holding the plate, place one foot on the foot pedal, making sure to keep the other foot well back. Press firmly with the foot pedal and the metal should cut neatly through. It is quite normal to have to use your full weight to achieve a cut through a large plate. Only use a guillotine that has a protective barrier between hand and blade, and keep your hands well back.

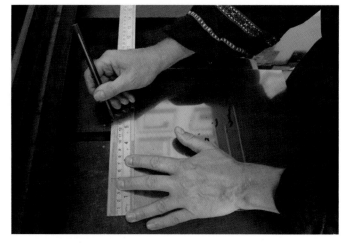

Measure your plate and mark it where you want to cut.

Slide your plate under the guillotine blade until the drawn line reaches the cutting edge, keeping your fingers well behind the hand guard.

Line up the drawn line and the cutting edge. At the same time keep pushing the side edge of the plate against the end block on the guillotine to ensure a right angle cut.

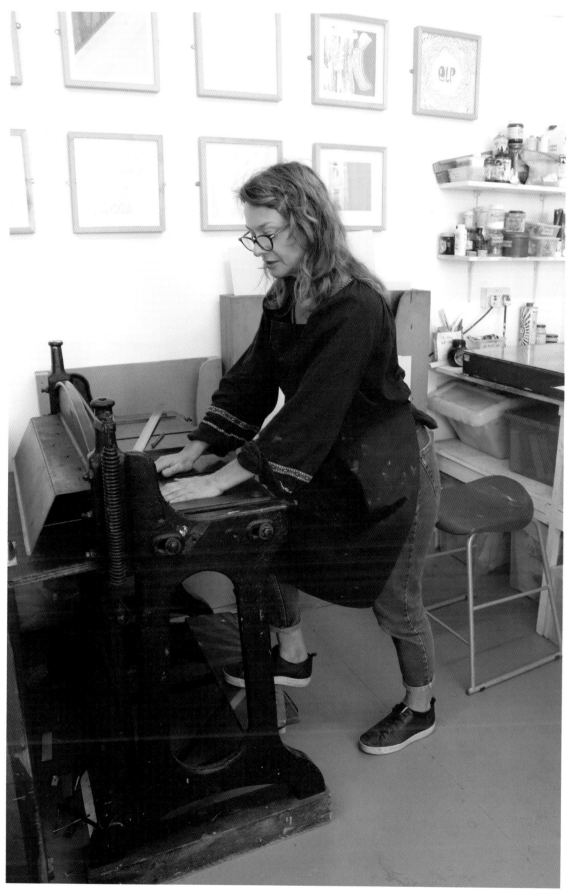

Keep your back foot well back while your front foot pushes down firmly on the pedal. As the pedal goes down, the shearing blade descends and cuts through the metal plate.

Polish the edges with a sanding block
and wet-and-dry paper. For really smooth
edges use fine then super fine and keep
replenishing the water.

Try to keep your metal file at a 45-degree angle as
you file along each plate edge in turn, several times.
This will help prevent the plate from cutting the
paper or blankets when it prints.

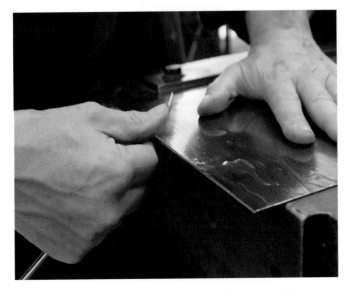

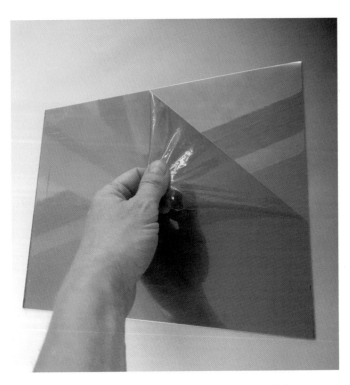

Apply a little oil to the plate edge with a rag and
run a burnisher along each edge several times to
smooth back the roughness.

Peel off the protective film. The surface revealed
is the one you are going to work on.

Filing and polishing

Materials and equipment

Metal files, preferably both coarse and fine

Medium and fine wet-and-dry paper

Sanding block

Small container of water

Plate burnisher tool

3-in-1 oil

Rags

Metal polish

Method

Blunt-cut etching plates have sharp edges. These edges need to be filed, partly to protect you from cuts, but also to prevent your paper or etching blankets from being cut during printing. It is best to file in a designated area as metal filings can play havoc with the inking, cleaning or polishing. A solid piece of furniture, such as the guillotine, is a good place to file.

Hold the plate firmly with one hand allowing the plate edge to project slightly. The end block on the guillotine can be useful to push against. Hold the coarse metal file at a 45-degree angle and file along the plate edge until there is a visible angle on the edge of the plate. Turn the plate and file each edge in the same way.

If you have a finer metal file repeat the process with this. Even if a 45-degree angle has not been achieved, the sharpness will have gone and the danger of cutting anything with your plate has been averted. For finer finishing use wet-and-dry paper.

Bevelling is done with a burnisher and oil. Apply the oil (3-in-1 or plate oil) to the edge with a rag. Holding the burnisher at a 45-degree angle, run it firmly and smoothly along each edge several times.

Remember that this is preparing a plate before you start etching, which is generally good practice. When the etching process is complete it is best to file and bevel again before editioning. This is covered more fully in Chapter 10.

New etching plate usually comes from the factory, milled and polished with sticky backed plastic protecting its polished side. The milling (rolling flat) can leave a slight grain on the surface, which will pick up an ink residue and print a slightly grey plate tone. So that you have the opportunity to create a good tonal range and print some sharp whites in your image it is important to polish away this texture.

To remove any slight markings from the manufacture of the plate, work the surface vigorously using metal polish and if needed, some fine 'jeweller's rouge', a polishing compound that can be obtained from most print supply companies.

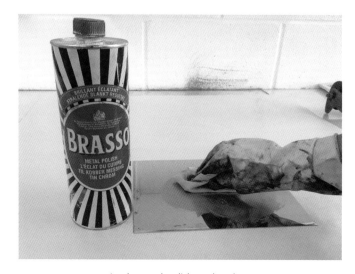

Apply metal polish to the plate.

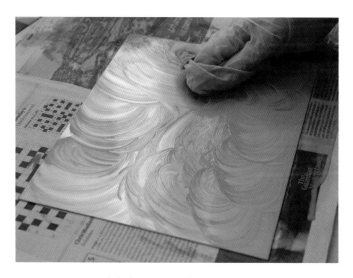

Polish the entire surface vigorously.

Degreasing

Whichever metal you are using you will need to prepare it for coating in an acid-resistant ground of one type or another. For any ground to adhere properly and protect the plate, the surface must be free from all grease. Degreasing is a cornerstone to effective etching. There will be many reminders throughout this book to degrease before applying any ground.

To remove all grease completely from a plate, a strong degreaser must be applied. The most traditional still found in common use is household ammonia diluted 10:1. However, the smell is powerful and inhalation not recommended so alternatives – such as household bathroom cleaners (without any added abrasive), salt dissolved in vinegar and even soy sauce – are also commonly used. The procedure is much the same for each.

Materials and equipment

Sink with running water

Plate

A ridged surface to lay the plate on – an inverted acid tray will do

Whiting powder

Ammonia/household cleaner, soy sauce or salt and vinegar solution

Soft, clean substance for wiping (e.g. a new section of sponge, a very soft rag or cotton wool, or an off-cut from a thin etching blanket)

Clean sheet of newsprint for blotting

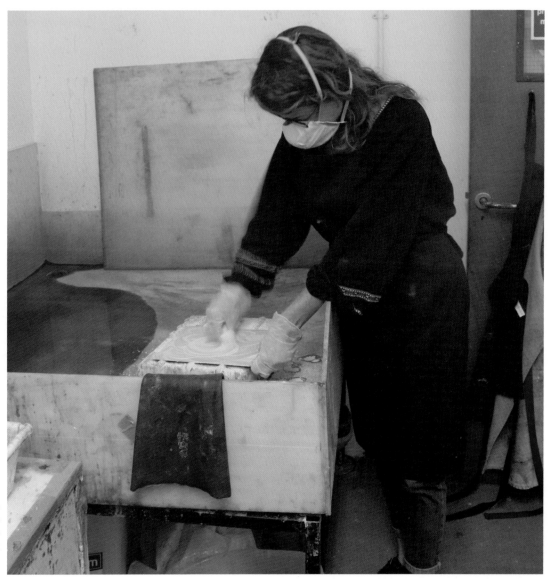

Work around the entire plate surface systematically to make sure every grease mark is removed.

Method

Sprinkle your polished plate liberally with whiting.

Pour your dilute ammonia or non-abrasive household kitchen degreaser. If using salt and vinegar, pour vinegar into the salt first to dissolve it.

Mix the degreasing solution with the whiting powder to create a paste.

Wipe over the entire polished surface of the plate with the paste, using a circular motion, diluting further with the degreasing solution when needed. This needs to be done for several minutes, making sure that you are covering all areas and are using the paste to almost polish the surface again.

Rinse the plate thoroughly with cold water. If the water gleams evenly across the entire plate your job is done. However, if there is water rejection on the plate, this is an indication there is still grease on the surface. Repeat as necessary until the water runs smoothly across the whole plate.

Lift your degreased plate by its edges and blot it immediately with clean newsprint. There is sometimes a residue of the whiting or chalk from the water left on the plate. Use a clean corner of newsprint or kitchen roll to gently wipe and polish this away.

Sometimes trying to degrease a plate that has already been etched and printed can prove difficult as the back of the plate is usually covered in a residue of ink, ground or cleaning spirit. If degreasing is proving a problem, clean and degrease the back of the plate before cleaning the front working face of the plate.

Why is degreasing the plate so important?

When a ground is rolled over the plate to protect it from the etching solution, any grease left on the surface if the plate will prevent the ground from adhering properly. When placed into the acid the hard ground will lift uncontrollably from the plate and you will get 'foul bite' or unwanted etched areas.

Although it may seem as if your cut plate has been kept grease-free, during the milling of sheet metal there will be many contacts with oil in the factory environment. In addition, the plastic film used to protect the surface for transportation can leave adhesive on the surface. All traces of oil and glue do need to be removed for the ground to adhere to the surface of the plate. Even a fingerprint can leave natural grease on the surface, so it is best to hold your degreased plate by the edges.

You are now ready to start the next stage. You can start with any of the processes described, as they are in no particular order of importance. Hard ground, soft ground and aquatint all have their own qualities that are well worth exploring. Each artist will have their own starting point when developing an idea and any one of these could be yours.

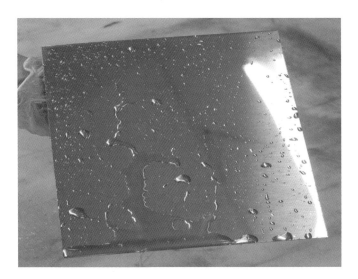

Metal plate is covered in grease from the factory and then the polish. Water pills on the surface and any etching ground will not adhere properly. To make the surface workable it is important to degrease thoroughly.

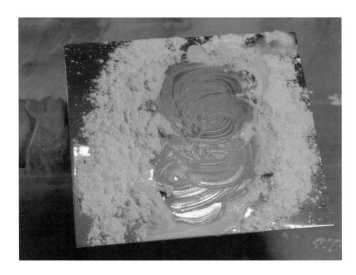

In the etching room sink, sprinkle the plate liberally with whiting before adding dilute ammonia or another degreasing fluid and covering the entire surface. Work the paste systematically around the entire plate several times.

HARD GROUND

Hard ground is made from a mixture of beeswax, bitumen and resin. The solid lump of ground is melted on a hot plate and applied to the surface of a prepared plate. Once cooled the hard ground can be drawn into with a simple etching needle or any finely pointed instrument, revealing lines of unprotected metal.

Place your degreased metal plate on the heating hot plate. When it is hot enough, melt hard ground beside it by running the block of hard ground across the hot plate surface.

Roll out the melted hard ground and apply it evenly to your plate.

When the plate is put into etching solution only the drawn marks will be bitten by the acid and create holes and grooves in the metal. It is within these etched areas of the plate that the printing ink sits and transfers to the dampened paper during printing, so creating the printed image. By contrast, the areas protected by the ground or varnish will be unaffected and as they will contain no ink, remain as clear, untouched areas of white paper when printed. As with all etching, preparation is key to getting the results you want.

In a nutshell

1. Prepare your etching plate by bevelling, polishing and degreasing.
2. Roll a thin layer of hard ground across the surface of the etching plate.
3. Smoke your coated plate using wax tapers to make it easier to see your drawing.

Materials and equipment

Degreasing equipment (sink, sponge or clean cloth, whiting and ammonia or similar)

A plate with filed edges and a polished surface (see Chapter 2)

Ball or block of hard ground

Preheated hot plate to heat plate and melt the ground

Rubber or polyurethane roller

Oven gloves, push knife or flat spatula to handle the etching plate when removing it from the hot plate

Preparing your plate

After bevelling and polishing, degrease your plate thoroughly. Be sure to repeat the degreasing process until water gleams across the whole surface of the plate without any obvious rejection. Rinse thoroughly both the front and back of the plate and ensure there is no whiting residue left behind.

Dry the plate with clean newsprint or kitchen roll. Be careful not to leave any fibres behind, or greasy fingerprints.

Covering your plate with hard ground

Carefully pick up the degreased plate by the edges and place on the hot plate. Both the etching plate and the hot plate must be at the same even temperature for the process to run smoothly, so leave for a few minutes for both to warm up to the correct temperature.

If your hot plate is big and clean enough, you can draw the hard ground ball across its surface and roll the melted ground, up and down and then from side to side, until the ground is evenly distributed across the roller. Then apply it to the heated etching plate. Alternatively, you can apply the hard ground ball directly to the etching plate, allow it to melt there and then roll it evenly across the surface. Whichever method you use, the aim is to get a thin, even coating across the entire plate.

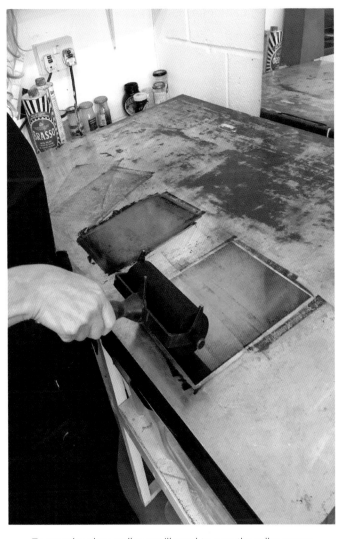

To coat the plate well you will need to pass the roller across several times, picking up more ground when necessary.

When the ground is even across your metal plate you can remove it to cool.

Hot plates and their thermostats vary in age and accuracy, so, as a rule of thumb, if the ground is lumpy either on the hot plate or the roller, the temperature isn't high enough. If, on the other hand, the ground slithers or separates out when rolled, the temperature needs to be turned down.

As soon as the etching plate appears suitably covered (it usually looks like it has a thin coating of old oak varnish), remove the etching plate from the hot plate to cool. If the etching plate overheats, the hard ground can separate and create marks of its own, which will be bitten in the acid, creating unwanted foul bites.

Use oven gloves, a push knife or spatula to slide the ground-covered plate off from the hot plate onto a nearby cool surface. If the hot plate is no longer needed, turn the thermostat down, switch off and clean.

Smoking the plate

Once the plate is cool enough to pick up you can darken the plate with smoke from wax tapers. The aim is to combine the carbon released from the flame with the hard ground when the heat from the taper melts the ground.

It may look like a fantastic, arcane ritual but smoking the plate fulfils two useful functions: it hardens the ground further, creating a more durable and exact surface through which to draw fine lines; and it darkens the ground, making it easier to see where you have drawn as the lighter colour of the plate shines through.

The plate needs to be upside down to allow the smoke to rise and mix with the ground on the plate. For a small plate a hand clamp can be used.

For larger plates studios often devise curious 'Heath Robinson'-style mechanisms. It is possible to make a quick makeshift suspension kit with coat hangers. Many studios have brackets that fold out from the wall to allow plates to be suspended on pins. I have even seen foot-operated pulley systems that open and close the arm to allow big plates to be suspended with care.

Whichever system you use do make sure to stop out any marks left by pins or clamps once the plate has cooled again with a suitable liquid stop out ground.

Materials and equipment

Plate covered with hard ground

Tapers fixed with masking tape handle fixed in a bundle

Matches or lighter

Metal tin for extinguishing tapers

Brushes

Stop-out varnish

Jam jar and lid

Sharpie pen (optional)

Timer/clock

Gloves

Goggles and mask if using nitric acid

Method

Open the smoking brackets or frame and place the plate face down so it rests on the supports, back and front. Find your bundle of tapers and a lighter and work out where you are going to extinguish the tapers when you have finished. An open metal biscuit tin with a lid you can close is a good option.

Light the tapers and let the flame settle. Pass the flaming tapers under the coated plate, moving backwards and forwards so the middle of the flame reaches the plate.

If you keep passing the middle of the flame under the plate, systematically covering the whole surface, you will start to see the hard ground turn glossy and dark. When the glossiness has spread across the whole hard ground surface, stub out the tapers in the metal tin or similarly safe place. Leave the smoked plate to cool in hangers before removing it, ready to draw.

If the lighted wick is held too close to the plate there is always the danger of dragging it through the softened ground, leaving marks that will etch. On the other hand, the top of the flame will just put soot on the surface, which can make it cracked and brittle. This is difficult to draw through and can create foul bitten areas.

Once a plate is smoked and cooled, the ground is hard and fairly robust so it can be carried out and about. For artists who like to work away from the studio this sturdiness is a fantastic gift. You can build a simple carrying case to protect it while you're on the move – a pizza box, carried flat, may do the trick if you're not travelling far.

Drawing and etching hard ground

Materials and equipment

Etching needle or other such sharp, pointed tool (nails, dentistry tools, etc.)

Drawing the plate

You have prepared your plate and it is now ready to draw on. How we approach the initial drawing on the plate is different for each of us. You might want to consider some of the following possibilities for your hard ground drawing:

- Drawing directly onto the plate in front of arranged objects, landscape or a figure.
- Referring to a painting or drawing you have made previously, maybe by selecting a detail to focus on and work larger or by shrinking the scale of the original and drawing out from there to extend the imagery.
- Working from found imagery in newspaper, magazines or posters, looking at current events.
- Personal photos, digital imagery and collages all provide rich pickings for reinvention.

Remember your image will be reversed when it is printed. The print will be a mirror image of the plate. Therefore, if you would like to keep your drawing the same way round as your source material, the reference drawing needs to be reversed. If you are using photographic or digital imagery you can simply reverse or flip the image before printing it out and refer to that.

To transfer a pre-existing drawing onto your etching plate, shop-bought red carbon paper or a homemade version using soft red chalk pastel rubbed onto newsprint is a useful transfer technique.

To reverse the drawing you lay your drawing on a light box, turn it over and trace over the main lines on the back of the drawing so you can see them. To put this image on your etching plate, lay the red carbon or pastel-coated paper on the plate with your traced drawing on top. Trace over the lines again with a soft pencil and the transfer of the red carbon or pastel will show on your ground-covered plate. This makes it easier to see where to draw lines with your etching needle. You can also draw freehand directly onto the plate with a soft chalk pastel.

Support your plate upside down in the clamp or brackets used for smoking hard ground.

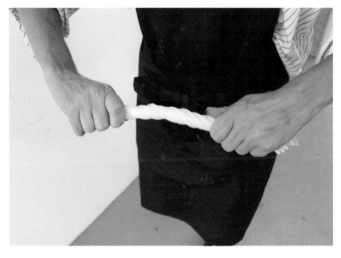

Twist the smoking tapers and wrap them together at the bottom with masking tape.

Light the tapers and have a safe place ready to put them out after use.

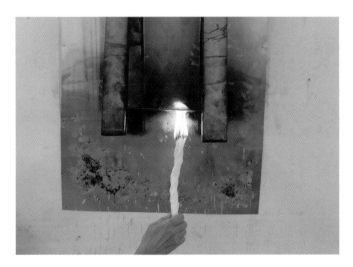

Keep the tapers moving under the plate until the hard ground mixes with the rising smoke and starts to darken and gleam.

The hard ground will now be more resilient; also your drawing on the metal plate will be easier for you to see against the smoked ground.

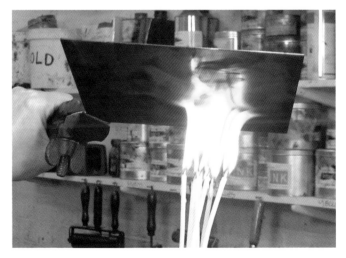

Some studios use a hand clamp to hold a small plate for smoking.

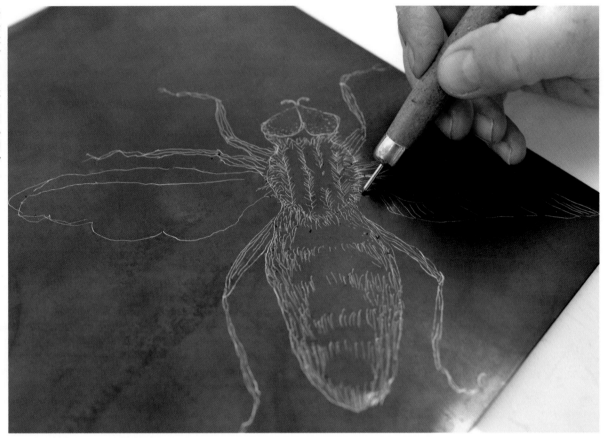

When the smoked plate has cooled it is ready for drawing with an etching needle. As the point moves through the hard ground it displaces the coating to reveal bare metal ready to etch.

Drawing with an etching needle

It is best to start by stopping out the marks left by the clamp or pin used during the smoking process. Pour a small amount of stop-out varnish into a jam jar. Using a brush, cover the bare metal pin or clamp marks. While the varnish is drying you can start to work on the rest of the plate.

Draw the etching needle through the hard ground, revealing bare metal below. Ideally the pressure should be such that the metal is revealed but not scratched by the needle. The marks will be etched into the plate by the acid, so there is no need for excessive pressure at this point. Keep the lines separate for now, drawing in the bare bones of your design.

In principle, every mark you make will etch. If you accidentally draw areas you then decide you don't want, stop out those lines with stop-out varnish. If the marks are tiny, a Sharpie pen is etch-resistant and is a quick way to stop out.

Etching the plate

How light or dark any particular mark will eventually print is determined by how much ink is held within the plate. The deeper the bitten area, the more ink is held and therefore the darker the mark will appear on the paper.

The depth of each mark is essentially controlled through two factors: how strong the acid is and how long the plate is left to bite in it. Each acid tends to have optimum concentrations to give the best quality of mark, etched within a reasonable time. Too strong a concentration of acid will tend to break down the finer, subtler marks, giving a cruder printed image. Too weak a mix can just result in a long and tedious wait for something to happen.

If your chosen metal is zinc, the acid most commonly used is nitric. This is a fast-acting, aggressive solution that needs to be dilute, at around 10:1 for hard ground and sometimes 15–20:1 for soft grounds and aquatints. This means one part acid to 10/15 or 20 parts water.

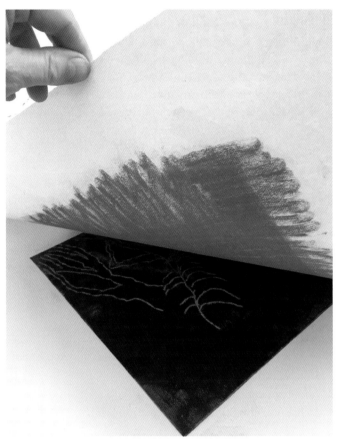

If you have a pre-existing drawing you want to transfer onto hard ground you can lay red carbon paper on the plate and trace it. Homemade transfer paper can be made by rubbing red chalk pastel onto newsprint.

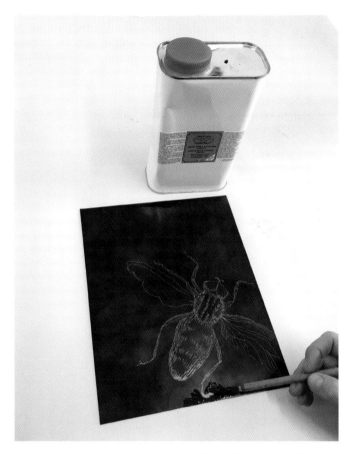

Any areas of ground that look too thin, such as spaces left by smoking brackets, can be covered with stop-out varnish to prevent them from etching. Brush on the varnish with care and allow it to dry.

When mixing acids you must always add the acid to the water. This instantly dilutes the acid, making it safer to handle.

When using zinc plate in nitric acid, you can expect as a guide when using a 10:1 mix for hard ground, fine lines will take 1–5 minutes, for medium depth lines 5–10 minutes and deep etch lines can be anything up to 30 minutes.

If your chosen metal is copper, there are a number of etching solutions that can be used, ferric chloride, Dutch mordant or Edinburgh etch being the most common. For the purposes of this book we will be using the copper/ferric chloride combination as our starting point, but the principles remain the same for all of the other etchants.

Ferric chloride, being technically a salt rather than an acid, bites more slowly and more cleanly than the zinc/nitric combination. Copper is a softer, subtler metal, so the quality of line produced on the print can have a broader and more exact tonal range.

Ferric strength, when bought, is measured in 'Baumé', rather than as a percentage like acids, and is generally found in the 36–42 Baumé degree range. The most common dilution is 50/50 with water which, when mixed, gives a clear, nut-brown solution. As the solution is used and becomes saturated with the dissolved copper, it turns green. This is still usable and some studios prefer a greenish solution for gentler processes such as soft ground and aquatint.

Using the copper/ferric combination, you can expect, when using a 50/50 solution, that etching a hard ground can take between 5 and 15 minutes for fine lines, 15 to 30 minutes for medium lines and anything up to an hour for deeper, stronger marks. These are rule-of-thumb guidelines that can be worked with. There are of course many variables to consider, such as the freshness of the acid and the temperature at which it is stored. Older etchants will be weaker and therefore slower to bite. Colder etching solutions can slow the process down and hotter solutions will speed it up (this is particularly true with ferric chloride).

Most etching solutions, when they are first mixed, tend to bite very aggressively and in a slightly uncontrolled way for the first half hour or so. This means if you are the first one to use a new mix of acid and put in a delicately drawn plate, there is always the danger that the lines will be etched off, or at least to a much greater depth than you had hoped. Because of this it is good practice to place a piece of discarded metal in the acid for up to 30 minutes, simply to take the aggressive edge off the acid.

As you progress through the etching process and become more confident and more ambitious for your work, it is best to make test plates in order to give a visual directory of how long a particular set of marks should be left in each etching solution to give the desired effect. There are instructions on how to make a test plate in Chapter 1. There may also be a print of a test plate on the wall of the studio to which you can refer.

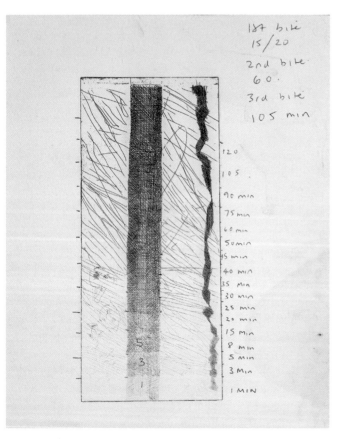

This hard ground test strip shows etching timings. The bottom of the plate was in etching solution for one minute before it was stopped out with varnish; the lines at the top were etched for 120 minutes. The timings up the side show how long the plate was etched at each step before it was stopped out. This particular batch of ferric chloride was gentle and etched slowly. The batch of etching solution you are planning to use is likely to etch a bit differently so it is worth making a test strip to find out. The notes at the top indicate the etcher's planned timings for lines drawn into each new hard ground applied to the plate.

Step-biting your drawing

You can use the information provided by a test plate to step-bite your own hard ground drawing. Step-biting is a way to create a range of tones in your lines. The length of time that the plate is left in the etching solution will vary the depth of line and the darkness of the line it will print. There are two approaches that both work equally well; the descriptions below will enable you to work out which approach will suit you best.

One option is to draw and etch the strongest lines in your image, then draw and etch the finer lines in stages. The first drawn lines will etch longest and print darkest while the last lines will etch least and print lightest. (The notes below focus on this approach.) The second option is to draw the entire image on your plate to begin with. Then you can stop out the lines you want to print lightest and continue to etch and stop out in stages.

In a nutshell

1. Protect back of plate, plus any fragile areas of hard ground.
2. Etch and rinse.
3. Add more drawing.
4. Etch, rinse, draw, protect until ready to print.

Method

When you decide the time has come to etch the first drawn lines you must prepare the plate in readiness for the etching bath. The back of the plate must be covered; unless the back of the plate is protected, that too will etch.

To protect the back of your plate, you can lay waterproof tape, sticky-side up, on a cutting mat. Place your plate on top of the tape and cut the tape at the plate edge. Repeat until the back of the plate is covered in strips. Run your thumb over the backing to ensure the tape edges are stuck to the plate and to minimize the risk of etching solution seeping in.

Other common ways of covering the back of the plate are varnish, or sticky-backed plastic. Whichever of these backings you decide on, you will also need to create a 'handle' to allow you to lift the plate out of the etching fluid with ease. Some etchers use a corner section of a cut plastic container to rest their plate on in a flat tray. This can then be used as a lever to help lift the plate out.

In the acid room, check which tank or tray is the best for etching your metal plate coated with hard ground. Once an acid has been used for one type of metal you cannot switch to using a different metal in the same bath.

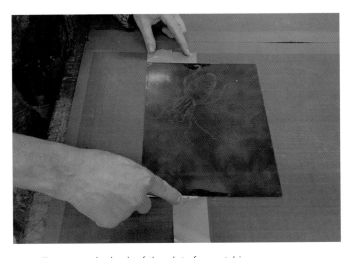

To protect the back of the plate from etching you can use waterproof tape. Roll out a strip sticky side up and lay the plate on top. Cut at the plate edge and repeat until the plate back is completely covered.

Plan how long to etch your plate for. As mentioned above, different metals have different etching times in different solutions. Take a moment to check which you will be using in your studio and therefore which of these timings below is relevant to you.

These timings are only approximations based on my experience. They can vary by quite a lot from studio to studio. They are all dependent on concentration of the etching solutions, how recently they have been mixed and the temperature they are kept at. Check notes and test strips supplied or on view in your particular studio.

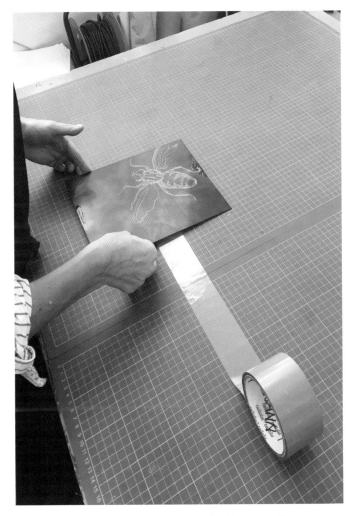

When the back of the plate is covered with tape, roll out one last strip to act as a handle. Fold it over to give yourself a non-sticky piece to hold.

Metal plate	Etching solution for hard ground	Suggested etching times for step biting
Copper	**Ferric chloride** This is technically a salt. It is generally supplied in 36–39 degree Baumé strength. As a rule of thumb the etching bath is mixed 50:50 with water.	5–10 minutes for lightest lines, approx. 30 minutes for mid-tone lines, and 60 minutes for darkest lines.
	Edinburgh etch If 300ml citric acid is poured into 1 litre of hot water, 4 litres of ferric chloride solution are added to create Edinburgh etch.	Up to 10 minutes for faintest lines, approx. 20 minutes for mid-tone lines and up to c.40 minutes for the darkest lines.
Zinc	**Copper sulphate** 100g copper sulphate crystals are dissolved in 1 litre of lukewarm water.	Up to 8 minutes for the faintest lines, approx. 18–20 minutes for mid-tone lines and up to c.35 minutes for the darkest lines.
	Nitric acid This is generally supplied in concentrated form. A basic bath is mixed at 15%. Acid is always added to the water.	Up to 5 minutes for the faintest lines, approx. 10 minutes for mid-tone lines, and up to 15 minutes for the darkest lines.

Suggested etching times for step biting.

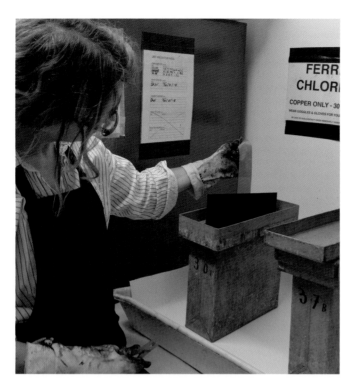

Use the handle to lower the plate into the etching tank or tray.

Wearing gloves, (plus goggles and mask if etching zinc in nitric acid), lift the lid off the tank or tray of the etching solution and put it safely to one side. Lower your etching plate in slowly. Fix the tape handle to the edge of the bath with a clothes peg to prevent it disappearing into the solution. Put on your timer for your first etch.

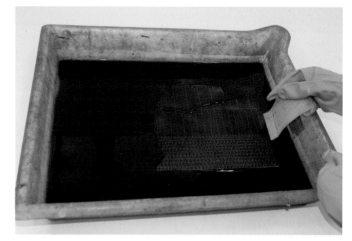

If you are etching a hard ground plate in an open tray of etching solution the plate will need lifting and rinsing at regular intervals to remove the residue created by the etching process. A plastic L-shaped handle from the corner of a cut container can help to lever it out.

A copper plate in a dip tank can be pegged in place by its tape handle. As the residue will fall away it can be left to etch for as long as you choose.

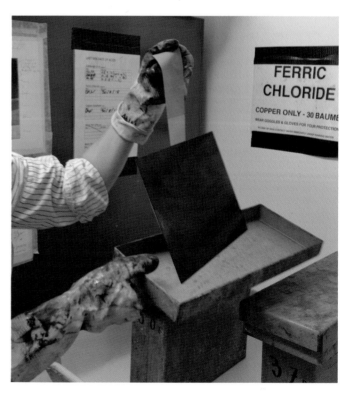

To see how your etch is progressing, lift your plate from the etching tank or tray and take it to the sink to rinse. Try to catch drips in a tray while you carry it.

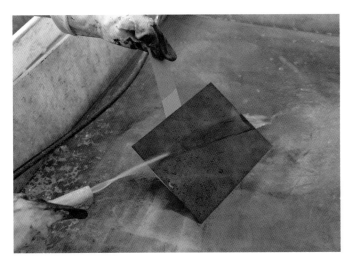

Rinse your copper plate front and back in the sink.

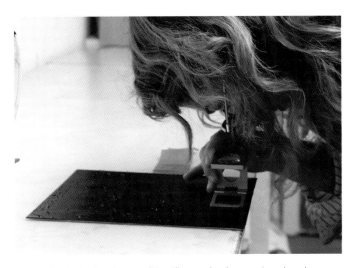

To check the hard ground is still completely covering the plate well you can look for areas of breakdown using a magnifying loupe. You can dry the plate, stop out areas or add extra drawing and return it to the etching solution.

If you are etching copper plate in ferric chloride in a flat tray you may find the biting slows down. This problem is caused by a residue that builds up in the lines as the plate etches. There are a number of possible solutions: some people invert the plate and lay it on balls of plasticine or blue tack to support the plate off the base of the tray. The residue then falls out of the etched grooves. Another solution is to rinse the plate quite frequently in a bath of dilute citric acid or acetic acid (the former is cheaper). This acid cleans the lines out so they will etch better subsequently. If salt is added to the solution the etched lines will also shine, so you can see the marks more clearly.

A ready mixed solution has been devised to solve this particular problem. Edinburgh etch is a solution of ferric chloride with citric acid, which cleans as it etches. Please be warned that etching times are shorter by about a third and for very delicate work Edinburgh etch may be too vigorous a solution.

If you are etching zinc in nitric acid or copper sulphate you will need to remove the gas bubbles you see emerging along the etched lines. If the bubbles are allowed to collect there the bite will be uneven. The traditional method for removal is to take a feather and brush it lightly across the plate at regular intervals while it is in the etching bath.

After your first timed etch, with gloves on, remove the plate from the etching solution and gently rinse it with running water.

If etching zinc in copper sulphate, rinse your plate in the rinse bath. The use of the rinse bath is important, as it is unsafe for marine life to rinse copper sulphate straight down the sink.

If etching copper plate in ferric chloride or Edinburgh etch, hold a small tray in one hand and carefully lift the plate from the bath with the other. Put the plate in the small tray to avoid drips and move straight to the dirty sink. Rinse the plate gently and thoroughly using running water. When the plate is clean of etchant, rinse the back of the plate and the tape handle too to avoid even the smallest drop leaving the acid room. Rinse the drip tray too.

Once you have finished your first bite and the plate has been rinsed and dried, you can start to develop the next layer of drawing. Remember that this method of drawing and etching means that the first lines drawn and etched will end up being the strongest. Each subsequent layer gets etched for less time and so will be lighter.

Using an etching needle, draw your next level of detail. Refer to the step-biting chart earlier in the chapter, lower your plate back into the solution and set your timer for a second etch.

Add more detailed drawing and etch. If at any time you wish to stop a line from etching, dry the plate and cover the selected area with stop-out varnish. If the hard ground appears to be breaking down anywhere, stop this area out too.

Lines can become increasingly close to each other as you continue drawing. However, to introduce cross hatching it is safest to do this with a second layer of hard ground, as the ground can break down where lines intersect.

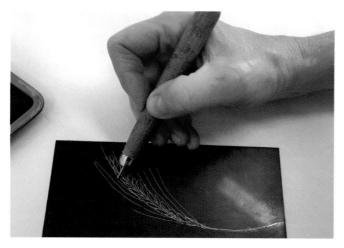

If you are using a zinc plate the preparation process is just the same as for copper up to the point of etching.

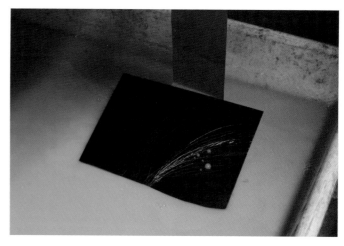

Lower the zinc plate into the copper sulphate solution and etch it for the recommended time (usually about fifteen minutes for hard ground).

Feather the plate when bubbles form. If bubbles are allowed to sit on the surface the etching can be affected.

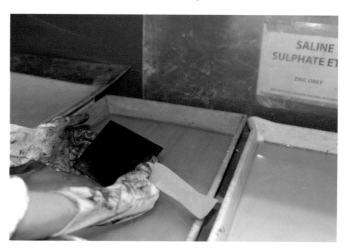

After etching your zinc plate in copper sulphate, rinse the plate in a water tray. This rinsing bath can be disposed of safely later (usually through evaporation) and avoids dilute copper sulphate entering the water system down the drain.

Open bite

As your hard ground etching progresses you may want to develop your image in a different way. As well as drawing and etching fine lines, hard ground can be used to protect the plate while wide areas are etched in a loose way giving an entirely different kind of mark. This is known as 'open bite'.

Open bite gives a wide, open mark with loose edges and an uneven surface. The ground can be removed in selected areas in a number of different ways.

For brush-like marks, it is possible to dip a brush in solvent, wipe it on a rag then draw it across the plate to remove ground. Absorb the

solvent with a piece of newsprint and check the solvent has either evaporated or been removed before putting it into the etching solution.

Wrap a rag slightly damp with solvent around your forefinger and wipe deliberately to remove ground in specific areas, being careful not to disturb the hard ground across the rest of the plate. Lavender oil, painted on to the surface and removed gently with absorbent tissue can create unique, painterly tonal marks.

Even using drawing needles and scrapers to remove larger areas of ground will create an open texture.

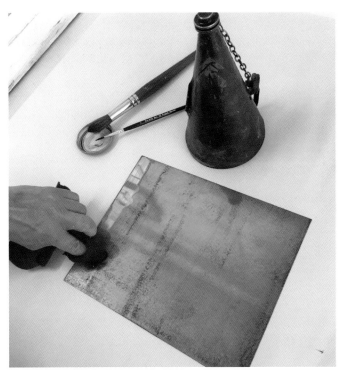

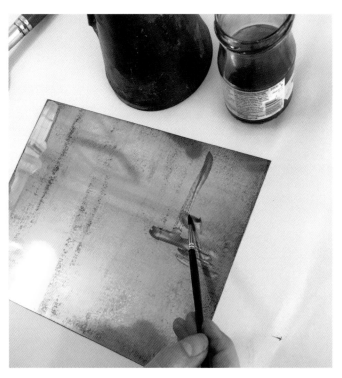

To work a hard ground plate differently you can coat it as above then remove areas to reveal bare metal ready to etch. There are various different ways you can do this. Here, a rag with a small amount of solvent is wiped across the surface.

Solvent or lavender oil can be painted onto the ground....

… and then carefully blotted and absorbed with a piece of tissue or newsprint.

Sizeable areas of the plate can be wiped in this way.

You can open bite for a long time and create an almost sculptural impression in your eventual print. This can create a good contrast to the fine line etching elsewhere in the same image.

Put the plate into the etching bath for a short time and stop out some of the open bitten area. Repeat twice or three times more until the bite is quite deep.

When you wipe the plate the ink will pile up around the edges of the bite with the effect of dark outlines around the deeper and often uneven ledges in the open areas of the plate.

The bottom of the open shapes can be worked with tools to create more marks. A drypoint needle, scraper point or roulette can scratch the bottom of the open shape in such a way that the marks pick up some colour when the plate is inked. This helps to pull the image together, incorporating the marked areas of open bite with the etched lines on the plate.

It is also perfectly viable to wipe areas of hard ground away and immediately move on to degreasing and aquatinting without pausing to etch an open bite. This can give a very bold introduction to your plate making – a strong, loose start that requires open thinking in response and a different kind of development.

Hard ground, soft ground and stop-out varnish can all be removed with either green wash, white spirit or turpentine substitute. Methylated spirit is used to remove aquatint and resin-based varnishes.

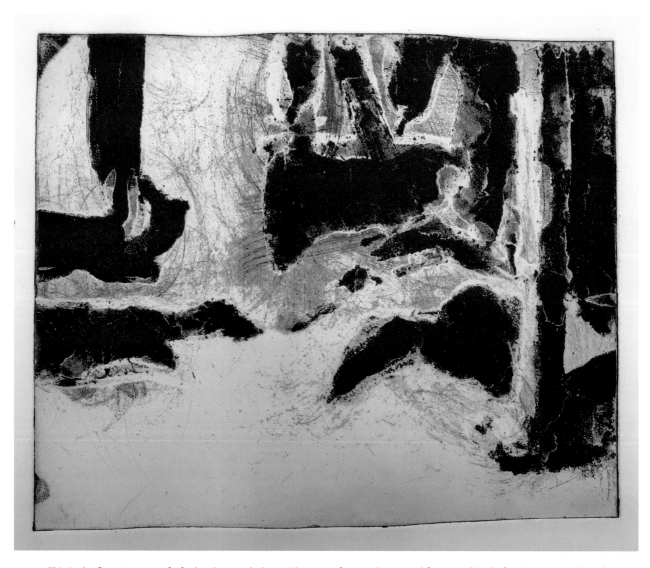

This is the first stage proof of a hard ground plate with areas of ground removed for open bite before it was aquatinted.

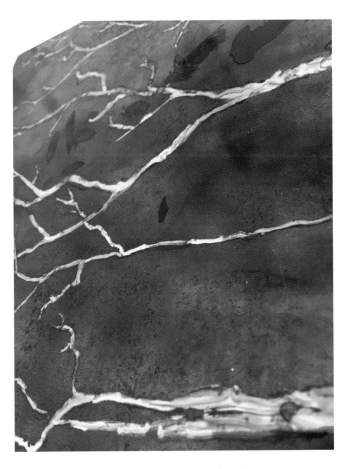

This hard ground plate was painted with solvent, which was then blotted for open bite.

After the plate was open bitten, the hard ground was left on the plate. It was aquatinted (*see* Chapter 6 for this technique) and stopped out in stages to give different tones of grey. This is the first proof print of *Warm Mist Rising*.

Reworking your hard ground plate

The image on your plate can start as one thing and become endless others. It will withstand many stages of etching and vigorous reworking. Allowing the image to emerge from the layers you etch into its surface is one of the great delights of etching.

You can print your plate to see what you have so done far, then clean, degrease and reapply another hard ground for drawing and biting many times. This reworking may involve one or several of the many other areas of intaglio printmaking, such as soft ground, aquatint, sugar lift and drypoint, as described in later chapters in this book.

Your first hard ground is not the be-all and end-all of your image making. You can move on to any other technique that suits your purpose. Over time you can build up a dense, deeply textured plate with lines etched upon tone after tone as well as earlier line drawing and texture. You can reapply hard ground at a later stage and etch

it on top of your other layers, maybe in a different way. If you want to remove or knock back etched marks there are details on how to go about this in the section in Chapter 6 on 'Developing your Plate'.

It is always worth looking at other artists' work to see how they use a particular medium and examples of hard ground etching are plentiful. There are fantastic examples of its use over the past five hundred years in museums and art collections around the world. The list of artists to look for is long and growing, including Dürer, Rembrandt and Callot, Piranesi, Whistler and Picasso as well as Freud, Dine and Hockney.

After etching with hard ground you can print your plate to see how it is progressing. Details on how to print can be found in Chapter 4. Interim test prints are known as stage proofs. They can be a valuable personal resource, helping to show what is working well and which areas need further development.

These stage proofs show how *Horseflies and Hayfever* developed through the etching process. Hard ground played a crucial role throughout the making of the plate.

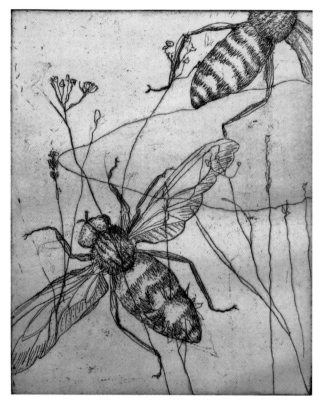

This early first proof shows the simple bare bones of the initial drawing in hard ground.

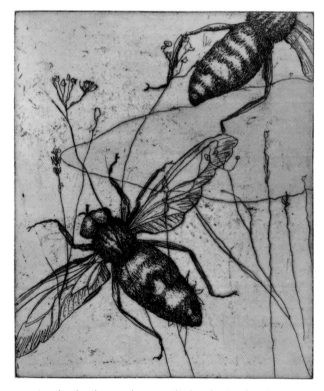

Another hard ground was applied and extra drawing was etched in stages, with the plate returning to the etching solution several times. The darkest lines etched the longest.

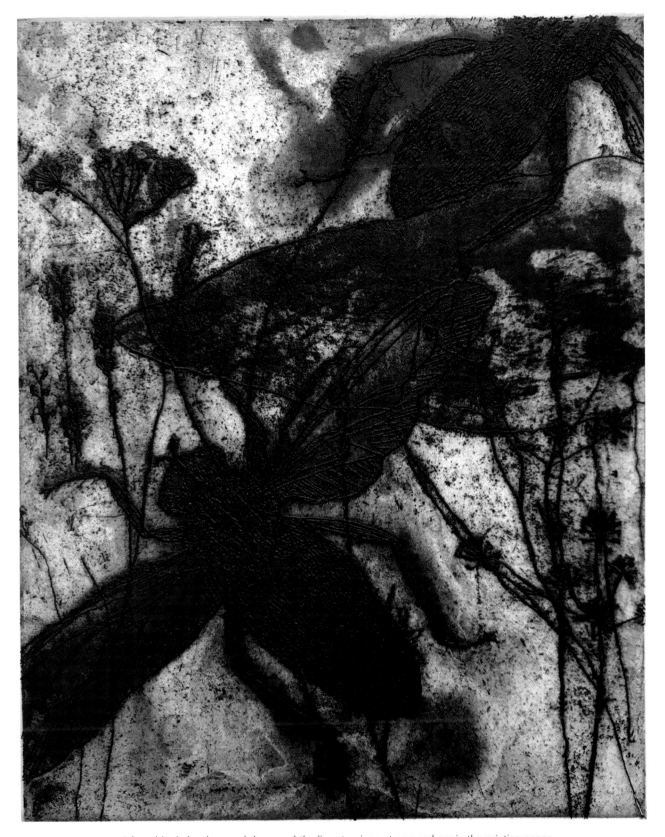

A long bite in hard ground deepened the lines to give a strong emboss in the printing paper. Once these were firmly established, spit bite (in the aquatint chapter) was applied vigorously to give the image its sense of an overheating environment.

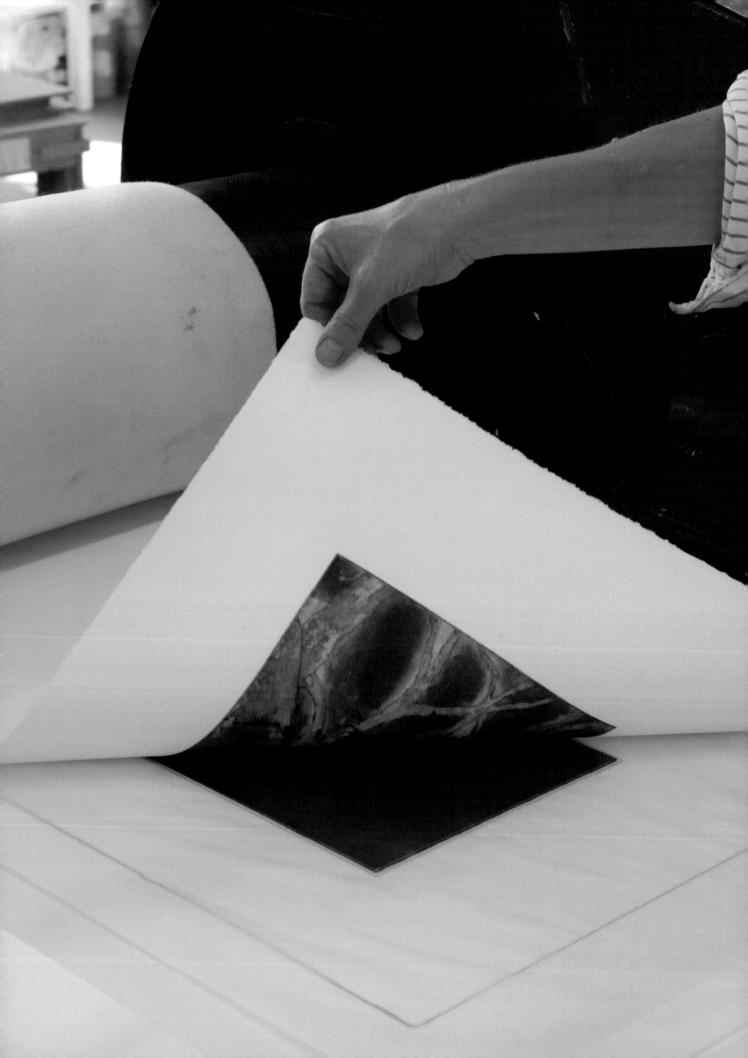

PRINTING

It is always exciting to see how your etched plate is progressing. Most printmakers take proof prints at different developmental stages of their evolving plate. The principle of printing an etching is that all the marks that have been etched, gouged or scored are filled with ink, the plate surface is wiped to remove surplus ink and damp paper is laid on top while it is rolled through a printing press. As the paper is damp it picks up all the ink held in the grooves you have etched on the plate. Soft blankets laid over the paper help this process of damp paper moulding to the plate and its ink-held grooves.

To get the most out of your image at any stage of development it is best to print your plate as best as you can and as cleanly as possible. You can start to explore the creative possibilities of the printing process itself once you have the image more firmly decided upon and etched on the plate.

The approach to printing a proof is essentially the same as when you are later printing finished edition prints. Whereas proofing is about development and experimentation, editioning is the reproducing of a resolved image. As a result, when editioning you may take more care to keep everything clean and use better paper. You may also decide, having experimented while proofing, to use a range of image specific techniques for moving and removing the ink around the plate to get the ideal print, such as different ways of wiping, consistencies of ink, colours, etc. There is more on the specifics of editioning in Chapter 10. Nevertheless, the method for printing a plate is much the same for proofing and editioning.

The more accurately the print reflects what is on the plate, the better able you are to make informed decisions about how to proceed with your image. There are several variables to consider and stages of process to refine but when you have practised printing a few times it will make sense and become easier. Expect wiping a plate to be slow at first. Patient, gradual wiping will be more likely to give you a print you are pleased with than any attempt at short cuts.

In a nutshell

1. Prepare the etching press and paper.
2. Ink and wipe the plate.
3. Use the etching press to print on damp paper.

Materials and equipment

Etching press

Set of etching blankets (two 1/16-inch wool felt blankets (frontings) and one 1/8-inch pusher blanket (swanskin)

Plate with bevelled edges

Printing/proofing paper

Bath or bucket of clean water for soaking paper

Sponge

Tissue paper

Preparing the press and paper

Begin by checking the press is ready, with blankets under the roller and the right pressure setting for your plate. There are details on how to do this in Chapter 1.

Prepare your paper. For proofing – test-printing – the paper does not have to be the most expensive. There is a section in Chapter 1 with more information on what papers are available.

Traditionally, paper is torn to emulate the deckle edges of handmade paper. In terms of scale, you will need to ensure your printing paper is bigger than your plate to prevent ink from marking the blankets. Although proofing paper does not have to be as large as for a final print it can be useful to have space around the image for handling.

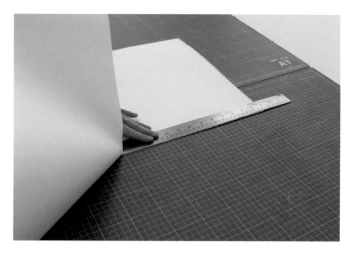

Tear your paper against a steel-edged ruler. This works best if you push down hard on the ruler with one hand and tear with the other a little at a time.

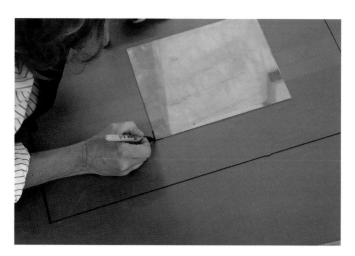

To make a simple template, draw round your sheet of paper on a sheet of acetate then decide where you want your plate to print and draw round that too.

When your paper is torn to size you can make a registration sheet. On a sheet of acetate large enough to accommodate the full paper printing dimensions, simply use a permanent marker to draw around a sheet of paper the same size as you are going to use, or measure out the dimensions, adding no more than 5mm on each side. When you then place the dampened paper into the template, the marking will accommodate any increase in size due to the dampening.

Decide where the plate should sit on the paper. Use a ruler to check spacing. Draw round the plate with the permanent marker. Mark the top if there is a difference in size between the top and bottom borders. Turn over the template to avoid accidental off-setting from the marker onto your damp print.

There are two basic methods for soaking paper depending on the facilities and space you have available, especially within a communal studio. Firstly there is the bath method: fill an etching bath or large tray with clean water, slide a couple of sheets of paper in one at a time, and make sure each is completely covered with water. Leave for a short while, remove and dry with blotters or towels.

There is often a misunderstanding that the soaking is to remove the glue size to soften the paper for printing. However, it is the glue size that binds the paper's fibres together. All we want the water to do is to soften the fibres, not to lose too much size, as it is this that gives the paper strength. When paper is soaked for too long, the paper can become weak and difficult to handle. If there is space available, the sponging and wrapping method shown below is the most controllable. If you are using the bath method, it is best not to soak for too long, as the paper will become sodden and weak.

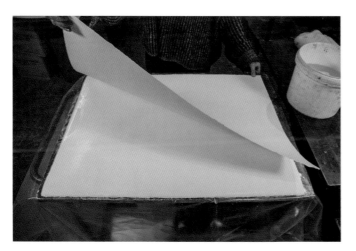

If you are damping your paper in a paper bath make sure it is completely under water for 20–30 minutes before it is needed.

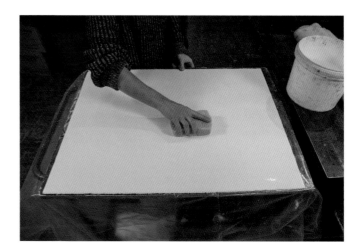

If there is no paper bath or you are preparing lots of sheets for a day's printing you can place a sheet on a clean plastic sheet and sponge clean water from a bucket over each sheet.

Stack and sponge each sheet at a time. You only need to get water evenly onto the paper; there is no need to scrub the surface.

When you have enough wet sheets, wrap the paper stack well with the plastic sheet and place a board on top to weight the pile.

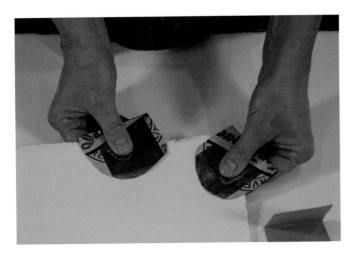

Paper grips made from a clean tin or card enable you to handle paper, blotters and blankets without getting ink on them.

Before your hands get covered in ink, make yourself some paper grips. These are for handling paper and blankets when you have ink on your hands. Two cut and folded sections of a drink can are practical, as they will be thin enough to slide under a piece of paper and are malleable enough to fold and grip paper well. Cut them with a curved edge to minimize the risk of hurting yourself on the edges. If a clean drink can is unavailable, then folded offcuts of thin card or thick paper will work well as grips for a short time. Keeping them in a clean area near the paper blotters will help avoid contaminating them with ink.

Inking and wiping the plate

Deciding whether to print with or without using a hotplate can exercise many a printmaker's thoughts. Both have their place and uses. However, in the majority of cases printing without resorting to the use of the hotplate will give better and more consistent results, create fewer problems and make for a more pleasant working atmosphere. The heat is used to soften the ink and make it easier to wipe. However, in practice it can be difficult to regulate the heat, printmakers often having to move between the hotplate and a cold surface. It is much easier to over-wipe a heated plate, more difficult to remove plate tone and over a whole day the heat can dry ink in the lines, so producing weaker images towards the end of the session.

Printing cold does quite often entail the use of ink modifiers, such as copper plate oils, tack reducers or 'easy wipe'. The downside of printing cold, especially black inks and some colours, is that they are initially harder to wipe, but after that first 'mopping up' wiping is finished, the ink is easier to clean down to clean plate tone, gives a richer print and the studio is less like a sweat shop to work in. Working over a hot plate all day is akin to an all-day cooking session over a hot stove! When printing in colour, heat is very rarely used, as coloured inks are generally softer and therefore easier to wipe.

There are times when the use of a hotplate does have its advantages, and so the practice should not be dismissed, but it is one that need not be the starting point of a day's printing.

Prepare your inking area with used and clean scrim pads, a rubber squeegee or piece of card for inking up and scrape your push knife around the top surface of the ink to give yourself a small 'reservoir' to pick up from.

Pick up ink from your reservoir and apply it to the plate using a small rubber squeegee or piece of card.

Materials and equipment

Paper grips for paper and blanket handling

Newspaper to ink up on

Latex gloves for inking (optional)

Etched plate, clean of all grounds, varnishes etc.

Black etching ink (see Chapter 1)

Push knife or spatula

Rubber, soft roller or piece of card to apply ink

Wiping scrim (sometimes called tarlatan or mull)

Method

Having dampened your paper, collect together the other materials listed above.

If taking ink from a tin, remove the lid and any protective layers inside the tin. Using a push knife or spatula, skim the top layer from around the entire surface of ink and put the fresh ink on the worktop as a reservoir to return to each time you need it.

To keep your workspace a bit cleaner than otherwise, especially while learning, it can be helpful to find a newspaper and place your plate on it for inking and wiping.

Dip your squeegee into your ink reservoir and apply ink to the surface of your etched plate. I use a softish rubber squeegee for ink application but others prefer to roll the ink across the surface with

a soft roller. If stuck for an applicator, try a small piece of mount board or other soft card but make sure you don't accidentally mark the etching plate with it. When you have covered the plate with ink, change the newspaper for a clean page to avoid picking up unnecessary extra ink while wiping.

Scrim wiping the plate

This can be an art form in itself, one that becomes a unique and personal engagement with the process. For many professional print editioners, there is an almost ritualistic preparation before and during the wiping of a plate, and variations in the process which can appear slight but are in fact useful tools to employ.

The basic idea is to remove all of the excess ink through the wiping with balls of scrim, leaving ink only in the etched or drawn areas. Once you have removed the unwanted ink, the plate can be further wiped with tissue, newsprint or with whiting powder to bring up the whites in the un-etched areas of the plate, which is then ready to have its edges cleaned with a rag or scrim before printing.

When wiping the plate with scrim, it is best to use a circular motion as you wipe. If you drag the ink in only one direction you end up with an under-inked and thin-looking print, as you are likely to have dragged too much ink along and then out of the lines.

Wipe evenly across and around the plate at the beginning. You can concentrate on specific areas that need more or less ink once the bulk of the excess has been removed.

It is best to have the scrim in a tight ball that sits firmly in the cup of your hand. Too big a ball of scrim is difficult to handle; too small makes your wiping movements tight and fiddly. You want the side of the scrim that comes into contact with the plate to be smooth, with no wrinkles, as these can dig into the etched lines and remove ink, so resulting in a weaker print. At the beginning of wiping the plate you are aiming for grand gestures, wiping the plate generally all over.

Stiff scrim may need a little rubbing to remove the scratchiness.

Using a dirty scrim, twist ink into every grooved mark from every angle.

Hold the scrim pad cupped in your hand and continue to wipe with circular motions across the entire plate as evenly as possible. The etched image will very gradually start to emerge.

When the plate is mainly wiped, make a new pad from a cleaner scrim and wipe the plate again. You may then want to also tissue wipe and/or hand wipe to clean away more plate tone.

To clean the edges of your plate before printing, wrap rag or scrim tightly around your forefinger and wipe each edge in turn.

Hand wiping the plate

Although the bulk of your image will be drawn and etched in the plate itself, there are many possible variations in the way a plate can be wiped that control the tonal range and marks made within and on top of the plate. These can be a big part of the final appearance of the finished print. Through the proofing you can experiment to see what suits your work best.

With scrim-wiping most of the ink is wiped away but there will still be a little plate tone remaining across the surface, looking like a very slight haze of ink. Plate tone can be removed all over the plate or left in certain areas to give a thin grey tone that sits behind the darker drawn and etched lines.

Tissue wiping is usually the starting point for hand wiping. Use the sheet tissue paper that is normally found in a print studio, or newsprint, or even an old 'Yellow Pages'. This is wiped gently with the flat of the hand over the plate to remove or reduce the plate tone. Do not dig into the etched lines, as this will lighten the image.

Chalk can also be used for wiping. If you use the heel of your bare hand to wipe your plate your skin will pick up surface ink and remove plate tone. Use whiting chalk on the hand, with the excess brushed away, and you will pick up even more plate tone than with skin alone. The function of the whiting is to dry out your hand so the ink sticks to it as it passes over the plate. This is possible even if you ink a plate wearing disposable gloves. You are not aiming to put whiting chalk either onto the plate or into the ink.

Having spent some time wiping and removing excess ink from the plate, a technique is often employed which may appear counter-intuitive at this point. '*Retoussage*' is a means of enlivening either the whole plate or just specific areas. After scrim- and hand-wiping the plate, take a clean and soft piece of scrim, again wrapped into the ball of the hand, and gently stroke the area you want to enhance just before printing. It almost appears as if you are tickling the plate. This will bring the ink to the surface a little more, giving a beautiful intensity to that area of the plate.

If you want to wipe away more plate tone, place your hand flat on a sheet of tissue paper and gently wipe the plate surface.

Hand wiping gives an extra lift to the white tones in your image. Dip the heel of your hand in French chalk.

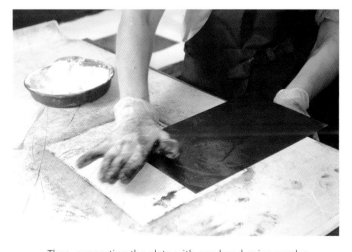

Then, supporting the plate with one hand, wipe surplus chalk off against your apron and skim the heel of your hand across the plate.

Printing your plate

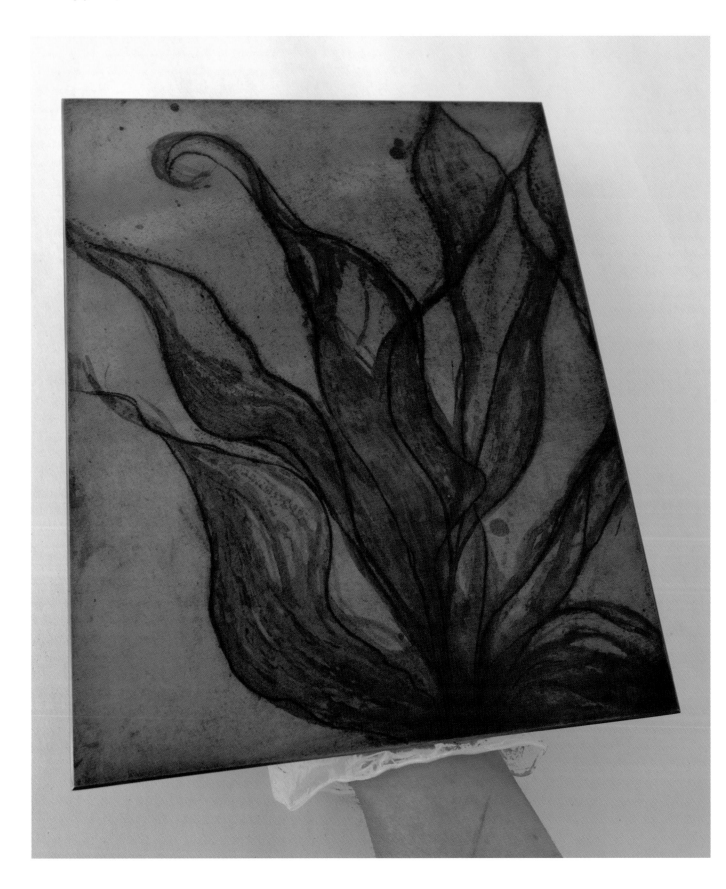

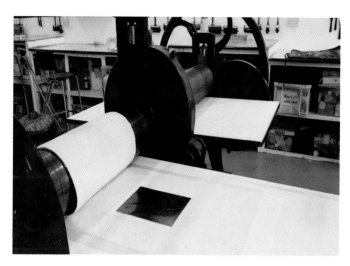

Place your registration template on the bed of the press, close to the roller. Place a sheet of tissue on top and drop your inked plate on the tissue. Now you can slide the tissue until the plate is in position on the template.

Remove your wet paper from the bath or polythene wrapping. Hold it at diagonally opposite corners to control it more easily. Paper grips will help keep the paper clean if your hands are inky.

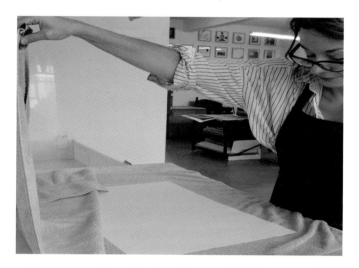

To remove surplus water, place the paper in blotters or towels.

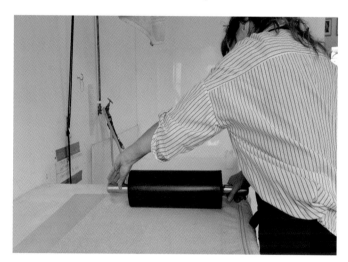

A heavy roller helps to blot the paper evenly.

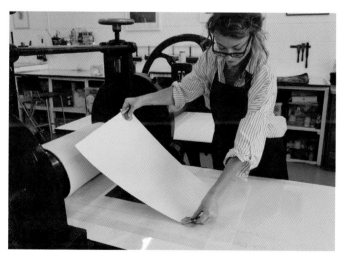

Use your paper grips to lay the blotted paper over your plate. The template will help you to position it.

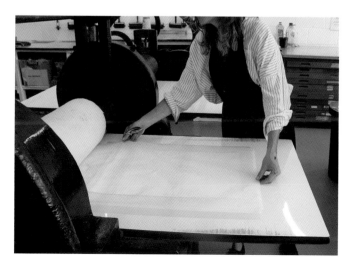

Place tissue over the damp paper…

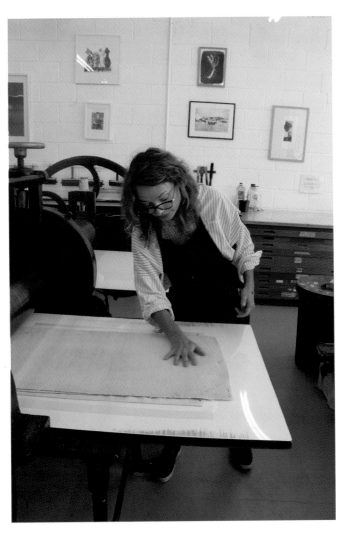

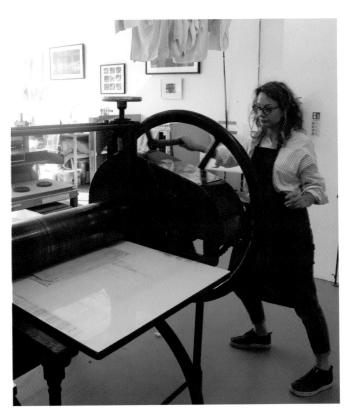

Turn the handle slowly and steadily to wind the bed through the press.

… and lower each blanket in turn over the paper and plate, smoothing them flat.

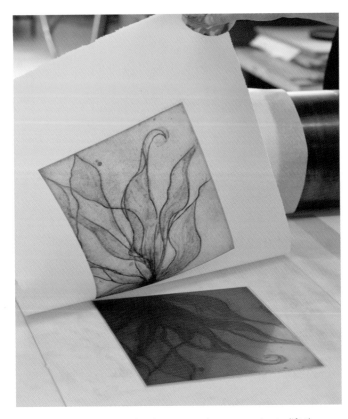

When your plate and paper have completely passed through, lift the blankets and fold them back over the top roller.

Carefully peel away the tissue. Use the paper grips to lift the print clean away from the plate.

Drying prints

Prints are made using dampened paper. If left damp for too long, even for as little as a couple of days, mould can start to grow almost imperceptibly, only appearing some time later. If the damp prints are left to dry naturally in the open they will wrinkle and no longer lie flat. In order to avoid these problems the aim is to dry prints in such a way that the emboss of the plate is retained, the paper is otherwise flat and there is no possibility of mould growth. These are the main drying options:

Lay your print on a drying board and cover it with tissue.

Place another drying board on top of the print and weight it to press the paper flat as it dries.

Millboards are dense but light fibre boards that are permeable enough to allow for drying even when stacked. To use them, lay your fresh print between sheets of tissue paper on the top board. Lay another millboard on top and weight it. Over the course of a day a whole stack of millboards may grow. In a shared studio it is advisable to name and date your boards with a protruding card label so that your prints can be readily identified. It also helps colleagues to know when you laid the prints down so they can be left until completely dry (usually about four days).

It is also possible to interleave the millboard with flat sheets of corrugated board, i.e. a sandwich of corrugated board, mill board, print with tissue on top of image, millboard, corrugated board etc. Then set a fan to blow air along the corrugations. To make this fan-drying technique as efficient as possible, you can enclose the stack of boards in a strong polythene sheet and funnel the air by fixing the polythene tightly to the fan at one end. This drying technique takes some organising but it is worth knowing about in case you find yourself in need of it at some point in the future. With this it is possible to dry a full set of prints completely and quickly.

Interleaving prints and tissue between sheets of blotting paper and pressing them between flat boards will dry the work in about four days. The moisture in the print is absorbed into the blotting paper so it does not matter that the boards are non-permeable. If you are drying prints at home between blotters you could use something as simple as a pile of books to weight them. You have to be careful to change the blotters several times because, as they become sodden with the water from the print, the blotters can wrinkle and transfer this to the print. You then need to have a small stock of blotters, as one set are damp with the prints, another is drying and ready to swap over the next day. Usually 3-4 changes is enough to fully dry the prints.

If you want to dry a few prints quickly you can stretch them on stiff drawing boards and leave them to air dry. This can be useful if you have a tight deadline. Take your fresh print and attach it to a board with gummed brown paper tape all the way round. The print should be dry by the next day when you can cut it out with a scalpel.

To dry prints quickly you can stretch them on a strong board. Place the print on the board. Tear a length of paper tape to the correct length for holding the print in place.

Stick each edge with tape, making sure the print is taut.

Wet the paper tape with a dampened sponge.

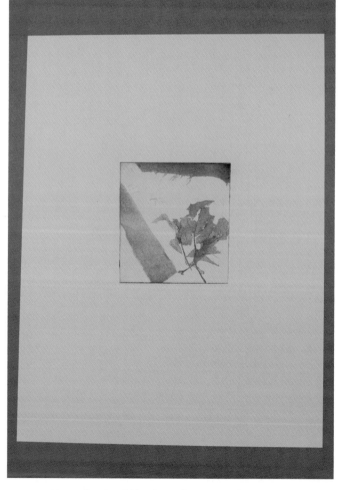

Your print should be dry within twenty-four hours. A fan heater will help. You can cut out the dried print with a scalpel run around the edge.

First proof of *Trash*. Sticking your proof up on a wall gives you the chance to see your print more objectively and start to decide how you would like to progress the plate.

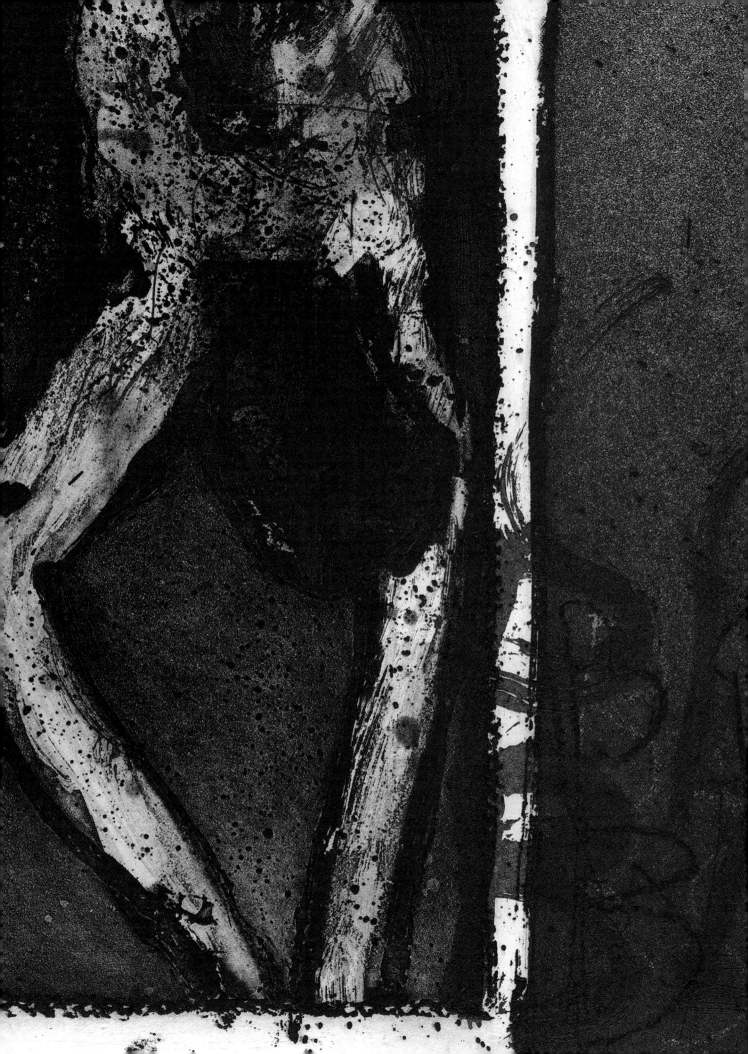

Echo Song II

This print has Marcus's characteristic double imagery, as if opening a book and seeing two images on opposite pages. His subtle, almost monochrome use of colour can be seen in much of his work.

MRR: The series is called *Echo Song*; the inspiration for it was a Hungarian poet called Miklós Radnóti, who died in the Second World War. He was a prisoner in a labour camp in Serbia. Towards the end of the war the prisoners were moved out of the camp and they made a long forced march back to Hungary. On the march, Radnóti was writing poetry. He was bullied by the guards for what they called his 'scribbling'. As prisoners collapsed from exhaustion, they were either left to die or they were shot. Radnóti was shot. After the war his body was found and identified because his notebook of poems was found in his greatcoat pocket. I imagined a notebook damp from rain and months underground. The staining and the words on the prints are suggestions of those wet notebooks.

In this etching, the portrait is vaguely Radnóti. The image on the left is a reference to Goya's *Disasters of War*. I didn't want these etchings to be an illustration of Radnóti's last days, but more an evocation of the suffering war brings, with only a tangential reference to Radnóti himself.

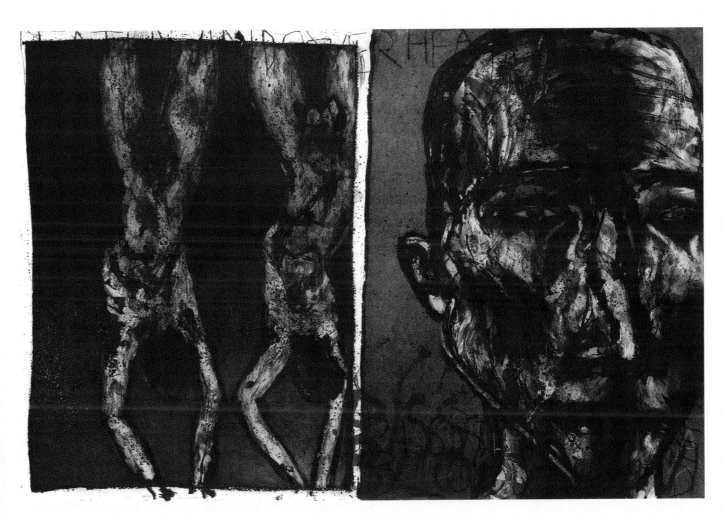

Echo Song II, 2012. Etching and aquatint. Printed on Somerset Satin white 300gsm.
Edition of fifteen. Plate: 40 × 60.5cm. Published: Pratt Contemporary.

SOFT GROUND

Soft ground, as its name suggests, offers a less resilient resist to the bite of an etching solution. Even when a coated plate has been removed from the hot plate and cooled, its texture remains soft so must be handled with care at all times. It is made from the same mixture as hard ground but with the addition of tallow fat, which keeps it permanently soft.

If you think of a hard ground line being an equivalent of a pen and ink drawing with its sharp, clearly defined edge, the a soft ground drawn line is closer to that of a soft graphite pencil line. It allows for a gentler and more subtle drawing. Simply by placing a sheet of thin paper, newsprint or Japanese tissue over a plate that has been coated in soft ground, the pressure of the pencil on the surface as you draw removes the ground, revealing the metal plate to the action of the acid, thereby recreating the mark drawn on the paper in the resulting print.

In addition, soft ground can be used to apply texture to the plate. Thin, flat shapes such as that of a leaf or a feather, fabric or textured paper, can be pressed into the surface of soft ground. When the texture is peeled away it takes some soft ground with it, and the exposed metal can be gently etched.

In a nutshell

1. Prepare registration for drawing.
2. Coat plate in soft ground.
3. Draw image through absorbent paper or impress with textures.
4. Protect plate and etch.

Preparing registration for drawing

Materials and equipment

Drawing board

2 sheets of newsprint cut to the same size, larger than your etching plate (some etchers use Japanese tissue for the second sheet but here newsprint is used in the explanation and photographs)

Carbon paper larger than your plate

Masking tape

Drawing pencil of whichever softness you prefer

Arm-resting 'bridge'

Method

Please note that it is much easier to prepare a registration template for drawing *before* you coat with soft ground!

To register a coated soft ground plate for drawing, stick newsprint to a board and hinge a second sheet on top. Place carbon paper face down between the two sheets.

Place your soft ground plate on the top sheet of newsprint and draw around the plate.

Take a drawing board and tape down a sheet of newsprint on all four edges. Take a second sheet the same size and tape it along the top edge to form a hinge.

Put a sheet of carbon paper face down between the two sheets of newsprint. Bring the top sheet down and place your plate in the centre of the top sheet of newsprint and draw around it. Remove the plate and the carbon paper and you will have the outline of the plate on both the top and bottom sheets.

The benefit of preparing this double template is that you will be able to draw, etch and proof the plate and then put a second soft ground onto the plate and return to add drawing to the plate a second or third time, knowing that as long as you place the plate in exactly the same place any subsequent drawing will be in register.

When you are ready to draw on your soft ground, you can fold back the top sheet of paper and place the plate in the template marked by carbon paper.

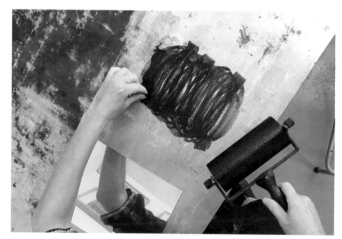

Lower the top sheet over the plate gently.

Coating the plate with soft ground

Materials and equipment

Metal file

Brasso polish

Very soft rag

Degreasing equipment

Hot plate

Soft ground

Soft ground roller

Soft ground melts at a lower temperature than that used to melt hard ground. If your hot plate has a thermostat, warm it up to 50–60 degrees and melt the soft ground.

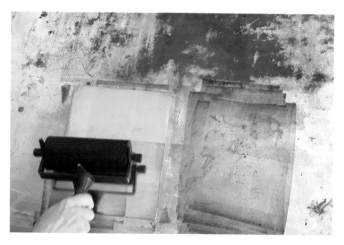

Roll the soft ground evenly onto the degreased plate. When cooled the ground is ready for drawing.

You may already have a drawing you want to refer to for your soft ground plate. Remember this will be reversed in the eventual print. If you want to avoid this you can print out a version reversed in Photoshop or simply trace the bare bones of the drawing on acetate and flip it over to refer to as you draw to get you started.

Prepare a bridge, which will sit very slightly above the soft ground plate and act as a hand support. In this way you will avoid touching and lifting the surface of the soft ground while drawing.

Method

Prepare your plate. File the edges, polish the surface and degrease thoroughly, as described in Chapter 2. Some etchers prefer to use a cream cleanser as a degreaser before applying soft ground instead of the traditional whiting and ammonia as it abrades the plate slightly and helps the soft ground to adhere. This can be helpful in terms of practicality. However, it is important to be aware that the abrasion will remove the shine on the polished surface and the background in the eventual print will be grey rather than white.

Put the hot plate on to warm up to a cooler temperature than for hard ground (50–60 degrees). Melt the soft ground on the hot plate and roll out an even square with the roller clearly marked 'for soft ground only', or one thoroughly cleaned of any other ground or ink.

Place the plate on the hot plate and allow it to completely warm up. Roll the soft ground across its surface. This may require you to roll several times across the surface, picking up new soft ground from your starter square if needed and rolling it across what is already there. The colour of the ground on the plate is a mid-brown, quite like a pine wood colour (in contrast with the old oak aimed for when rolling hard ground).

Carefully slide the plate from the hot plate and onto a cold surface to cool. Avoid touching the surface, as fingers will lift the soft ground and expose part of the plate.

To check if the ground is ready to use, look to see if the surface has turned from glossy to matt; you can also touch the underside of the plate to see if it is cool.

Drawing on soft ground

Place your coated plate on the bottom newsprint template and lower the top sheet ready for drawing. Place the 'bridge' above the plate, and rest your hand on it. Start to draw on the top sheet, bearing in mind that your print will be reversed.

As you draw, the absorbent top sheet of paper will pick up the soft ground, exposing the metal, ready to etch. There is no need to press too hard: in fact this can work against you as you can remove too much ground. What you want is for the ground to be partially lifted from the plate, allowing the acid to bite through. To create the characteristic tonal quality of soft ground you can add to your drawing in stages. If you place your plate in the registration template each time you want to draw, the top sheet will show you where you have drawn before, thereby allowing you to develop the drawing further. Remember to rest your arm on the bridge while you draw to avoid marking the soft ground accidentally.

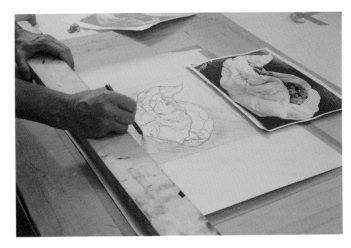

If you use a bridge to support your hand while you draw on the paper you can work over the plate without coming into contact with its delicate coating, other than through the pencil.

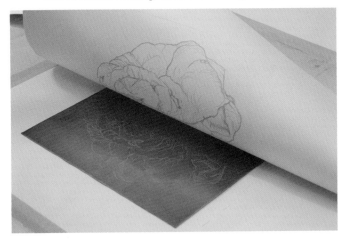

Roll back the top sheet to reveal the soft ground drawing ready to etch.

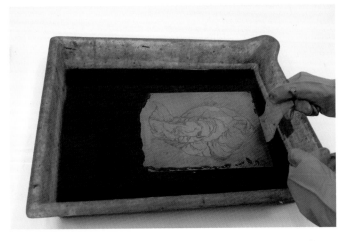

Etch the plate in weak etching solution, keeping an eye out for areas where the soft ground may be breaking down. This plate was etched for 10 minutes in ferric chloride.

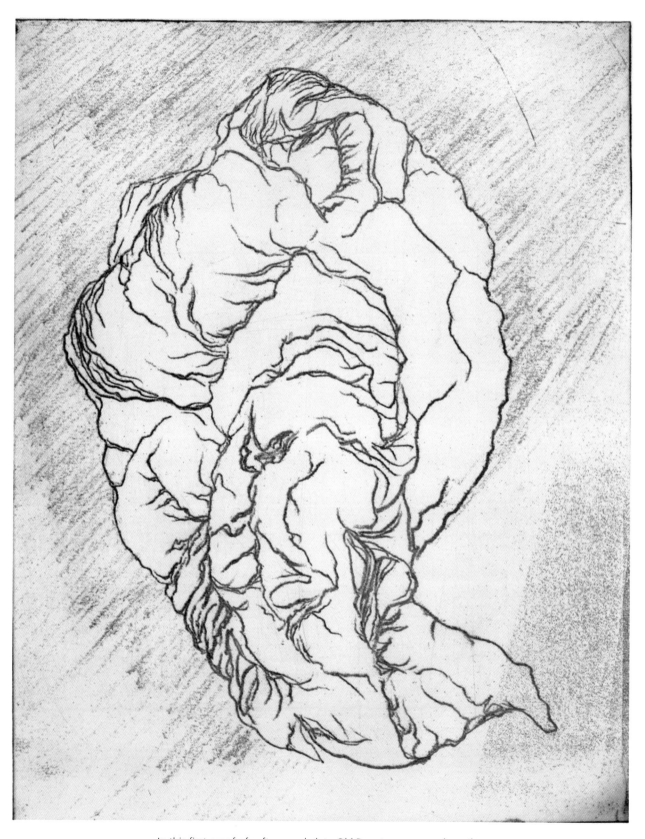

In this first proof of soft ground plate *Old Duvet* you can see how the
etched marks have retained the qualities of pencil drawing.

Place your soft ground plate on the bed of the press and lay your textured materials on top. Cover the whole plate with a sheet of newsprint and blankets and run it through the press.

Gently peel away the newsprint and lift away the textured materials. A scalpel will help to pick off pieces that stick to the plate.

Here you can see the textures in the soft ground. The newsprint can lift soft ground off the plate so stop out any areas you do not want to etch. When the plate is protected it can be etched in the gentler etching solution.

This plate was etched for 15 minutes in the first instance, then stopped out before etching the top section for a further 15 minutes.

Impressing textures into soft ground

Textured materials can be applied to soft ground allowing a very different kind of etched area to emerge on your plate. It is best if the texture in question is flat and thin enough to be run through an etching press on a gentle pressure. Scrim, lace, knitting or woven fabric can all be cut to shape and placed on the plate. You could try out flat leaves, wrinkled tissue paper or ribbon in the same way. It helps if the material is slightly absorbent, as this will help it to hold its place on the plate. A plastic net, for example, might skid as it is rolled or pushed into place.

Adding texture to a plate already etched with drawing in hard ground will add a whole new quality to the image. Alternatively, beginning with etching texture in soft ground on a plate, followed by the application of hard ground for vigorous drawing and etching can give a print a mysterious background, which enhances the atmosphere of the overall image.

If you prefer, you can emboss a texture over the whole plate and stop out areas in which you do not want the texture to appear before you etch. This can give you greater control over where the texture appears.

Materials and equipment

Plate coated with soft ground

Flat texture/s, cut to shape if required

Scalpel

Newsprint

Press set to light pressure

Set the etching press to light pressure. If it is hard to change the setting, remove one of the blankets instead.

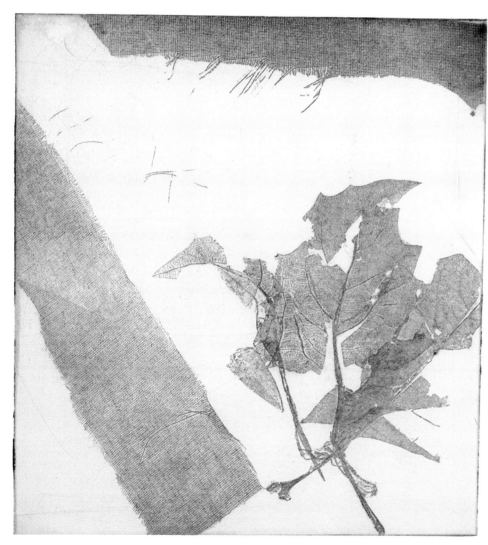

The resulting proof print shows how soft ground can capture remarkable detail from these impressed textures.

Etching soft ground

Soft ground requires a gentler etching solution than hard ground. Most etching studios have one strong bath for lines in hard ground and a weaker solution for more fragile etching techniques, including soft ground and aquatint. It is advisable to etch a soft ground test plate to find how long you can etch to get the required quality of texture or pencil drawing. Very roughly speaking I find that if a strongly etched line with a hard ground needs 60 minutes, etching a soft ground drawing, to give a broad tonal range, could take as little as 6 to 10 minutes overall. After this the soft ground can break down, the drawing loses its tonal range and appears as either an over-exposed black or a bitten-away, open-bite grey.

Although the qualities of a soft ground print tend to be gentler and less stark than those of a hard ground etching it is still advisable to etch the soft ground plate for as long as possible to achieve an interesting result.

Materials and equipment

Plate coated with soft ground

Waterproof backing tape

Stop-out varnish

Brush for varnish

Clothes pegs if using a vertical dip tank for etching, or plastic strips if etching in a flat tray

Jam jar lid or similar as small container for varnish

Weak etching solution

Sheet of newspaper to work on

Method

Soft ground can be quite a porous form of acid resist. If the entire undrawn soft-ground plate were immersed in an etching solution, it would eventually foul bite across the entire surface, printing as a kind of grey noise.

Firstly, any accidental marks you want to avoid etching need to be stopped out with varnish applied with a brush. Secondly, if you want any area to print bright white in the final image it is important to stop this out with varnish beforehand. Stopped-out areas will be noticeably whiter than the rest of the image so it is worth thinking through clearly exactly where you want to apply stop-out varnish.

Whether or not to stop out a soft ground plate is always a difficult choice. By the very nature of the ground being so soft, it takes a lot of care and control not to get a thin tonal foul bite over the plate. Any slight pressure on the drawing on top of the ground can remove enough for the acid to get through. You can protect the non-drawn areas with stop-out varnish, but in detailed drawing areas this can obviously be difficult and you can be left with an odd array of marks over the plate around the edges of the stopping out area. More often the plates are left without stopping out and any foul bite is looked on as part of the texture of the drawing. You can experiment with a slightly heavier ground to help protect the plate, but this may entail a heavier, unnatural pressure on the drawing pencil to get through the ground. It is usually a decision around the nature of the drawing itself: how clean and pure the marks actually need to be and how much any potential background tone would either enhance or interfere with the drawing.

Protect the back of your plate before etching. This is obviously difficult, as the surface of the soft ground is so delicate. There are two possible methods for coating the back of the plate. You can lay waterproof tape sticky-side up on a cutting mat, place your plate on top of the tape and use a scalpel to trim the surplus tape at the plate edge, repeating until the back of the plate is covered in strips (this method is described in more detail in Chapter 3); alternatively, you can prop the plate up against a wall or board so that you can carefully paint out the back of the plate with stop-out varnish. Whichever method you select, it is important to be mindful of the delicate soft ground.

Create a handle for your plate with folded waterproof tape so you can easily remove it from the etching solution without touching the surface. A wider plate may need two of these handles.

Set a timer and lower the plate into the chosen etching solution, generally weaker than that used for hard ground. Again, because the soft ground coating is so delicate, removing the plate from the acid can be more difficult than for a hard ground plate. If you are using a dip tank for the acid, then the handles of folded waterproof tape can be attached to the back of the plate to help lift it from the acid. Hold the handle(s) in place on the rim of the tank with a clothes peg or bulldog clip. If you are using a flat, open bath for the etching solution, thin strips of L-shaped plastic, cut from the edges of plastic containers or bottles, can be placed under the plate as it is put into the tray, so that the 'handle' part of the plastic is above the acid. This can then be used to help lift the plate out without touching the front surface.

With a hard ground it is usual to remove the plate at intervals during the biting and to rinse it with water. This removes any residue or bubbles and allows you to see what is going right – and wrong – so you can act accordingly. With a soft ground drawing this is much trickier, as the rinsing process can damage the ground. This means

Soft ground was the first stage in making *Overgrowth 2*.

To develop the image the plate was etched with spit bite. The qualities of the two techniques complement each other well when combined. Ann Norfield, *Overgrowth 2*, 2018, 20 × 25cm.

that when the plate is returned to the etching solution it bites more openly and loses its textural integrity. I find that, since the biting time in the acid is relatively short, it is usually best to leave well alone and allow it to bite to its full term undisturbed.

It is more possible to step bite if you are etching a soft ground texture, where the interest is more in the effect of the bite rather than replicating the mark of a drawn line. If you would like to bite the image in stages you can rinse the plate gently (both sides) and air dry it. It is fine to speed up the drying process with blown cold air (e.g. from a fan or the cold setting on a hair dryer) but heat will melt the ground.

When the plate is dry, place it on a sheet of newspaper to protect the work surface. Pour a little stop-out varnish into a spare lid and carefully brush it onto areas where you want to stop the plate from etching further.

When the soft ground starts to break down you will need to rinse both sides of the plate and take it out to dry. Repeat until you have

etched for as long as possible. If etched a little too long the lines will start to open bite and print grey instead of black, but this may add something different rather than simply be a problem or a mistake.

Examples of soft ground use can be seen in the etchings of Gainsborough, Käthe Kollwitz, Louise Bourgeois, Hockney (in his *Blue Guitar* series) and Celia Paul.

Most printmakers find soft ground a more difficult process to master than hard ground. Its technical parameters are tighter: the temperature of the hot plate for applying the ground, the thickness of the ground applied to the plate, the pressure of the pencil on the paper or on the press when using textured material, and of course the time and concentration of the acid used are all more critical considerations. But it is a beautiful mark that is produced and well worth the extra experimentation that can be required. I find it is best to approach soft ground with a more open mind, allowing the process to present new possibilities, even if they are different from those you had originally planned. With practice it can become a central tool in the printmaker's visual language.

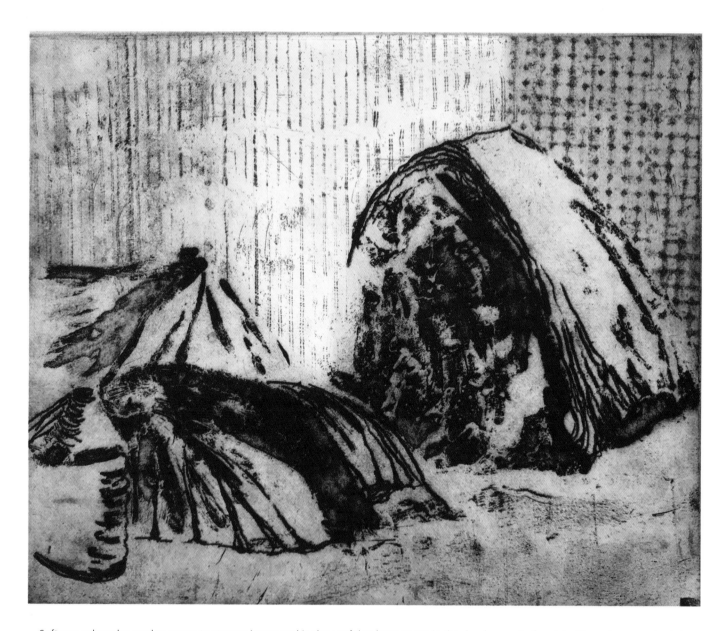

Soft ground can be used as a way to start an image and is also useful at later stages in the development of a plate. These two recent prints of mine, *Tent City* (above) and *Basking by a warm air vent* (right) were both started on the backs of old plates. This had the benefit of cost effectiveness but, more importantly, the used plates provided a rough, unpolished start to the images fully relevant to their subject matter. The project is a response to the separation, displacement and homelessness of people living locally that I witness on a day-to-day basis.

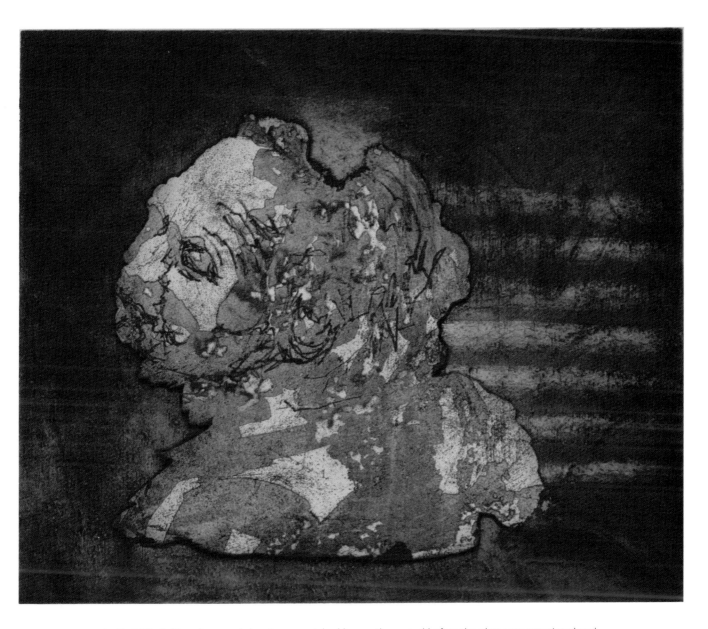

In *Tent City* (left), soft ground drawing was etched longer than usual before the plate was aquatinted and a second soft ground applied into which textures were pressed. *Basking by a warm air vent* (above) was etched with soft ground as a final stage.

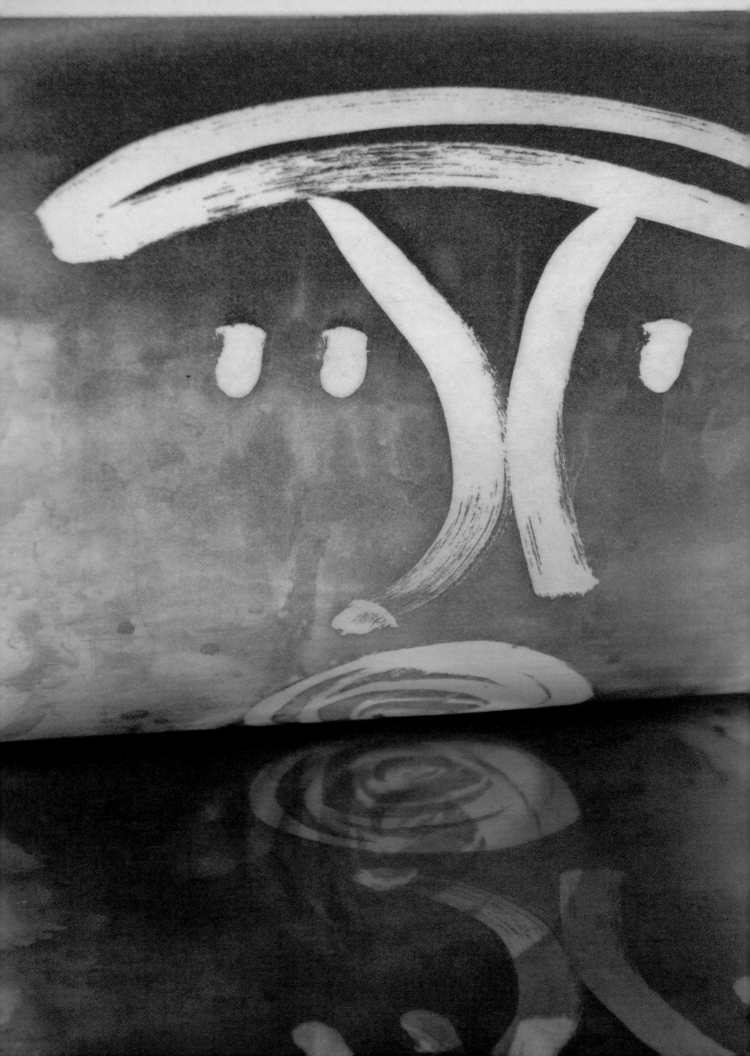

AQUATINT

If hard ground allows for a pen and ink drawn line, and soft ground a gentle pencil-like line, aquatint is the etching technique used to create broad brush washes of light and dark tones within an image. If we look closely at a newspaper photo, for example, we can see it is made up of a series of dots called a halftone. These dots provide the image with its lights and darks. An aquatint is a way of putting a fine random dot across selected areas of an etching plate, which then will print as light, mid and dark tonal areas. The areas stopped out with a varnish before the aquatint is etched will remain white in the final print. Over the rest of the plate, the longer the aquatint is etched in the acid, the deeper the bite and the darker the tone that prints.

The metal plate is degreased and coated with a fine resin dust, which is heated until it melts, so adhering to the surface of the metal. Each fine dot of resin acts as a resist so that when the plate is placed in an etching solution the metal around each dot of resin is bitten, leaving pitted marks. The longer the plate is etched the deeper the bite, therefore the more ink is held within the plate and so the darker the tone in the eventual print. Often a variety of tones are created by stopping out the image in stages, and the overall effect can be that of a series of washes – this is what gives the aquatint its name.

The process of aquatint was developed during the eighteenth century and made popular by Goya, whose 1799 series *Los Caprichos* is considered one of the first major group of prints to fully demonstrate the considerable creative possibilities of the technique. The darkness of the subject matter is perfectly complemented by the velvety richness of dark, painterly aquatinted tones.

Another way of understanding the tonal variety possible with aquatint is to think of a brushstroke of black watercolour paint, which begins dense with colour but gradually pales to a thin grey wash. Loose, nuanced tones are also possible with aquatint.

Aquatint resin is a fine dust that can easily travel around the studio and be inhaled. Like many fine dusts this can have considerable health consequences and can cause lung damage. It should be treated with care, caution and good studio practice at all times. A good mask with new dust filters must be worn when handling it, right up to the point of melting it. No dust should be allowed to escape into other areas of the studio.

In a nutshell

1. Degrease plate.
2. Coat plate in resin dust.
3. Melt resin onto plate so it adheres.
4. Stop out resin in stages to etch different tones.

Materials and equipment

Dust mask with good filters

Degreased metal plate

Flat board bigger than the plate

Gas canister camping stove, or similar, used to melt resin (this must be kept outside the aquatint cupboard as resin can be very flammable)

Mesh shelf used for melting resin with a canister from below

Method

First, degrease your plate thoroughly and put on a good dust mask.

In the past the aquatint resin was applied by hand, resulting in quite a coarse textural quality to the image. Later, specially designed boxes were designed to apply the resin dust. These days these most commonly have an internal 'paddle', which stirs the dust when a handle is turned. Alternative dust-stirring mechanisms you may come across in your aquatint box include hand bellows or a reversed vacuum cleaner/blower. Whichever method you use in your studio aquatint box, the aim is to create a fine cloud of resin dust that will fall randomly over the whole plate.

The exact quality of the texture and tonal range each aquatint produces can be determined as much by the application process of the dust to the plate, as by the etching process later. For instance, the longer you wait after creating the cloud of aquatint in the box before putting your plate in, the finer the grains of resin will be on the plate, as the larger, heavier grains fall first. This can give a smoother etched quality to the print. If you put it in earlier and take it out later, this will mean that many of the larger grains will be on the plate which, when etched, give a coarser quality to the final print.

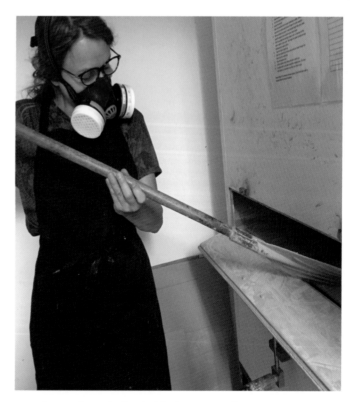

Scrape the resin dust inside the aquatint box to loosen it.

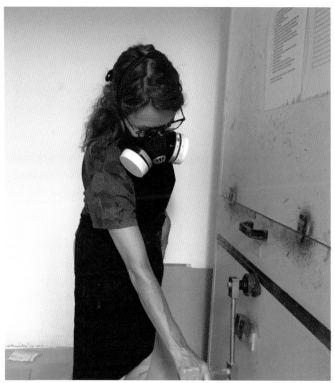

Close the hatch to the aquatint box and grab the handle
(or switch on the fan).

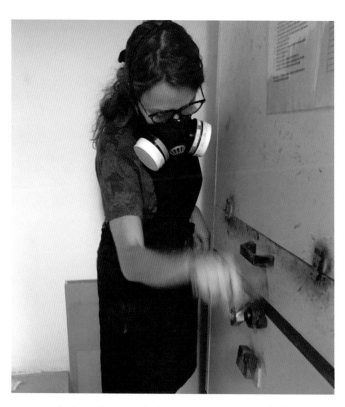

Activate the resin dust as much as recommended.
Here the handle was turned vigorously thirty times.

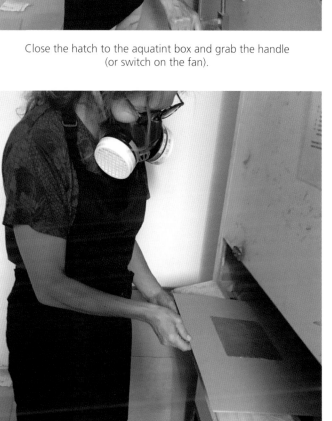

Wait a few seconds to allow the biggest lumps of resin to fall.
Place the plate on an old board and slide it through the hatch
into the box. Fasten the hatch securely and leave it for the
recommended time (usually 2–3 minutes).

Place the resin-coated plate on a mesh shelf for melting.

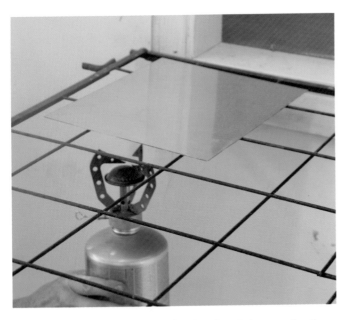

Ignite the gas and slowly warm the plate from below, moving the flame across the underside of the plate repeatedly.

Aquatint dust before melting.

When the resin has melted it adheres to the plate. Now it can be used to create different tonal areas.

Although the resin will already be in the box, the dust may need some encouragement. Wearing a mask with good dust filters, use a spatula or paddle to scrape the insides of the box to activate the particles that have adhered to the walls. Close the box and pummel the outside before turning the handle vigorously or starting the bellows or blower. If using a turning handle, lock it in place after use, to steady the paddle board inside.

Place your degreased plate on a piece of thin board. This will enable you to carry the plate without touching the surface. It will also help a more even distribution of dust along the edges of the plate.

After creating the dust cloud wait for whatever time you have decided on, then open the hatch and slide the board with the plate onto the wooden slatted or wire shelf inside. Move quickly but calmly to shut the hatch door and keep the dust enclosed. Inside the cupboard the dust particles will settle on the plate in an even layer.

Leave your metal plate on the shelf for long enough to allow the dust to settle in a dense enough covering. This may take as little as 40 seconds or as long as 3 minutes, depending on how much dust is inside and the denseness you require. Avoid leaving it too long: if the entire plate is covered there will be no room around individual grains for the etching solution to bite. The best guide is to see how your studio colleagues are timing their plates, or by making a timed test plate. There are instructions on how to etch an aquatinted test plate in Chapter 1.

Take out the sheet of card with the resin-coated plate on it. Close the hatch to the aquatint cupboard behind you. Carefully slide the coated plate onto the metal mesh or shelf used for melting the aquatint.

Keep your mask on while you heat the aquatint resin. Light the camping stove or gas poker. Hold the flame under the coated plate and move it in slow circles to heat the metal plate gradually. As the metal warms the resin will reach melting point and you will see each dust grain turn shiny and almost transparent.

Once you spot that one corner has started to melt the process will be quite swift. Starting in one corner, keep the flame moving in small circles from one corner of the plate to the opposite side and watch the resin melt across the plate. It is important to stop as soon as all the dust has melted; an over-cooked aquatint will melt into a solid layer and will not etch properly.

In some studios a hot plate is used to melt the resin. The hot plate has to be very hot and so the plate needs to be watched carefully. Remove the plate as soon as the last grains of aquatint are melted. Make sure you have the means to remove the aquatinted plate from the hot plate, as well as somewhere safe to put the plate.

Allow the plate to cool. It is now safe enough to remove your dust mask. You can look through a magnifying 'loupe' to see how your aquatint looks. If the particles of resin are close but still clearly separated and definable, the aquatint will be good. If they are too sparse you will end up with a thin, washed-out look to the tones made. If the coating is too dense or has been overheated the particles will fuse together, acting as a barrier to the acid. It is then best to clean off with methylated spirits, degrease and start the aquatinting process again.

The third stage of stopping out resin in stages is described below: 'Adding tone to your image with aquatint'.

Other methods for applying aquatint

Hand aquatint

Resin is usually bought pre-ground. However, it is possible to make your own dust if you have a sealed aquatint room in which to make it. The benefit of making your own is that you will create a greater variety of sizes of dust particle and so etch a wider range of pitted marks on the plate. It can be very liberating to have this loose approach to tonal etching.

Another occasion for the use of a coarse aquatint is if you want to etch a second aquatint over a fine one. Two fine aquatints on top of each other can easily cancel each other out as the particles and the etched areas are the same size and so you can unwittingly etch away the first aquatint. If the grains of resin in a second aquatint are of a different size they will fall differently from the first and so etch more successfully. This can be a good way to create very dense, velvety areas of black.

Materials and equipment

Aquatint room with closed doors

Chunk resin

Plastic bag

Small hammer

Metal tablespoon

Two or three small squares of scrim

Two rubber bands

Pencil

Jam jar (optional)

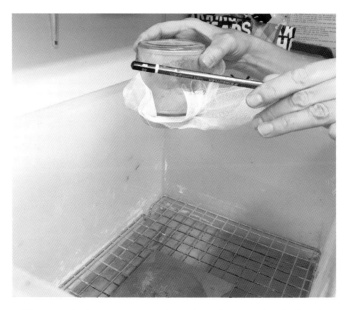

You can grind your own aquatint resin and coat a plate by hand to get a coarser dust grain. Place your plate on a mesh tray in the bottom of a box. Tap the scrim-covered jam jar while moving it evenly across the plate.

Method

To make your own resin dust, put on a good dust mask and work inside the aquatint room. Place the equivalent of a quarter of a cup of resin in the plastic bag and gently hammer it to pulverize the chunks. It is also possible to grind chunks of resin in an old hand-turned coffee grinder set aside specifically for the task. This mechanical approach will create more evenly sized particles of resin than a hammer but may suit you better.

Take the squares of scrim and lay them flat, placed on top of each other. Spoon the pulverized resin into the centre of the squares. Remove any large pea-sized chunks as these will tear the scrim. Gather the four corners of the scrim together to form a pouch with the resin in the centre. The pouch should be loosely full, retaining some space around the resin rather than being densely packed. An alternative to the bag is to pour the pulverized resin into a jam jar and cover the open top with the layers of scrim fixed in place with the two rubber bands.

If possible, use a wide-topped box with a lid to contain the dust. A wire cooling tray in the bottom will make it easier to remove the plate after coating. The lid can be used to cover the dust when you have finished. Place your plate on a board and tap the bag or jar of resin gently with a pencil outside the area of the plate to begin with. This will give you an indication of how much dust is falling. Keep the bag or jar moving systematically over the whole plate, continuing to tap until the entire surface is covered. The plate will

have a fine covering of resin. If some parts of the plate still appear thinly covered, shake some more over those areas. Try to keep your coverage as even as possible.

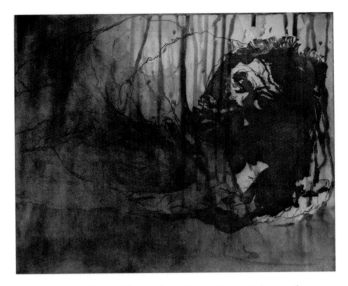

Aquatint can be used in a variety of ways to create layers of tone. The plate for this print began with sugar lift aquatint. After a soft ground etch it was aquatinted again and spit bite was applied. *Oxford Street W1*, Ann Norfield 2019.

Alternatives to resin aquatint

You may find that your studio has no isolated space available for an aquatint box. Given the health and safety problems surrounding the use of resin dust it is only possible to apply it in a safe, sealed location. Fortunately there are a couple of alternative ways of creating an aquatint effect and it is worth experimenting to see which suits you best.

Sandpaper aquatint

This is the most safety-conscious approach to an aquatint, but it does have limitations. It is not possible to easily vary the depth of the aquatint, so it has a 'one-size-fits-all' quality. It is also difficult to make very fine marks over a plate. But it does provide an alternative if one is needed and, with a bit of trial and error, you will be able to modify the process to suit your ideas.

There are two basic approaches. The first method begins by applying a thin layer of hard ground to a plate. Place a sheet of sandpaper on top and either burnish it with a wooden spoon or roll the plate through the press under very light pressure, to allow the sandpaper

to create marks in the hard ground. This can then be bitten as a hard ground plate, in stages to create different tones.

The second method is to lay a sheet of sandpaper face down onto a polished plate and run it through the press. For specific aquatinted areas, cut fine sandpaper into shapes. For a denser aquatint, shift the sandpaper a little and run the plate through again and again until the pitted marks reach the required density.

Paint spray aquatint

Enamel spray paint (e.g. car spray) works well as an aquatint ground. As with resin dust, each dot of enamel resists the etching solution, which bites around the particles. Instead of stopping out the aquatint in stages the spray paint can be applied in stages and etched each time. Paint spray can be used in situations where heat cannot be applied to the plate, such as if you want to apply aquatint to a large open area when there is still ground on the surface.

Wear a good mask to avoid inhaling atomized enamel. Protect the surfaces all around the plate, as spray paint diffuses far beyond the area you intend to cover. Practise spraying on newspaper first. Spray from a distance of approximately 40cm and stop before the particles are too close together. If there is no designated space within the confines of the studio the plate can be taken outside and car spray applied there. Draughts of wind are best avoided!

Air-brush aquatint

This is an extension of the previous process. Acrylic resist or bitumen paint can be applied as an aquatint with an airbrush and a compressor. The airbrush must be cleaned thoroughly before use, as it can easily clog.

Place the copper plate almost vertically on white paper at the back of a spray booth or a large cardboard box. Fill the glass container under the airbrush with acrylic/bitumen aquatint solution and screw it into place. The density of the aquatint grains is determined by the amount of air used to project the acrylic/bitumen ground. You can adjust the density and size of the dots by loosening or tightening the valve of the spray gun. Changing the distance between the gun and the plate will also make a difference.

Although it can be difficult to see the tiny dots of sprayed ground on the copper plate, the white paper behind your plate will indicate the size and density of your aquatint spray. It is a good idea to practise on a sheet of paper first.

Etching an aquatint

Aquatint is a great way to add tone to a linear image. The original etching could be line drawn in hard or soft ground, or you can use the tonal differences between aquatints as a pure way to create an image without the need of any linear work.

The aim is to etch the aquatinted plate as long as possible for very dark, velvety black tones. Lighter tones can be created by stopping out areas and etching them carefully in two or three different stages.

Have a look at the chapter on etching solutions to check which will work best for your plate. As aquatint is fragile it is better to use a weaker or gentler etching solution. This will help you to control the pace of etching your aquatint.

Before etching a plate in which you have invested time and effort it is best to make a test strip. Once you have a print of this test strip, you will have a clearer idea of the time needed, in a particular strength of acid, to produce any tone you may require. It is worth remembering that the more an acid is used, the weaker it gets, and this shows itself particularly in aquatint. Therefore if you have an important plate, in which you have already invested a lot of time, it is wise to make a specific test rather than rely on an old one that exists in the studio, as it could be months or even years old. There are instructions for making a test plate in Chapter 1.

Materials and equipment

Stop-out varnish

Brush

Backing and tape for handle

Timer and paper to note times on

Magnifying loupe

Soft rags

Solvent for stop-out varnish removal

Methylated spirits for resin removal

Method

Degrease and coat your plate with resin as described above. Protect the back of the plate and create a handle. Remember that before you start any etching you need to stop out all those areas you want to remain white.

Aquatint bites more quickly than other grounds so use a gentler solution for etching. Place the plate in the acid for the required time. Remove, rinse and dry the plate.

The next area you stop out will be the area you want the lightest tone. Once the stop-out varnish is dry, you can return the plate to the etching solution for the next predetermined time. This is then repeated: etch, wash, stop out, until you have bitten all the areas and to the tonal depth you want for the print. Although it is feasible to bite many tones, and so many times in the bath of acid, it is generally impractical to go beyond four or five.

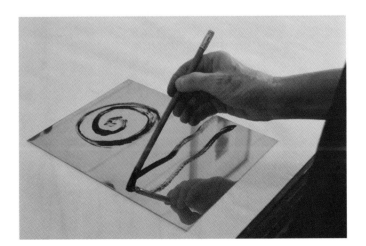

You can stop out an aquatinted plate before etching it. This will give marks that will print white in an area of etched tone.

Here an aquatinted plate, previously etched using hard ground, has been degreased and coated with aquatint. It is being stopped out before etching, starting with the areas to be white when printed.

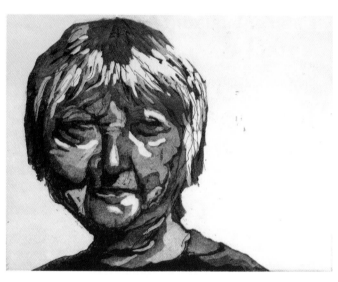

Lower the plate into the gentler etching solution and etch according to your test plate. If you have no test plate remove after a very short time. Dry the plate and stop out successive areas, etching each stage for a short time. Use your test plate to calculate how long each etch should be.

This proof shows the effect of stopping out in stages, creating different tones in different areas.

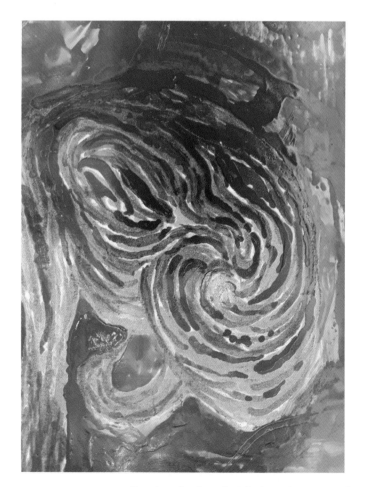

The plate detail on the left shows how areas of aquatint were stopped out in stages for step biting. The corresponding print detail on the right shows the effect of step-bitten aquatint.

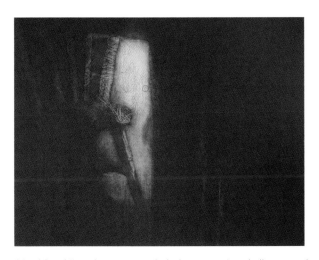

This old etching plate was sanded, then aquatinted all over and worked into with burnishing tools, treating it like a mezzotint. The etched marks from its previous incarnation show through. Ann Norfield, *Under the Table*, 49 x 49cm, 2002.

The best way to check on the progress of your plate is to use a magnifying loupe. Place the magnifier on the plate and look for a dense covering of resin grains across the surface. You will be able to see where the etching has started because the metal around each resin grain will start to sparkle or change colour. If the resin grains start to disappear the plate will open bite.

Once you have completed the final bite, remove the plate from the etching solution, rinse and dry. Then use a soft rag and solvent to remove the stop-out.

After the varnish has been removed you will need a new soft rag and methylated spirits to dissolve the remaining resin. Treat the plate extremely gently to avoid damaging the aquatint. Check that all the resin has been removed, as the plate will stick to the printing paper if resin is left behind.

You can then print a proof to see exactly what has happened and decide how to proceed with the print.

Aquatint beyond flat tones

Aquatint is an exciting way to create areas of dense tone. These can be clearly delineated or stopped out gradually. Referring to the print of your test plate you can decide to go all the way for velvety blackness or stop out in a painterly fashion to create light, medium and darker tones, leaving just a few areas for the darkest black.

Aquatint can also be used in ways that go beyond merely the creation of flat, graphic tones. It can be used to create drawn marks, both positive and negative, as well as washes that mimic watercolour blends. It is also a vital ingredient in photographic processes; these

are fully explained in Chapter 8. Some of the ways you can extend your use of aquatint are described below.

Aquatinted mezzotints

Traditional mezzotint is a hard-won process that involves the use of a specially designed serrated tooth tool to rock an even texture into the entire surface of the plate. The plate is rocked many times, in many different directions, eventually ending up with a plate that, when printed, produces the richest, densest black imaginable. The image is then created by the gradual removal, through scraping and burnishing, to create gentle tonal gradations. In other words the image is revealed by going from black to white, so the opposite to the way in which we normally create an image.

The easier way of achieving a passable version of traditional mezzotint is to etch an aquatint to a solid black over the plate. Apart from the obvious time saving in producing an etched aquatint instead of a rocked plate, there is also the possibility of using this approach on a specific area of the plate, rather than all over. The limitation of this technique is that, no matter how good your aquatint, the tonal range and your ability to work the plate is not as extensive as that possible with a mezzotint. Nevertheless, it is a much more realistic technique for most people and can look stunning.

To manage this with confidence, draw the outline of your image on the plate with a pencil or lithographic crayon. A detailed outline could be hard to negotiate so it is best to keep the shapes fairly simple.

When you are satisfied with your drawing outline, start by using a small ball burnisher, with a little 3-in-1 oil, to gently run around the outline. This will give a more permanent outline to work with.

Collect a variety of differently sized burnishers to suit the marks you are making. Apply oil to the plate and start to gently work away at the aquatint. Work the whites vigorously and the greys less so. If you want to add more marks to an over-burnished area, try running a roulette wheel over it repeatedly until you like the tone achieved.

You can take a proof to see what exactly is happening to the image but sometimes it is just as useful to ink up the plate and wipe it back with scrim, without printing, simply to see more clearly what you have been doing. You can then carry on burnishing, re-ink, and continue on until it becomes necessary to take a print. Then clean out the ink being used simply to see the marks, re-ink and print.

It can take some time to get the image to work, so the process needs commitment. Nevertheless, when done well there are few tonal techniques to surpass this.

Acid resist pens and crayons

These are manufactured especially for the stopping out of fine lines in etching. They are especially helpful for fine drawing on aquatint where they can be used to create a crisp, graphic quality to your drawing. Sharpies or paint markers can also help stop out fine, clear-edged details. The effect of etching aquatint drawn on with them will give quite clear, graphic white lines in the final image. The benefit of using these rather than an officially designated acid resist pen is that you can apply a different coloured paint marker for each tone. This may make it easier to visualize the tonal development of your image and can be especially helpful when you are etching and stopping out many times to create a subtle gradation of tones in your final image.

Lithographic and chinagraph crayons, which are greasy and therefore resistant to the water-based acids, can be used to stop out lines or broad areas before and during the etching of an aquatint. You draw directly on top of the aquatint before it is placed in the acid and it will give you a soft crayon-like white stop-out mark. You can then use it at every stage of a stopped-out aquatint. As the tones of the aquatint get darker, so do the marks of the crayon.

Spit bite

Spit bite is a technique used to create subtle graduated tones that can appear cloud-like or watery as a result of the way the acid is put into contact with an aquatinted plate.

Many people initially come to etching to extend their drawing. Aquatint techniques described above can complement drawing beautifully, turning line drawings into exciting tonal images that extend beyond the usual range possible with drawing alone.

With the use of spit bite, marks more painterly than drawn are created by brushing a strong etching solution directly onto parts of the plate without areas necessarily being stopped out. Traditionally, an etcher would use spit on their brush before dipping it in strong acid. The spit acts as a means of breaking down the surface tension on the plate, so that the acid flows freely. Without some means of doing this, the acid would simply form into globules on the surface and bite in indiscriminate balls of acid.

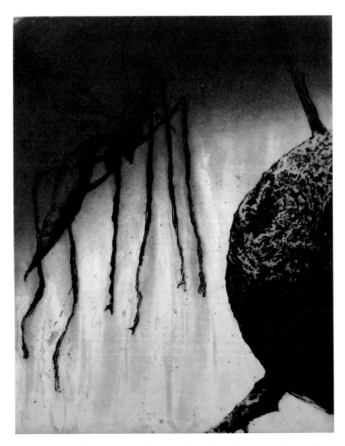

The rotting fruit on the right of the print was stopped out in stages using litho crayons, giving soft, textured marks in aquatint.

When spit bite was used across the plate the atmosphere of the image changed entirely. Ann Norfield, *Overripe*, 21 × 25cm copper plate printed on Somerset velvet 300gsm.

These days, both social niceties and health and safety concerns are likely to mean that the use of actual spit is unlikely to appeal to you. Luckily there are ways of achieving the same effect without the spreading of body fluids. Instead put a little gum arabic, washing up liquid or liquid soap either in a groove in the etching tray or a glass jar. Periodically dip your brush into it and then into the etching solution. After a short while there will be enough on the plate so that you can continue just with the acid.

Remember that with spit bite, the acid is by necessity very strong, and so care must be taken with your own safety, as well as that of others who may be working nearby. Always wear goggles, as well as gloves and an apron. Always make sure your working space is clearly defined and that those working nearby are aware that strong acid is being used. Always work directly in or next to a sink with a tap so there is immediate access to water. Only decant strong acid if you are fully qualified and experienced to do so and if your communal studio has a technician, ask them to do it for you.

Nitric acid should NEVER be heated using the method described below. If you want to spit bite a zinc plate it will be safer for you, as well as your studio colleagues, to use a copper sulphate solution.

The method described below only applies to the use of copper plate and ferric chloride.

Materials and equipment

Aquatinted copper plate

Old or cheap paintbrushes with a plastic ferrule that will not be affected by etching solution

Polypropylene tray for plate and acid

Strong glass jar with lid

Sharpie

Strong container that withstands very hot water, wider than the jam jar (an old saucepan is ideal)

Gum arabic (if unavailable, washing up liquid will do)

Gloves, goggles and protective apron

Small measuring container for etching solution

Etching sink

Kettle of hot water

Method

Heat the kettle of water to until it is hot but not boiling. Pour hot water into the bottom of the saucepan or strong container.

Mix a dilution of three parts ferric chloride to one part water (always add the acid to the water, not vice versa) in a glass jar. Put the jar of diluted etching solution into the pan and top up the surrounding hot water. Take care to stop pouring before the jar floats.

While the etching solution is warming, prepare your work area on a surface in the acid room next to the etching sink. Place the plate in a polypropylene tray, protect the work surface with thick newspaper and have gum arabic, paintbrushes and equipment at the ready.

When all is ready, dip the brush firstly into the gum or soap, then into the acid. You will normally only need to dip each brush once or twice to pick up enough to control the surface tension of the etching solution.

Start painting directly onto the aquatinted plate. Each brushstroke will affect the plate but it is worth bearing in mind that once the etching solution is brushed on, it will have a limited life on the plate before its power starts to fade. It is best to keep the brush moving, concentrating on the areas you want to darken most by adding new etching solution to the brush.

Although the plate will stain quite readily this may not indicate the degree of etching accurately. It is best to have a sense of how many times an area has been painted with acid to gauge how your spit bite is progressing.

This is where a visual sense of how a bitten aquatint looks on the plate comes in handy. If you can see the aquatint being bitten around each grain of dust very clearly, then you know you are on your way. To get rich blacks can take some time, through a continual adding of fresh etching solution to the brush. Lighter tones can be as little as a single sweep of the acid-laden brush. This is a technique that requires working on several plates to get a real sense of control. Do not be put off if your first attempts are too weak or, to compensate, you have over-etched them. As frustrating as that can be, the process is a beautiful one to use and the results can lift your ideas to a new level of sophistication.

You can vary the way you apply spit bite. If you keep your plate wet after rinsing you can paint or drop etching solution into it and watch the wash spread through the water. You can also stand the plate vertically and use a brush to run etching solution along the top edge a few times, allowing it to drip or run down the plate. By adding more etching solution to these areas you can create dark centres with soft light tones at the outer edges.

Preparing for a second round of spit bite. The dilute etching solution is warming in a double container, surrounded by hot water.

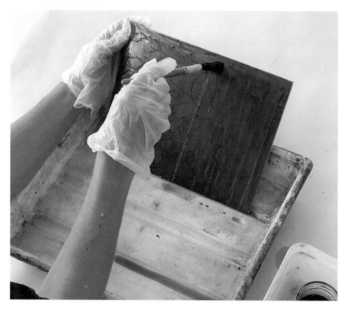

By running spit bite along the top edge the acid trickles down the plate and across the image.

Once you have finished, rinse the plate thoroughly, as well as the brush and any other equipment used. Then remove the aquatint dust with methylated spirits (or if acrylic aquatint spray with the appropriate solvent), and ink up and print as usual.

One of the delights of spit bite is that proofing your plate will always throw up surprise results. Occasionally the first print shows exactly the degree of nuanced bite that you want in your final image. More likely you will want to develop the spit bite further. It is possible to repeat the whole process with a new aquatint.

With the first round of spit bite it is best to paint almost the entire plate, much as you would work an entire canvas in the first layer of a painting. With the second or third round you may want to focus on particular areas. It is best to avoid areas that are already dark as continued biting there will just as likely result in a reduction of tone as the new bite removes the first, instead of adding to it. You could stop out areas but before you apply varnish it is best to consider first the effect that the stop-out will have on your image overall. For instance, stop-out varnish usually gives sharp, clear edges to the areas protected from etching solution. This can be great if you want very clearly delineated areas of contrast but if you find this is at variance with your image overall you may prefer to use lithographic crayons to stop out some areas to give a looser, more textured outcome. It is worth experimenting with acid resist pens, paint markers, sharpies, and chinagraph pencils as well as litho crayons to see which acid resist techniques best suit your purpose in combination with spit bite.

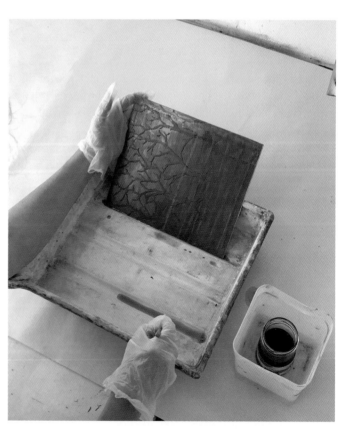

Before applying spit bite the brush is dipped into the little reservoir of gum arabic held in the groove of the tray. This simulates the spit that gives the technique its name and helps give a good consistency for painting the etching solution.

The second round of spit bite provided a broader variety of washy tonal marks.
Ann Norfield, *Overgrowth 6 (Warm Mist Rising)*, 21 × 25cm on Somerset velvet 300gsm.

Sugar lift

'Sugar lift' is so named because sugar is the unlikely but useful ingredient in helping to create painterly marks in an etching. A sugar solution design is painted on to a plate, which is then coated with an acid-resistant varnish (stop-out varnish), hard ground or liquid hard ground. When dry, the plate is placed in a bath of warm water until the sugar melts and lifts the varnish away to reveal only the brush marks you have made. This is then aquatinted and etched, resulting in clearly defined brush marks, as opposed to the amorphous washes of spit bite.

There are several different mixtures suitable for making a sugar lift. The tried-and-tested traditional mixture is made by pouring a small amount of hot water into a jam jar and adding enough caster sugar until it takes on the consistency of honey when dissolved. If the sugar soaks up all the water but remains crystalline, add a touch more warm water. When the sugar has dissolved to a viscosity suitable for painting, add a small amount of gum arabic, washing up liquid or liquid soap. This will break the surface tension on the plate and allow the solution to flow and remain as intended, instead of forming small globules of sugar lift with no form at all. Also add a small amount of Indian ink or black watercolour to the solution to make it easier to see what you have drawn on the plate.

There are a couple of alternatives to this homemade solution. 'Camp' liquid coffee essence can be bought in supermarkets and is dense with sugar. It is already viscous enough for application with a paintbrush.

You can also buy a mixture that has the same kind of effect as sugar lift, despite being manufactured with no obvious sugar content. This low-calorie variety comes in a glass bottle and is known as 'sugar lift ink'.

Lastly there is 'photo opaque', used for touching up photographic film and negatives. This makes a very good substitute for the sugar-based methods and is still available from printmaking suppliers.

Materials and equipment

Plate that has been bevelled, polished and degreased

Sugar lift solution

Clean brush, dip pen or toothbrush for applying the solution

Small jar of stop-out varnish, diluted by perhaps 20 per cent with white spirit

Gloves

Newspaper

Two polypropylene trays

Hot (but not boiling) water

Soft, clean brush

Method

Paint the sugar solution onto your degreased plate with a clean brush. It is also possible to draw with the sugar solution using a dip pen. You may find that a bamboo pen is more pleasant to use on metal than a traditional metal-nibbed pen.

To break up the surface of your image in a more haphazard way you can try dipping a toothbrush into the mix and running a stick or pencil through the bristles to splatter sugar solution across the plate. (It may be worth practising this approach on scrap paper first. Keeping the brush low and close to the plate and starting the splatter with the bristles closest to the surface can help produce the best effects.)

Leave the sugar solution to dry on the plate. If, after the sugar solution has been applied, there are areas with sugar on you are not happy with, you can stop out these after the sugar has lifted and before you aquatint or etch. It is not possible to clean the sugar solution off and re-apply a new layer of drawing as the plate has already become greasy through the first drawing. This will simply result in the whole area where you have cleaned off floating away in the water, with no delineated brush marks left behind.

Stand the plate on a workbench against a wall or a board. Place the bottom edge of the plate on small blocks or sticks. Your aim is to coat the whole plate with a thin layer of stop-out varnish to protect the undrawn areas from etching.

To do this, put gloves on and hold the plate away from the wall slightly with one hand, without touching the front surface painted with sugar.

Start by moving your open jar of dilute stop-out varnish across the top edge of the plate, gently pouring its contents along the top as you go. You can use a large brush. The varnish will run down the plate quite quickly. Be ready to pick the plate up and turn it from side to side to allow the varnish to cover the entire front surface. Your aim is to get a thin, even layer of varnish over the whole plate.

Place it on the blocks to allow the excess to drip away from the plate and lean it against a support to dry.

Prepare a tray large enough to hold your plate by filling it with hot water. The water should be hot enough to melt the sugar solution but

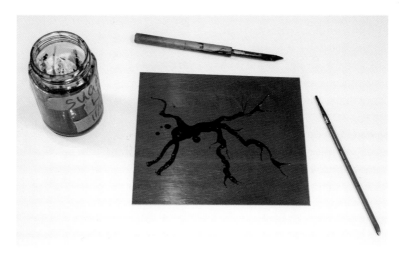

Paint with sugar solution onto the degreased plate
and leave it to dry completely.

Dilute stop-out varnish 50:50 with white spirit and paint with
it across the top of the plate. As the varnish trickles, tilt the
plate so the covering is as even as possible.

When the entire plate is covered,
leave the varnish to dry.

Soak the plate in warm water for about 20 minutes, then start
to encourage the varnish to lift where the sugar melts. A soft rag
or brush will help to gently lift it away. When the sugar has lifted
the varnish it is ready for aquatinting.

The aquatint has been etched then removed with methylated
spirits, the varnish has been removed and the plate printed.
The fluid marks of the sugar lift are held in the plate.

should not be boiling as this could lift the varnish as well as the sugar. Place the dry, coated plate in the tray and leave it to soak. You should start to see the surface crack as the sugar lifts up and away from the surface to expose the metal plate underneath. Gently rock the tray so the water moves a little across the plate.

You will see your sugar lift drawing start to appear as the clean metal plate underneath becomes exposed. You will need to encourage some areas, especially around the fine hair marks of the brush. You can do this by gently rubbing the surface with an old, clean brush. Be careful not to disturb the varnish as it too has been softened by the heat from the water and could foul bite when placed in the acid.

Sometimes sugar lifts can be very difficult to lift. This is usually down to the varnish being too thick or sometimes the drawing being too thin. Either way persevere, add more hot water and encourage it to lift a little harder.

Keep an eye on the tray and as soon as you like the amount of varnish that has lifted, remove the plate. Dry the plate in air and stop out any areas you want to protect from etching solution.

Once the plate is dry, stop out the back of the plate and aquatint as per normal. Once the plate is fully coated and the aquatint melted and plate cooled, it is then time to etch. With reference to your aquatint test plate for timings, you can etch a number of tones into the sugar lift, stopping out between bites to achieve a varied, painterly quality across the plate.

Alternative sugar lift method

An alternative method of grounding a sugar lift is by using a hard ground rolled over the sugar lift. There are several artists I have known who use this method and it works very well. It also has the advantage that the ground can be worked into separately after the sugar lift drawing has been washed out.

To use this method, the plate preparation and sugar lift drawing are made in exactly the same way as above.

The hard ground coating for sugar lift is good for allowing fine detail to come through, as the rolled ground is generally thinner than the poured varnish. It is something that needs practice to perfect. Once the plate has had the ground applied, it is washed out and etched as per the previous method.

Whichever method you use, it is worth remembering that there is always the option of etching your plate as it is, without the use of aquatint. This would allow the areas opened by sugar lift to open bite and create a distinctive, open textured area, as described in Chapter 3.

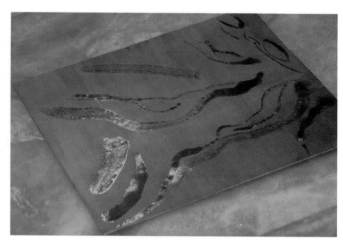

Take a degreased plate and paint it with sugar solution, then put it on the hot plate to harden. When it is completely dry, melt the hard ground. Use as few passes as possible to roll the ground evenly over the sugar painting.

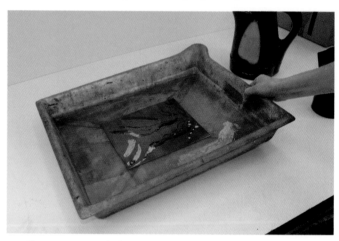

Place your coated plate in a tray of hot but not boiling water.

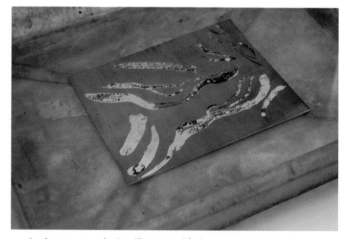

As the sugar melts it will start to lift the ground in the painted areas. Agitate the tray a little to encourage the lift away from the plate. Over the course of 15–20 minutes the brush marks will gradually reveal themselves.

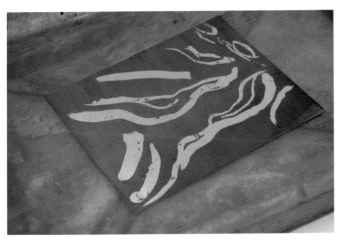

When the sugar has lifted you can still see the life and vigour of the original brush marks. Decide how you want to proceed with the plate. Options include aquatint, open bite or extra line drawing in the hard ground (as described in Chapter 3).

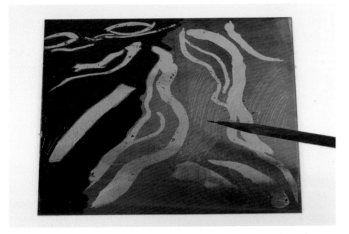

This plate has been prepared for open bite. Some areas have been stopped out with varnish to prevent any etching and to create white areas in the eventual print. Other areas of hard ground have been marked with an etching needle to create etched lines.

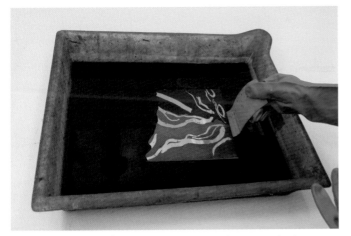

Etching in an open tray, resting your plate on a plastic lever-handle allows you to check on it regularly. Rinse away any residue for a clean, deep bite.

White ground

This is a very painterly technique that uses the idea of the progressive etch, one that involves putting an aquatinted plate into a single bath of acid, but, because of the nature of the materials used, creates a broad tonal range as it slowly breaks down in the acid.

When you paint it on, white ground seems slightly counter-intuitive. The thinnest area of ground painted on the plate will break down first and bite for the longest time and therefore be the darkest tone etched. The heaviest layer of ground will take the longest to break down and will therefore be the lightest bite and tone. In between the two extremes a varied array of tones will be made. It can be used over a plate previously stopped out so that the biting only takes place in specific areas. When used well it gives a unique textural quality.

Materials and equipment

1 part Titanium white dry pigment

2 parts soap flakes (Ivory Snow granulated detergent)

½ part raw linseed oil

1 part water

Method

Mix all the ingredients together and leave them to fully dissolve. Degrease a plate, apply a fine aquatint and paint the white ground mixture onto the plate. Allow it to dry and, after protecting the back of the plate, place it in a bath of etching solution. An aquatint test strip will give you a good idea about timings. The difference with white ground is that it breaks down more readily than other acid resists so it is even more important to keep a close eye on the plate as it etches. When you can see the thickest area of the ground biting, it is usually time to take the plate out, wash both the acid and remaining ground from the plate and print.

The many variants of aquatint make it an exciting medium to work with. Artists who use aquatint extensively include Goya, Rouault, Picasso, Paula Rego, Brice Marden and Norman Ackroyd.

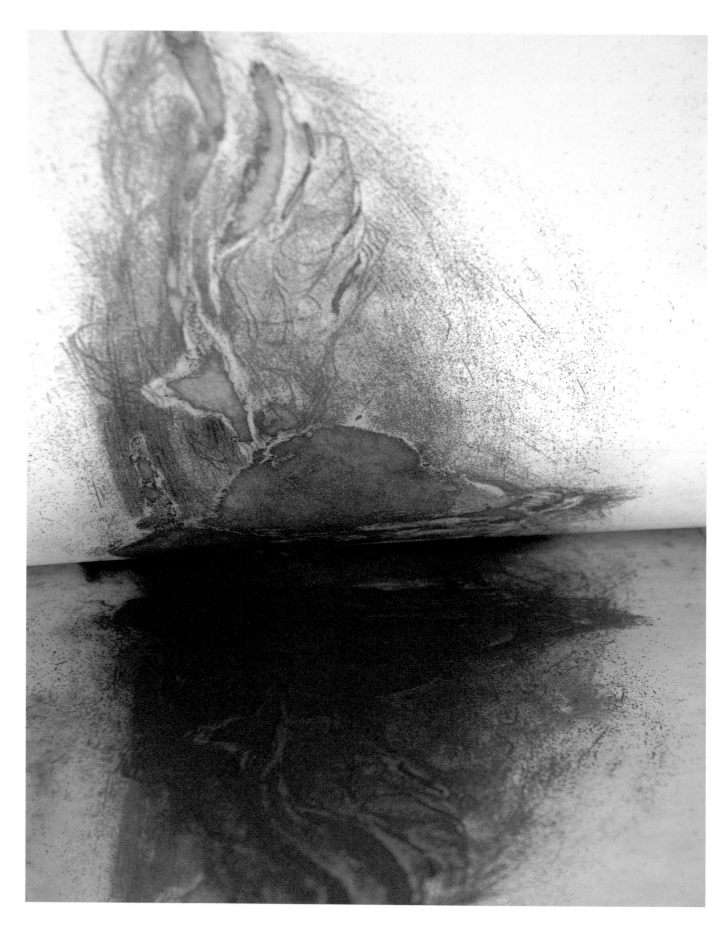

Developing your plate

As you become conversant with the etching processes of hard ground, soft ground and aquatint you will start to find certain ways of developing your plate work really well for you. Nevertheless, there may come a point at which you feel a bit stuck and unsure of the best way to progress. When thinking about how to take your print forward, how to decide what to do next and what techniques to employ, the following approaches are very useful in making you aware of alternatives that you might not have first thought of.

Collect source materials from the outset and develop these in themselves. Try photocopying any photographic references or sketches, changing the scale, trying out different compositions and areas of interest. Try out different layers on acetate or tracing paper and start to think about working these ideas into your etching so you are working an entire plate, rather than a specific subject.

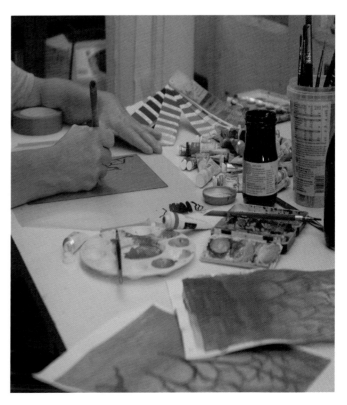

Photocopy proofs of a plate and work on these to try out new versions of the same image. Work on these cheap, disposable versions of imagery with whichever drawing or painting materials you prefer, plus any others you can lay your hands on.

Make sure you keep all proofs, no matter how bad they may initially seem. Keep the proofs visible: stick them on a wall or board on a table in front of you. Work on the proofs, draw and paint on them, cut them up and stick bits of proofs together to make a new version. Remember that we are making visual our ideas, so keep them all where you can see them.

Scanning your print and changing it in an image manipulation program can throw you in another direction entirely. Any ideas thrown up by Photoshop can be used or even replicated, either on the plate itself or through different approaches to printing.

Take advantage of all the possibilities of multiple print. Print different colour versions of the same image over each other, print completely different images on top of each other, print one upside down on top of the other.

As silly and pointless as some of these suggestions might seem, we sometimes need to jolt ourselves out of our comfort zone. All of these approaches to your plate have the potential of revealing something entirely new; an image, mark, colour or texture that we could never have thought of directly, but that we store away in our memory locker for use another time. If, as artists we only deal with what we know, we soon run out of steam. We need to find access to all of the other possibilities that we do not yet know, but that are there waiting to be found.

In practical etching terms, there are some aspects of reworking a plate that are worth remembering.

Keep all your original references alongside your different versions and stage proofs while you are still developing a plate. As you finalize an image take the latest proof and draw on it to work out where to take the plate next.

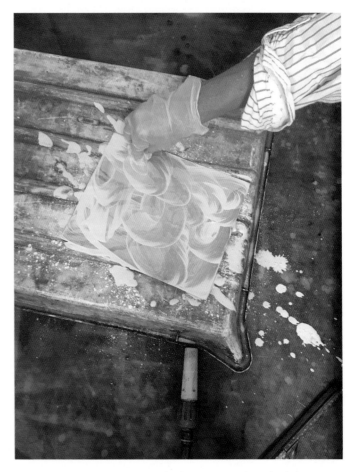

Any new ground can be applied to a previously etched plate as long as the metal is degreased thoroughly first.

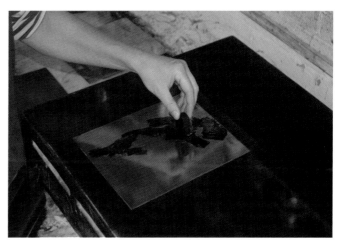

As well as rolling hard or soft ground onto your warmed plate, apply it directly to heavily worked areas to ensure the coverage is dense enough to protect the image.

Soft ground can be quite a fragile layer but using it as a second etching ground can throw up some exciting accidents.

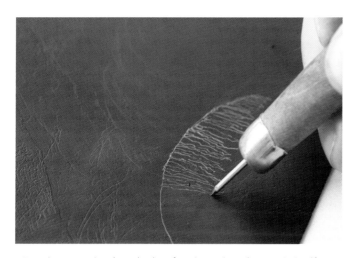

Drawing a previously etched surface is a gritty pleasure in itself!

Stop-out varnish will protect any areas of the plate you don't want to change.

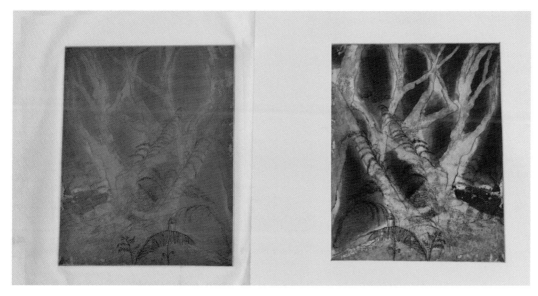

Night Copse,
plate and print.

How to remove or knock back etched marks

When it comes to editing out areas of your plate there are three approaches you can deploy. Scraping and burnishing away areas of the etched plate no longer wanted, using both tools specifically designed for the purpose, as well as power tools like dremels and hand sanders, are possible starting points. Wet-and-dry sandpapers are also an option for knocking back marks over broader areas and can be used before or after scraping your plate. Burnishing is the finishing stage where a scraped area can be smoothed out a little to minimize unwanted marks on the print. Moderate removal can be done with burnishing alone.

Materials and equipment

G clamps
Pad of felt
3-in-1 oil
Scraper
Burnisher
Wet-and-dry papers (medium, fine and super fine)
Jeweller's rouge, a fine polishing powder
Metal polish

Scraping

Clamp the plate to the table with the felt pad between the plate and the clamp.

Decide in which direction you would like to use the scraper. Hold the scraper firmly in one hand while controlling the plate with the other. Draw the scraper across the plate until the unwanted etched area is removed. Carefully remove all the metal scrapings from the surface.

Sanding

Start with the coarsest wet-and-dry paper to knock back the roughness of the scraped area. When the worst has been removed, move on to the fine and superfine papers. For larger areas, electric sanders can be very useful. Then try using a paste made with water and jeweller's rouge or, if needed, a slightly coarser pumice powder.

Burnishing

Consider the direction in which the burnisher is moving. Apart from its job of smoothing out unwanted marks, burnishing can also be a way of adding highlights to your image and can be used to create a mark in its own right. This is similar to using a rubber in a pencil, granite or charcoal drawing to create negative marks that become a part of the drawing.

Apply a few drops of oil to the ridges on the plate where you have removed marks left after scraping and sanding.

Burnish the plate using 3-in-1 oil until the plate is smooth enough to print cleanly. You can control the amount you burnish and how smooth the plate becomes by the pressure used.

To remove etching you can sand a plate, either with an electrical sander or, for shallow etching, increasingly fine grades of wet-and-dry paper.

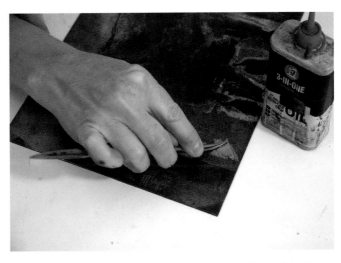

If you want to erode etched marks from a particular area a scraper is the best tool to begin with. Scrapers come in different sizes and can be selected for the scale of mark you want to tackle. The double-ended tool being used here for a small area is called a scraper-burnisher and the scraper end is being used to knock back an aquatint with repeated movements in one direction.

After the scraper has taken away the top layer of aquatint, 3in1 oil has been applied to the plate and the burnishing tool is being used to smooth away marks left by the scraper. This will also have the effect of bringing back areas that will print white in the eventual image.

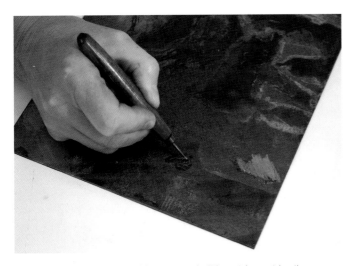

Thus far this book has described the use of the three main etching grounds of hard ground, soft ground and aquatint and any one of these can make a good starting point for an etching plate. You can move on to develop your image using any variant of these grounds, in any order, providing the plate is thoroughly degreased before each application. You may want to protect areas with stop out varnish or, equally, erode etched marks using the methods described here. The next three chapters on printing with colour, photo techniques and non-etch approaches offer further options for development.

For finer burnished lines use a ball burnisher with oil. A few highlights can make all the difference in bringing an area of a plate back to life.

Afterwards you can polish those areas of the plate with a metal polish and jeweller's rouge, mixing them together on the plate into a paste. This helps to bring the shine back into the plate and reduce the possibility of residual marks being left to hold ink.

Bligh's Bounty Box

I worked with Clare Bryan, who was a genius bookmaker, an artist who also makes the books for me. She and I discussed the ideas about the special box for these pieces. With *Bligh's Bounty Box* I said I had a vague idea of the box itself, like a kids' colouring-in set and she came up with brilliant suggestions for things of course, really picking up on details in the work which is just perfect, so it's highly collaborative but heavily weighted on her side! So in *Bligh's Bounty Box* the images are very simple etchings using hard ground, sugar lift, deeply etched with gouache hand colour.

AN: There is an element of stop frame throughout your work. Just looking at your falling man for example.

OG: Yeah, and that's something I'm doing a lot more now. I am interested in the single image, but people always say, 'Why don't you do animation?' But actually, I'm not ready; I think animation is probably too…

AN: Too literal?

OG: Yeah, exactly, so I like the idea of the single frame, which has the suggestion of past and future, and you do it yourself.

The recent work is still very much drawing, stealing so much from print processes – stencil sprays from screenprinting, a lot of collaging and layering, colouring-in but in a more direct form. The thinking is the same: all those early lessons are my foundations, strong foundations that permit often perilously rocky structures!

Bligh's Bounty Box comes with its own set of colouring pencils.
For younger visitors the invitation to draw has proved irresistible! 4

Bligh's Bounty Box 3, etching, gouache and letraset, 24 × 62cm.

COLOUR

The first few times we proof a plate it makes sense to print with black ink to see exactly how the plate is progressing. No matter which etching techniques have been used to get to this point the marks and tones are clearest when seen in plain black and white.

Once we have got to a certain point in the image-making, many of us then want to start thinking in colour. We can of course print any plate in any colour we choose. A single plate can be printed in blue or red, or lime green. This is fairly straightforward. But if we want a combination of different colours, we then have to plan our plate-making in different ways.

It is possible, using all of the techniques so far covered, to print a single plate in several colours. It is also possible to print several plates, each containing several colours, on top of each other to produce an infinite variety of colours and tones. We can use simple collage techniques to bring in further possibilities, print negatively or even remove all ink from the printing process and rely simply on the physical nature of the printing process to produce our image.

Before embarking on making plates intended for making colour prints, it is worth knowing that some metals print colour more cleanly than others.

Applying a coloured etching ink to a zinc plate can give you a muddier result than the same colours on copper, due to the chemical reaction between the ink pigment and the metal plate. Steel prints colour cleanly and brightly. It is possible to buy and etch steel plate but it is noticeably heavier than other metal plates and it is less popular in communal studios because of the need for a separate etching bath. Although a completely steel plate is rarely used these days it is possible to have an etched zinc or copper plate coated with a fine layer of steel. The benefits of steel facing (electro-plating) are that the etched image will last longer and give you more prints; also that it will print colour cleanly, bright and accurately (*see* Chapter 1 for more details regarding metals). However, steel facing is expensive and it can be difficult to find a company that treats your plate with care, rather than as if it was simply a household utensil.

Colour printing techniques

À la poupée printing

The term itself refers to the small 'dollies' of scrim, which are rolled and wrapped together and used to ink the plate, one 'dolly' per colour. This makes it possible to ink up one plate in several different colours. The method below explains how to apply three colours to one etching plate. With practice you may be able to include more colours, using a whole family of different sized 'dollies'.

Materials and equipment

Etched plate

Small strips of scrim to make inking dollies

Masking tape

Coloured inks

Clean scrim for wiping, one for each colour

Method

Firstly make one dolly for each ink, as shown here.

To make a dolly for inking a small area, cut a rectangle of scrim.

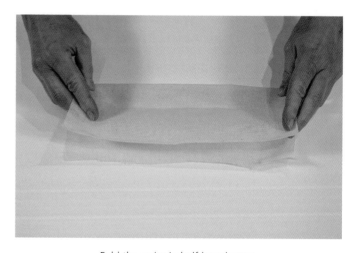

Fold the scrim in half lengthways.

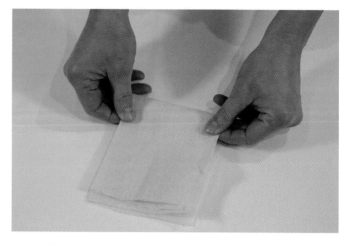

Fold the length of scrim widthways in half and half again.

To print using your dollies, start with the smallest area of colour. Dip the tightly rolled dolly end in the ink and apply it where wanted. Wipe the inked area with scrim and tissue or hand-wipe if desired.

Use a second dolly to ink up a second colour area. Wipe this with a separate piece of scrim. Repeat for the third colour.

Start to roll the folded scrim tightly and evenly.

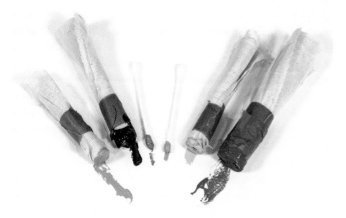

Fasten the rolled dolly together with a strip or two of masking tape.

A family of dollies for different areas of coloured inking. The smaller the area, the smaller the dolly.

The red ink was mixed and applied first with a dolly and wiped. The black was then inked around it in the usual way and wiped to blend with the red.

This stage proof was inked *à la poupée* in a lemon yellow mixed with extender for translucency. The second ink was mixed from Payne's grey and silver with a small amount of extender to fit the overall tone.

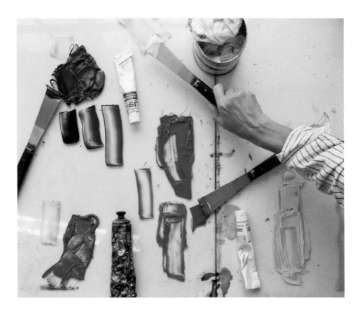

Mixing colours with extender adds translucency. This can give an image an entirely different look and feel.

This method means that all three colours are blended together where they meet. Hopefully these blends are interesting and make sense within the image. If, however, they do not, you may have to think about how best to keep a space between each colour so that they can be wiped cleanly. This means pre-planning the plate-making to some extent.

Chine collé

Chine collé is a way of incorporating colour or pattern into your prints through a type of collage. A thin paper is coated in a glue paste and laid onto the inked etching plate, glue side up, before the damp paper is laid on top and the whole is run through the press. When the print is peeled away from the plate, the inked lines are on top, the *chine collé* paper behind, and both are one with the surface of the printing paper.

The collage paper needs to be both thin and absorbent for it to stick to the printing paper properly. Papers that work well include Japanese tissues and patterned papers, Indian khadi papers, thin 'end papers' intended for book making, and some newspapers, although it is worth checking the viability of the particular newspaper you have in mind as some modern newspaper inks completely resist the starch paste.

Chine collé was first introduced as a way to provide a backing colour behind a stone lithograph where the image, generally a portrait, had no edges or boundaries. The image seemed to float on the paper. By using a cut square of paper to sit behind, the image then had a picture frame within which to sit. Etching obviously has the plate mark to create the image boundary, but *chine collé* is a subtle and relatively quick way of backing the printed image with colour, texture or pattern.

The same technique can also be used to provide a small area of colour within the image, with torn sections of *collé* paper providing a looser, slightly random element to an image. Newspaper images can be an exciting addition, bringing a completely different visual language into the work. Remember, though, that newsprint does not have a long shelf life and can fade quite quickly.

Japanese rice paste or bookbinder's wheat starch are the recommended glues. An affordable and very effective alternative is non-fungicidal wallpaper paste. Avoid PVA as it throws up too many problems.

Materials and equipment

Rice paste in a tube or non-fungicidal wallpaper paste in a sealable jar

Thin chine collé *papers cut or torn to the required size*

Old credit card

Small stack of clean newsprint pieces larger than your chine collé paper

Spray bottle of water

Inked etching plate

Template and tissue paper ready for printing

Prepared, damp etching paper

Scalpel

Method

As damp etching paper stretches slightly when printed through the press, it is best to dampen the *chine collé* paper before printing. This way the two papers stretch together. Most papers used are too fragile to take much soaking so instead you can use a spray bottle to spray half the sheets of clean newsprint lightly with water and one at a time interleave these with dry *chine collé* pieces. Place a heavy board on top of the pile and by the time you are ready to use them the *chine collé* pieces should each be the right consistency and dampness.

Alternatively, interleave the *chine collé* paper between the damp printing sheets, after any excess water has been removed. This will mean that they are both equally damp and are easier to handle. If you try damping or sponging thin papers just prior to printing, they have a tendency to curl and are difficult to handle.

Ink your etching plate and place it on the bed of the press.

Take the dry pieces of newsprint to use as a clean surface for applying paste. Remove a piece of damp *chine collé* paper from the stack and lay it on a dry sheet of newsprint, with the back side uppermost.

Take a little of the starch paste on the credit card and scrape the card from the middle to the edge of the *chine collé* paper, repeating all the way round until the sheet is covered. Be careful not to move the *collé* paper around, otherwise the paste can find itself on the front of the sheet. This will stick it to the plate, rather than the paper.

Lay the pasted paper with the sticky side uppermost on the etching plate.

Lay the damp etching paper carefully across the whole etching plate, cover with tissue and run it through the press as normal.

With a little more care than usual, peel the print away from the etching plate. If the *chine collé* paper sticks a little to the plate use the scalpel to encourage it to lift with the rest of the print paper. After a brief pause for admiration, flatten the print immediately under tissue and weighted boards.

Chine collé. When you have mixed a small amount of wallpaper paste, ink up your etching plate.

Spoon a small pool of paste onto the back of the *chine collé* paper.

Use the plastic card to spread paste from the centre out to the edges.

Keep spreading paste from the centre to the edges until the sheet is coated with a thin, even layer.

Carefully place your pasted paper on the inked etching plate with the sticky side uppermost.

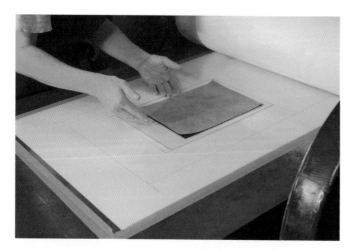

Place your plate on the bed of the press with the pasted paper on top.

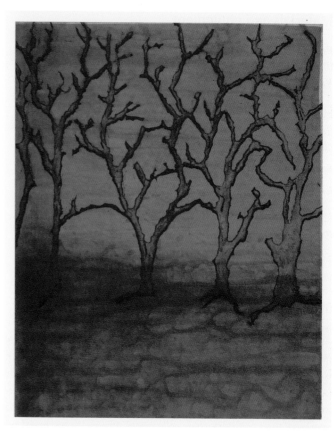

Run the plate through the press and very carefully peel your print away from the plate. The coloured chine collé paper will sit behind with the etching on top.

For the adventurous who are using multi-plate printing, you can try putting different papers on different plates, inked up in different colours. Registration for printing with more than plate is explained later in this chapter.

Rollover inking

The rollover is very straightforward and, as the name suggests, is simply an ink which is rolled over the plate. This ink sits on top of the plate, while any colour that has been inked into the etched lines of the plate will sit below. This means that if we get the ink consistencies right the etched colour will be seen through the flat colour of the rollover.

If you want to print a line etching with a foreground of flat colour you could try this technique, using both the intaglio and relief (surface) possibilities of a single plate.

Materials and equipment

Etched plate

Etching ink of any colour

Applicator for etching ink

Scrim

Relief ink of different colour

Spatula

Extender

Large roller for relief ink, if possible slightly wider than the etching plate and thick enough in diameter to cover the whole plate in a single rotation

Damp paper

Method

Apply the etching ink and wipe the plate with scrim as usual. Then follow the steps below to roll out and apply relief ink. If you would prefer the ink to be more translucent, add extender.

You can develop this further. Try cutting a 'mask' in thin newsprint paper to cover part of the plate. Ink the plate up intaglio and wipe it as usual. Lay your newsprint mask on the chosen area after you have inked intaglio and before you roll over with relief ink and print as usual. The etched marks will show clearly where the mask has prevented the relief colour from covering the plate.

This mask may have a secondary use, depending on its shape and fragility. If you leave the plate with the ghost image on the bed of the press you can use a scalpel to carefully lift the newsprint mask. If you flip the mask and replace it on a slightly different area of the plate and print you should get the ink offsetting from the mask against a background of the ghost image.

The following pictures show how the ink is rolled across the surface of the inked etching plate in just one movement to create the print.

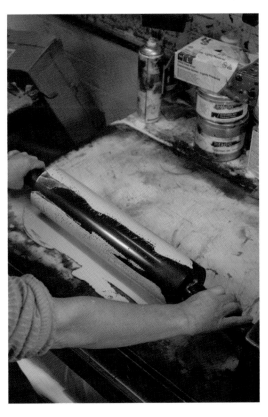

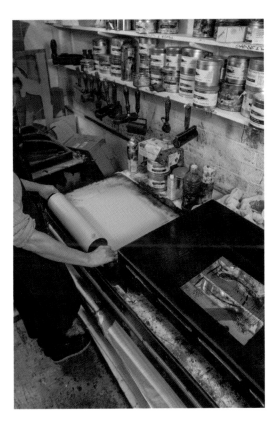

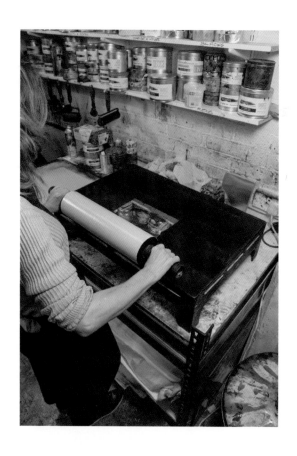

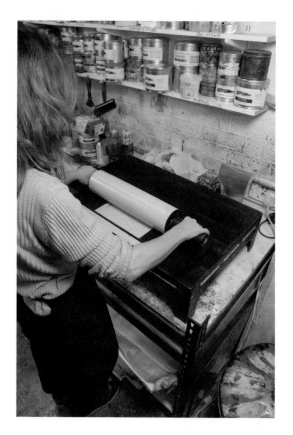

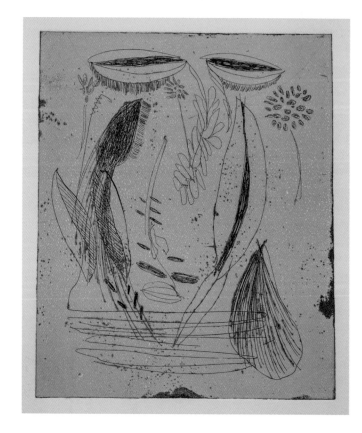

Multilevel viscosity printing (Hayter method)

This is a very particular use of a rollover technique, again using both the intaglio and relief (surface) possibilities of a single or multiple plates. Developed from the 1930s onwards by Stanley Hayter in his workshop Atelier 17, the aim is to use inks of different viscosities, which either resist or adhere to each other because of their consistency. Hayter developed his techniques throughout his working life so there is much to read on the subject if you would like to take this further. Here just the basic principles are described.

The three main factors for successful viscosity printing are the different levels etched in distinct areas of the plate, the relative viscosities of the inks mixed, and the hardness or softness of the rollers used.

In multilevel viscosity printing, the shortest, stiffest ink is applied first and wiped hard as for an intaglio plate so the colour sits in the deepest grooves and leaves no plate tone on the surface.

A thin ink of a second colour is rolled with a hard roller over the top to sit on the plate surface.

After this a third, much stiffer ink is applied with a soft roller so it sits in the lower areas of the plate but resists the first rolled ink as a result of the difference in viscosity. The hope is that in the final image the three inks print as separate colours.

To take these factors one at a time, a plate etched as evenly and cleanly as possible will help a viscosity print to work well. Clear separation of the colours will be easier if the etched areas are clearly defined as separate from the un-etched surface.

Secondly, the inks will need extra preparation. Most inks are a medium viscosity when they arrive. These can be stiffened with magnesium carbonate or thick plate oil; alternatively they can be loosened with thin plate oil.

Thirdly, large relief rollers can be hard, soft or medium. A hard roller will lay ink down on the relief or top surface of the plate whereas a soft roller can lay ink not only on the top surface but will reach down into the etched areas too. If a medium roller is introduced into the mix the range of possibilities is increased.

This is a technique that requires considerable time and commitment in order to be able to make consistent and reliable results, but they have such a particular appearance that for many printmakers they are well worth the investment of time.

Traditionally associated with quite abstract work, such as that made by Hayter himself, this kind of technique could be used for a range of imagery. There is more information in Hayter's own book *New Ways of Gravure*.

Multi-plate printing

One way to increase the number of colour options available is to increase the number of plates used to make a single image. If you have two etching plates the same size and thickness, each one with three colours on, you can imagine that by overprinting one on top of the other, the resulting print will have a mass of colour and tonal variety. Imagine then a third or even fourth plate with each one carrying three colours. We then have the possibility of changing the plate order, changing the colours and changing the transparency or density of each colour. The possibilities are almost boundless.

We do, however, arrive at the same point as anybody who uses Photoshop to alter an image and first discovers the filters button: there are thousands of potential possibilities, many of which may be interesting, but we have to decide on a single option and that may not be so simple.

The first practical issue we have to deal with is how to register the separate parts of an image split over several plates. The easiest way I can think of explaining how to go about this is to find an image we are all familiar with and break down how to make this into a multi-plate etching.

If we imagine a national flag, one that has clear, sharp distinctions between very different colours, each must be very clean and precise. We could not consider making this as a single plate etching because the colours would blur and smudge together and lose the clear, distinct graphic outlines.

By splitting the image over three plates, we can print each plate in a single colour allowing for the colours to be clean and precise. By printing each plate on top of the next until all three are printed, all of the colours are as clean and precise as the original flag.

There are a number of ways of approaching the main technical issue of how to register each plate to the other; the method described here is simply the one I find easiest and most accurate.

Registering plates for multi-plate printing

Materials and equipment

Plates

Registration blocks

Printing paper

Black ink

Method

To register several plates together, we first must get each of the plates, of the same thickness, cut to the same size.

Then etch the first plate; choose the part of the image that contains most of the structural information. It needs to have all of the main areas of the image clearly delineated. This is often called the 'key' plate. This can be made in any technique but you do want it to print well, ideally solid black.

Degrease the remaining plates.

Print the key plate on paper which is slightly longer than you would normally use, but do not remove it from the press once it has gone through. You want to keep the edge of the paper 'pinched' under the etching roller, so that the paper is held in place.

Carefully peel back the paper, without disturbing the plate. Place the registration blocks along two edges of the plate, without moving the plate.

Remove the plate and replace it with the first of the cleaned and degreased plates.

Remove the registration blocks and run the print and new plate back through the press.

Once it is through, keep the paper 'pinched' again under the roller and lift the paper. What you should see is a ghost image of the first plate on the second plate.

Use the blocks again to register the second plate, which is then removed and replaced by the third plate.

At the end of the process you should have three plates, the first with the key drawing etched onto it, the other two with ghost images of the image, strong enough to use as guides for stopping out for the second and third plate colours.

It is very important that you mark which sides you placed the registration blocks and in which order they were printed. Paper stretches during the printing process and we need to be able to control this if we want all the plates to sit comfortably on top of each other.

Once you have etched the second and third plates you will want to take a proof. Register to the same edges and print in order. Generally speaking this means printing the second plate first, followed by the third and lastly the first 'key' plate. This is because the first 'key' plate you made is the one that normally has the most information on it and tends to be the darkest colour.

When you are planning a multi-plate print, think about which colours should be printed first and which overlaid. As a rule of thumb, lightest tones tend to be printed first, with the darker layers building the image up. The final plate tends to be the darkest, which also helps to tie the whole image together. If we look at commercial four-colour printing, known as CYMK and used to print magazines and posters, it is printed in a set sequence, yellow, red, blue and lastly black. This is going from the lightest tone, through the mid tones to end on the darkest. Multi-plate etchings quite often follow the same idea. This is to allow the overprinting to create as many variations as possible. This is not a set rule but simply a starting point; individual images may require changes to this sequence.

Registration blocks are sections of solid steel bar around 5–8 cm square. They are heavy and cut to a clear, straight edge.

If registration blocks cannot be found, it is possible to simply mark the bed of the press with a thin permanent marker. It is not as accurate but can be a perfectly acceptable alternative.

Printing multiplate prints

Materials and equipment

Etching plates

Various coloured inks

Extender ink

Inking spatulas

Scrim

Printing paper

Tissue paper

This version of the plate was trialled in different colourways.

In this variation just one plate was used. The etching was inked in Payne's grey then relief ink was rolled over the top. The rolled ink resisted the intaglio ink.

In this variant, two etching plates were inked up and overprinted. The first (backing) plate was printed in silver; the second (top) plate was overprinted in Payne's grey using registration blocks.

This is the ghost print of the first two. The plates were retained without re-inking and overprinted again.

Method

Printing multi-plate etchings with coloured inks is in some ways no different from printing single plates in black. Ink is applied to either the whole plate, or in specific areas with each different colour. Then it is wiped back with scrim, tissue and perhaps hand wiped with chalk or whiting.

Prepare the inks, mixing the specific colour and adding either white, which will make the ink more opaque, or extender base, which makes the ink transparent.

Coloured inks are generally softer than black inks and so generally do not need any modification with copper plate oil or tack reducer.

Once you have inked up all of the plates and prepared the press, paper and registration blocks, place the first plate on the bed, put the paper on and run through the press, remembering not to take the paper all of the way out.

Once through, lift the blankets and paper, making sure that it is pinched under the roller. Without moving the plate (you sometimes need to put a firm hand on the plate to stop any movement) place the registration blocks at the plate edges. Remove the plate and replace with the second. Remove the registration blocks, drop the paper and blankets over the plate and roll through the press. Repeat for as many plates as you have.

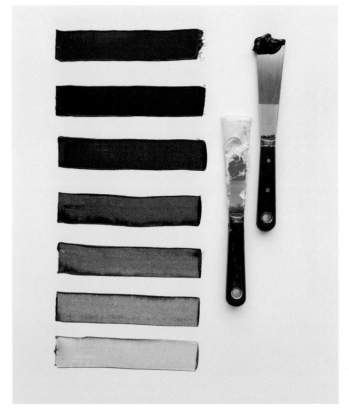

The black ink at the top has had extender added gradually to make it increasingly translucent. The bottom stripe is about 95 per cent extender.

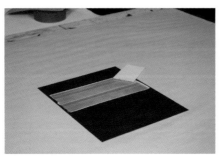

Apply ink to the backing plate.

For this particular print a second colour is applied to the same backing plate.

Wipe each colour with a separate scrim.

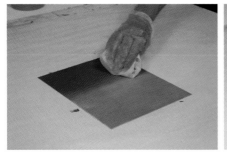

After wiping each colour individually, gradually wipe the blend between the two areas.

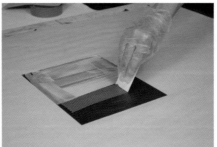

Ink and wipe the second plate.

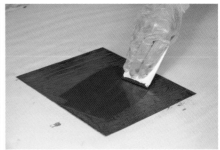

Finally ink and wipe the top plate, which will be printed last.

Place the first plate on the bed of the press. Lay your long, damp piece of paper on top and run the plate through the press, keeping the paper pinched under the roller.

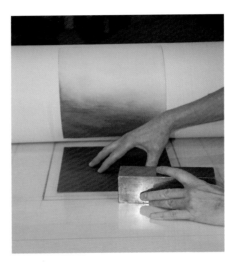

Use one hand to hold the plate still and with the other slide two registration blocks along one end edge and one side edge.

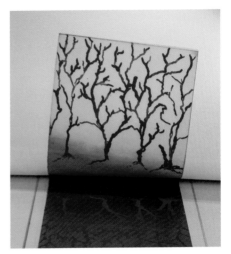

Remove the backing plate and replace it with the second plate. Remove the registration blocks and print.

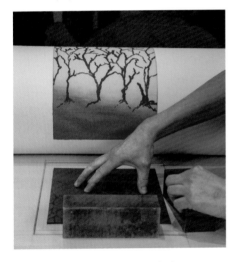

Run the second plate through the press, again trapping the paper under the roller. Slide registration blocks into place along the top and side edges.

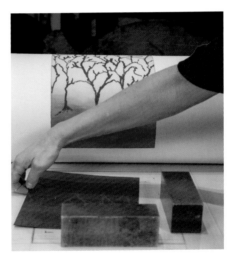

Lift the second plate out from the registration blocks.

Swap the second plate for the third.

Remove the registration blocks and run the plate through the press.

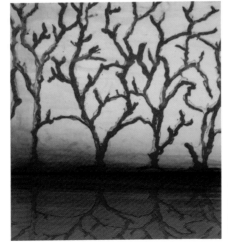

The third colour lies across the entire print and pulls the image together.

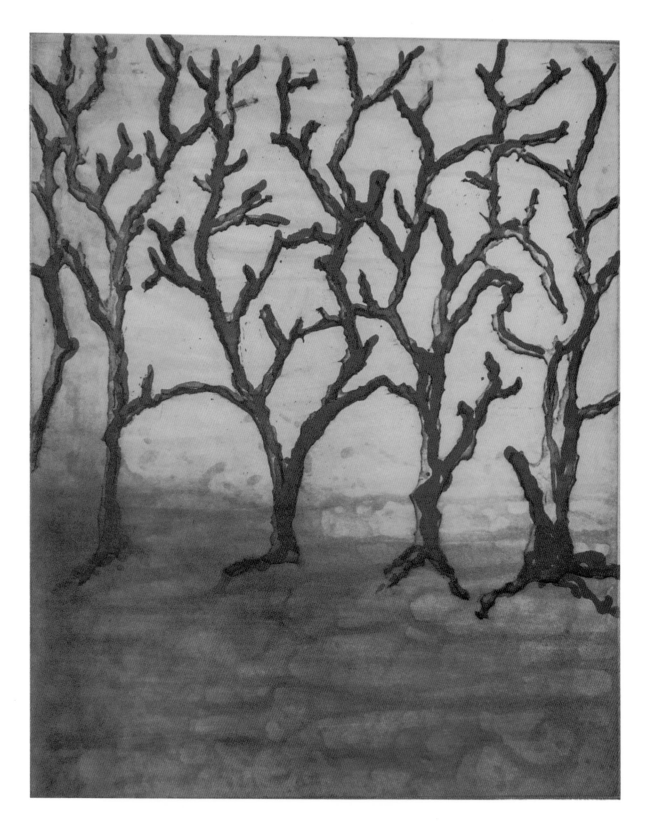

Ann Norfield, *Warm Mist Rising – 2*. Multiple proof using copper etching plate in combination with two registered backing plates made with photopolymer (*see* Chapter 8).

Warm Mist Rising – 3. The last plate was printed again without reinking.
The remnants of all three plates are held in this 'ghost' image.

Printmaking tends to be thought of as a means to make a single, definitive version of a particular idea or image but it is also possible to use the process as a way of throwing up the unexpected. With multi-plates, all except the first can retain 'ghost' images of the previous printed plate, as there is residue of the ink left behind. Sometimes these variations provide valuable ideas. Try taking a print of the backing plates without re-inking, or re-ink one plate and print with the ghosts of the others. Sometimes you find a new version of the image in this way. Take all opportunities to surprise yourself with what you have done, but may not yet see.

This image comes from a series of prints entitled *Outtakes*. Using badly taken photos as source material I drew and etched twelve plates of people and places and overprinted them in different combinations.

A blue ghost plate was printed first, then masked with a tiny piece of tissue over one eye of the figure in the backing plate. When the second plate was overprinted in orange the blue shone through clearly.

Different plate combinations in different colours of various strengths threw up a range of effects. Dozens of prints were made from the same twelve plates.

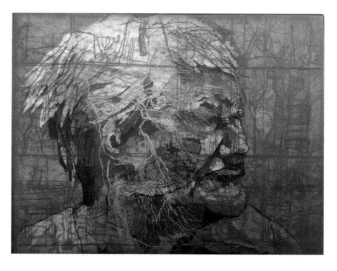

There are five different plates in this image. Each plate was inked up ready and registered one at a time for overprinting.

Embossed prints

Finally, there is also a technique that uses no colour or ink at all. A deeply etched plate is run through the press with damp paper on top to print what is known as a 'blind emboss' or 'inkless intaglio'. The image is created with the hollows and shadows of the relief on the paper instead of with ink. A debossed print uses the same technique but the paper is turned over so the relief is concave rather than convex.

It is possible to print an inked plate then follow this with a carefully registered un-inked plate to emboss part or all of the image. This can be a subtle but exciting effect. If the un-inked plate is smaller it will intensify particular areas; if larger it will extend the image out beyond the 'frame' of the plate. If the inked print is already dry it can be re-dampened and either embossed or debossed subsequently.

Embossed print. There are many ways of going about an emboss. The image is created through the texture on the paper, so a deeply etched plate is often used. For this particular image, old etching plates were cut up and reused. Firstly, the plate pieces were put on tissue on the bed of the bed of the press. The plate pieces were covered with a second sheet of tissue and damp printing paper and the whole arrangement went through the press.

When the paper is peeled back you can see how the smooth emboss contrasts with the velvet finish of the paper.

In an alternative version the plate pieces were turned over, inked up and printed.

Pressure is also an important factor for consideration. Because the information in the image will all be held in the relief of the plate you may need to increase the pressure a little to emphasize the dips and hollows. The best way to do this for an emboss is to lay a sheet of foam rubber over the plate, damp paper and tissue before laying the usual felt blankets on top. A 2–3cm foam sheet should compress as it goes under the roller and give that extra little pressure to the deeper areas of the plate.

Drying a blind emboss print requires some extra care and attention. The problem here is that you want the paper to dry flat but the emboss to remain in the middle. There is a method that will help with this.

Materials and equipment

Sheets of blotting paper (two or three per print with more to replace as they absorb water)

Plastic sheet large enough to drape across entire stack of prints

Light board such as millboard

Method

As you pull each print from the press, lay it on a sheet of blotting paper and cover it with two or three more. The blotters will help keep the prints flat without extra pressure in the first instance.

Lay a sheet of plastic over the prints in their blotters to help prevent the edges from drying much sooner than the centre. Change the blotters every few hours.

When the prints are almost dry, lay a lightweight board on top. By this stage the emboss will be substantial enough to withstand a bit of pressure and the board will help the print edges to dry flat.

The method is as for printing any etching plate (just without the ink) but there are some extra ingredients for consideration. The first of these is that the deeper the etch, the stronger the emboss will be. You will want to leave a plate in etching solution much longer than usual to bite it more deeply. You could draw into hard ground and wipe away areas of ground so they open bite. If you keep an eye on the hard ground to check regularly for foul bite and stop out areas where you think the ground may be breaking down you could leave the plate in the etching solution all day (then re-ground it and repeat the next day if you want to).

Paper is an important consideration when embossing a plate. Thinner papers tear easily when they go through the press because the relief of the plate is so pronounced. A thick paper will withstand the pressure and will hold the emboss well afterwards.

Printing with colour, whether it is with single or multiple plates, using *chine collé*, collage, rollovers, viscosity or any other variant you can find, is not a singular choice. It does not have to be one or another but a combination of any number of the different approaches described. You can use plates made with hard and soft ground, aquatint and drypoint as well as photographic, carborundum or monoprint (all described in other chapters). In other words, colour is simply another part of the whole mixture of techniques and approaches that can go into making a print.

In a nutshell

1. Find optimum exposure times for your UV unit.
2. Expose positive onto plate.
3. Expose random dot 'aquatint' screen onto plate.
4. Wash out and set your image.

Materials and equipment

Pre-cut photopolymer plate, still in its original non-permeable wrapping

Positive printed or drawn on clear acetate film

UV exposure unit

Aquatint screen

Etching tray larger than your plate

Warm water

Soft scrubbing brush

Sheets of clean newsprint for blotting

Electric fan

Method

Find and set the optimum exposure time for polymer plates for your UV unit. Unwrap the polymer plate and place it on the bed of the exposure unit. Peel away the thick protective acetate from the surface of the emulsion. (This is worth keeping as it is usually thick enough to use another time.)

Remember that your plate will eventually print a reversed image, so turn it over before laying it carefully on the plate.

Close the lid of the unit and switch on or otherwise engage the vacuum pump. This removes all air from between the unit and the glass, pulling the positive film in close contact with the plate. If there were any gaps then light would seep underneath and the printed image would look blurred and fuzzy.

Switch on the UV lights and set the timer to the optimum exposure time.

Different units have different methods of engaging both the vacuum and lights and units of calculating time. Whichever methods are used, keep a record as you may sometimes want to alter them a little based on the image you have. Sometimes your positive may be a bit weak, so a reduction in exposure times is useful. Sometimes it may be very strong and you want to bring out some of the tonal marks in a very dark area and increasing the exposure time can help draw these out. Nevertheless you need a base figure from which to work, otherwise you will waste a lot of plate trying to find the optimum exposure times for a particular image.

After the image has been exposed there will be blank 'white' areas on the plate where the positive blocked the light and the emulsion is still unexposed. To create tone in these (and therefore enable you to print them as black and greys) you now need to expose a random dot onto them using an aquatint screen.

To do this, remove your positive and replace it with the random dot screen. Set your timer to approximately half the time for which you exposed your positive. Run the exposure unit for this new time following the same procedure as before.

Fill a tray larger than your plate with lukewarm water and put on thin gloves. Open the exposure unit. Lift the random dot screen away and take your exposed plate to the tray of water. In the first instance this will soften the emulsion where it was protected by the image.

Using the super-soft brush, gently wash over the entire surface for 2 or 3 minutes.

Very quickly you should see the image, especially the darkest areas, show through as a milky white substance is released from the plate. Keep washing with the soft brush for the entire few minutes.

After persistent brushing in tepid water, rinse the plate in cold water. This helps the emulsion to set a bit. Immediately blot the plate using clean newsprint as this will avoid unwanted watermarks. If the newsprint sticks a little to the plate do not worry. Any residue left behind from the newsprint can be gently washed off with cotton wool and cold water.

Place the plate in front of a warm fan to dry and harden it a little. Once the plate is completely dry, put your plate back in the UV unit and expose it again for approximately double the original image exposure. This hardens the coating on the plate, protecting it and giving it greater longevity.

Cutting photopolymer plate

For your first plates it is probably best to buy pre-cut photopolymer. If you continue working with photopolymer you may want to economize and buy larger sheets to cut up before exposure, or you may want to expose an image with crop marks for registration and then cut the edges before printing.

Polymer plates are usually cut on an ordinary guillotine. However, this can be tricky if your guillotine is designated for metal plate as the blade may perversely bend the polymer edges instead of shearing cleanly. A strong card guillotine may cut polymer better. Practising on offcuts is a good way to test your cutting without too much frustration.

Process them as below and print them all to find out how long you are likely to need for your proper plate. It is a good idea to keep prints of the test plates with recorded timings for future reference.

In a nutshell

1. Degrease a your plate and coat it with photo emulsion in a dark room.
2. When the emulsion is dry, expose your positive.
3. Wash out the soft emulsion and clean the exposed areas.
4. Degrease the exposed areas and apply an aquatint.
5. Remove the photo emulsion.

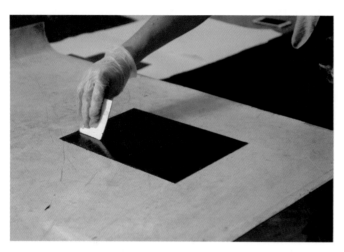

A photopolymer plate is light, so placing it on a magnetic mat for inking and wiping will make your task easier.

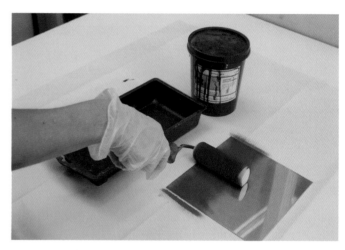

To prepare a plate for photo etching degrease an ordinary etching plate 24 hours before you need to use it and take it into the dark room for coating.

Photo etching

Photo-etching plates can be bought pre-coated, or tubs of emulsion can be bought and the plates hand coated when needed.

Much of the processing for exposing a photo etching is similar to that used for photopolymer. The main difference is that you roll on an etch-resist photo emulsion yourself. This is an acrylate resin or polymer coating that can be applied with a paint roller.

The exposure times are also different from those for photopolymer and need to be worked out using a similar approach to the polymer plates. To gauge more exactly what will work for you it is best to coat two or three small test plates the day before and expose these for different times.

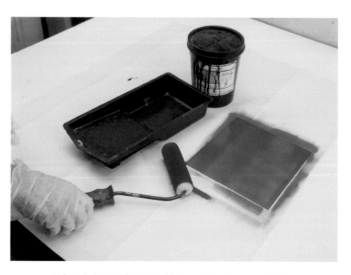

When it is evenly coated leave it to dry overnight in the dark.

Prepare your image. The image below was derived from the photo above. After the colour was removed and the brightness and contrast heightened, the whole image was bitmapped in Photoshop.

The bitmapped image was printed on acetate on a home printer.

Materials and equipment

Degreasing materials

Newsprint

Copper or zinc plate, filed and polished

Photo emulsion

Gloves

Small paint roller intended for applying gloss to radiators

Roller tray

Clean, dry etching tray bigger than your plate

Tray bigger than your plate in which to wash it out

Warm water

Soda crystals (used for hand-washing fabrics)

Cotton wool

Method

Although the process for photo etching is quite straightforward it is worth reading through the more extensive notes below for further details before following the method explained here. Note that you will need to set aside 24 hours between coating your plate and exposing it to allow it to fully dry.

Degrease your plate thoroughly as usual. Rinse and blot it dry with a sheet of clean newsprint, being careful to remove any chalky residue from the surface of the plate.

Lay down a newspaper to protect the work surface and place your degreased plate on it.

Using gloves for handling the photo emulsion, open the container and pour enough to coat your plate into the roller tray. Roll the emulsion in the tray until the roller is evenly coated, then apply it in a thin, even layer to your degreased plate. The coating should be quite thin and it may appear uneven from the roller marks. These tend to disappear as the emulsion dries.

Leave your plate to dry overnight or, if still not dry, use a warm air fan to speed the drying up. Different emulsions take different amounts of time to dry in different circumstances but if you allow 24 hours between coating and exposure your plate should be dry. In a dusty environment you may have to protect it with a covering such as an inverted, dry etching tray, to stop dust affecting the surface. It should be left to dry in a darkened space for, as it dries, it becomes more light-sensitive.

After a day drying the plate will be very light
sensitive. Place it on the bed of the UV unit, and lay
your reversed film on top.

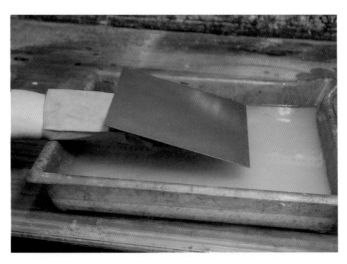

While your plate exposes, prepare a washout solution for
developing the plate. Dissolve washing soda in the ratio
of one tablespoon of crystals to a litre of warm water.

Use a wad of cotton wool to work the entire plate until
the emulsion starts to lift to create a photo stencil.

Even when the emulsion appears to have dissolved it is
important to carry on gently rubbing the plate as photo
emulsion can leave an invisible residue behind.

Exposing your positive image

The instructions for exposure are similar to those for photopolymer, but obviously using times chosen for this material.

Remember that your plate will eventually print a reversed image. Take your positive and turn it over before laying it carefully on the plate. Make sure your film is touching the emulsion across the whole surface as a gap between the positive and the plate will allow light to seep underneath onto the emulsion and give a blurry edge to your exposed image. During the exposure the vacuum will help compress the positive and plate still further.

Using your test plate timing as a guide, set the timer for your exposure and start the machine or switch on the lights. If you have blackout curtains pull these immediately and fasten them shut.

Prepare a washout solution for developing the photo emulsion by dissolving washing soda crystals in a tray at the ratio of one tablespoon per litre of warm water. Make sure the soda crystals are fully dissolved before removing the plate from the exposure unit and immersing it in the tray. Using the wad of cotton wool, gently rub the surface to remove emulsion from the exposed areas. This is worth spending some time on as the emulsion can leave an invisible residue, which will inhibit the development of the plate if allowed to remain on the surface.

When the exposed areas are completely clean, remove the plate from the tray and rinse it off with clean water. Blot it dry it with clean newsprint.

This is the point at which the difference between a photopolymer plate and a photo-etched one becomes really apparent because now you can change your plate in whichever way you see fit.

The most popular approach is to degrease the exposed areas of your plate and apply aquatint, as described in Chapter 6. The photo emulsion acts as an acid resist so only the aquatinted areas etch. Remember to stop out the back of the plate before you etch. By biting the aquatint in short steps you can develop a subtle range of tones by manual rather than photographic means.

You could stop out the back of the plate and open bite the exposed areas deeply. These you could aquatint or possibly even leave rugged and bare in preparation for a relief roll of ink across the surface to create a negative image.

You can treat the hard photo emulsion as a kind of hard ground. It is possible to draw into it with a very sharp etching or drypoint needle and etch them. You can then move on to aquatint these along with the exposed image, stop out the back and etch.

Once you have finished etching your plate remove the aquatint with methylated spirits. There is now one final step: to remove the photo emulsion and print.

Materials and equipment

Gloves, mask and goggles

Good ventilation

Caustic soda crystals

Tray of hot water

Method

This is the biggest drawback of using this kind of photo emulsion. In order to remove it from the plate to enable further etching to take place, the coating must be removed using a strong solution of caustic soda. To make it work relatively quickly, the solution must be made using hot water. This is not a very comfortable combination and health and safety precautions must be taken. This is to protect you and also colleagues working nearby.

Before you even begin, switch on the ventilation and put on a mask, goggles and robust gloves (not disposable gloves). Carefully add one heaped tablespoon for each litre of hot water to the tray and allow it to dissolve, gently agitating the bath to make sure all the crystals are dissolved before you put the plate in.

Carefully place your plate in the caustic solution and leave. You will need to agitate the tray gently to encourage the emulsion to dissolve. After a while you will see it start to lift. You can help the process along by using an old soft brush.

When the emulsion has all gone, remove the plate and rinse it thoroughly in cold water. Pour the caustic solution away and rinse the sink thoroughly, along with all the equipment that has come into contact with it. Finally you can remove your goggles, mask and gloves.

Once the whole process is complete, you will have a plate with a photographic image aquatinted and etched on the plate. You can then proof the plate as normal, or re-ground it with any of the traditional processes, add more aquatint, drypoint or any combination you feel necessary to take the work forward.

This proof from the photo etched plate was printed after aquatinting. The strong blacks and whites created in the bitmapped image used as a positive have printed well. Although it lacks the tonal nuances of a photopolymer print the metal plate can now be treated and developed using any traditional etching technique.

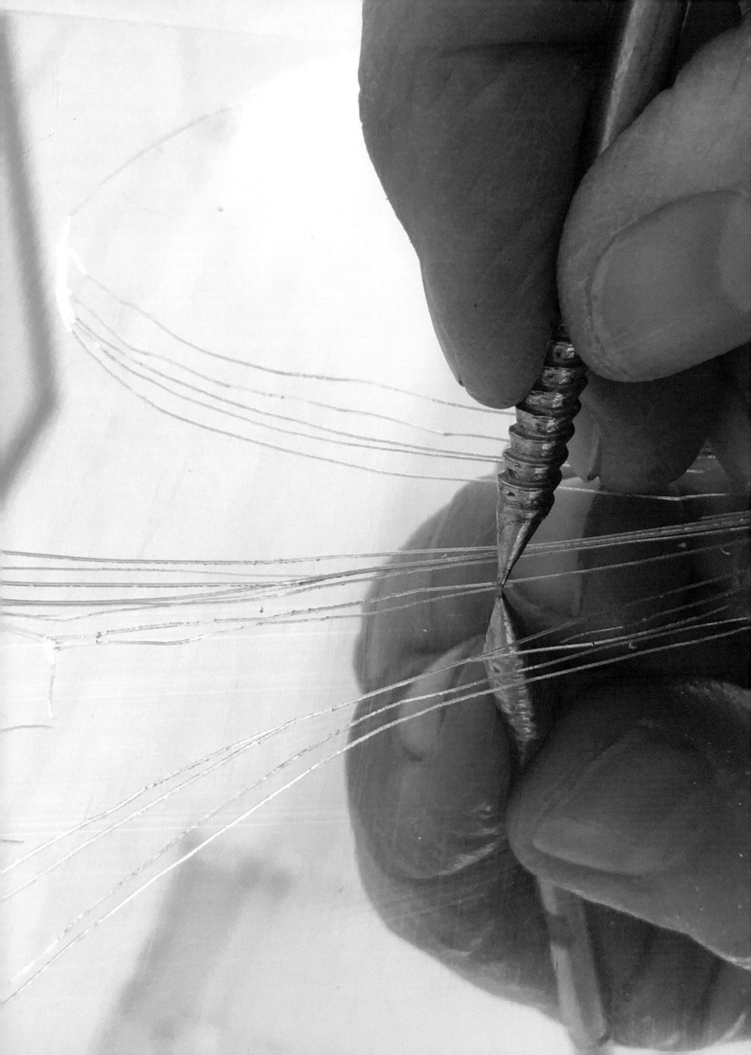

NON-ETCH AND EXTENDED TECHNIQUES

Until this point, all the techniques described have required the use of an etching solution to bite your drawing into the plate. This chapter explores how other non-etch techniques can be incorporated into your work. There is often an immediacy to the images produced simply because the plate-making can be quicker in comparison with the pace of etching.

Non-etched plates can either be printed alone or in combination with etched plates using multi-plate registration as described in Chapter 7. The results can be unusual and intriguing prints.

Drypoint

When lines are incised directly into a plate with a sharp metal pointed tool, the technique is called drypoint. The drawing tool does not remove any metal, but instead displaces it, like a plough through the earth. The scraped metal sits beside the incised line, forming a raised burr. This burr holds the ink both within the line on the plate and also around the burr itself on the surface of the plate, so giving the line a dark velvety quality, coarser in appearance than the etched line, but one that provides drypoint with its characteristic look.

You can use all of the main metals for drypoint; however, some are better than others. Zinc, for example, is relatively easy to work directly into with a drypoint tool, but it tends to break down quickly when printing. The pressure of the press flattens out the burr, so limiting the number of prints that can be taken off before the image noticeably deteriorates.

Copper is the softest to work into and so is much easier to handle in terms of a natural drawing style. Even the lightest of marks will print. However, as it is so soft the burr is flattened very quickly under the pressure of printing. With copper you will generally have to steel-face the plate to protect it. A steel-faced plate allows for a much greater number of prints but is inevitably not something everyone can afford or have access to.

Steel is so hard it is almost impossible to drypoint in any traditional way. Nevertheless, solid steel offers a great opportunity for vigorous drypoint with the aid of power tools.

Aluminium is the softest and easiest plate to use: it takes working the surface well and can provide both subtle qualities of tone and line, as well as robust, gestural and darker mark making. It does break down quickly but is cheaper than other metal plates. Used lithographic printing plates are a very good source of material and are a very easy and accessible starting point for drypoint.

Perspex and other plastic or composite materials can also be used. Clear Perspex or acrylic sheet also has the added advantage of being able to be placed over a drawing or photograph, which will then provide a guide – but remember the print will be reversed.

Materials and equipment

Filed and bevelled plate

Drypoint needle

Used scrim covered in black ink

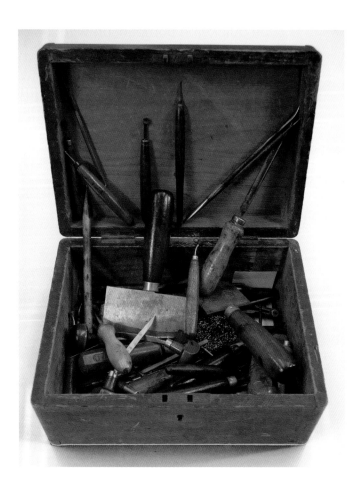

Drypoint tools from left to right: screw, 5mm drypoint tool, steel drypoint needle, scribe.

Method

A traditional drypoint needle has a hardened carbide steel or diamond point but, with practice, you could use almost anything made of steel and pointed. Alternatives to try could be a long nail with a sharpened point, industrial tools or steel brushes. These will require a more vigorous approach to plate making but can be very exciting additions to your drypoint tool kit.

For initial outlines on your plate you will need drawing materials such as litho or wax crayons, felt tip pens or even a soft pencil.

When the basic outlines and shapes are drawn in, you can start to work directly into your chosen metal with your drypoint tool, holding it a bit like a pencil. When you draw with the needle perpendicular to the plate you will get a line with a burr either side of it. If you tilt the needle a little the burr will tend to be on just one side of the line. This will give a different type of mark, which will hold the ink slightly differently. There is no particular right or wrong way of approaching the drawing onto the plate. You will find a variety of ways that suit you, which you can then exploit to the full, varying according to your image.

To see how your drawing is progressing without proofing through a press you can gently rub oily black intaglio ink or used scrim into the plate.

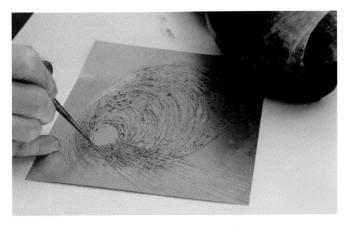

Drypoint is exciting because of the immediacy of its effect. If you rub used, inky scrim across your plate you can see how your drawing is progressing.

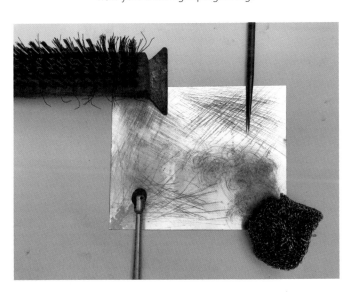

Raid the toolbox and dig out any sharp, unused items ripe for recycling. There are always new ways to add to your drypoint.

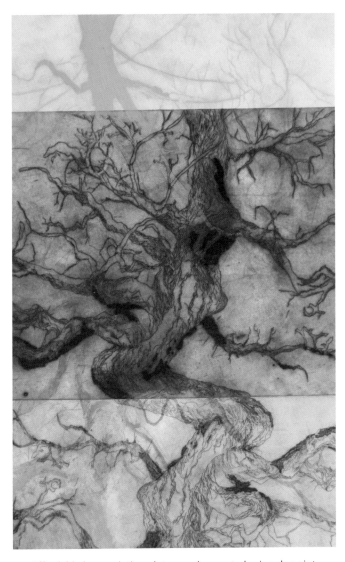

Affordable large printing plates can be created using drypoint card. They may not last long but print well for a while. Here the two non-etch techniques of drypoint and carborundum are combined. *Backlands*, Ann Norfield, 70 × 110cm, drypoint and carborundum on radiant white Somerset velvet 300gsm.

Printing a drypoint

Special care needs to be taken when printing, to avoid squashing the burr. You can start by reducing the pressure on the press a little. However, you will tend to find that to get the best out of a drypoint plate, you still need to use a fairly standard pressure setting.

The printing paper, whether it is of a proofing or editioning quality, needs to be damp and soft, as for all other intaglio processes. Ink consistency is a very important factor with drypoint. There are two schools of thought, both of which can be useful. Some printmakers prefer to use stiff ink and others soft. Much depends on what effect you want and the range and scale of mark-making on the plate. You can try a very dry ink, stiffened with added pigment or magnesium carbonate. French ink makers Charbonnel produce 'Doux', an ink especially useful for drypoint as it is easy and quick to wipe, so stressing the burr less, and can clean back to almost clear white plate tone.

The alternative approach is to use a softer ink, one reduced with light to medium copper plate oil. This is also easy to wipe, and sits well in the burr, but is harder to wipe to a clean plate tone. Usually this gives a print with more of a 'blur' and a noticeable grey plate tone over the whole image. Both inks are useful and both are capable of giving a good print. It really comes down to practice and deciding what is best for your image.

I would generally not recommend using heat when printing a drypoint, as it is very easy to remove too much ink from the plate.

Despite its material fragility, drypoint can be a liberating and exciting technique and a wonderful way to produce rich, vigorous images. Rembrandt used it in combination with etching and engraving to give emphasis and deepen areas of dark tone. Other drypoint artists to look for include Christopher Nevinson, Max Beckmann, Louise Bourgeois and Kiki Smith.

Carborundum

Carborundum is not an etching technique but it makes sense to describe the basics here as printmaking artists do use it in combination with etched plates. If it is to be layered with etching or drypoint it is advisable to paint carborundum on a separate plate and print them one at a time using the multi-plate printing technique described in Chapter 8. This is partly because carborundum is wiped differently from an intaglio plate and partly because any dislodged grit can scratch the plate surface.

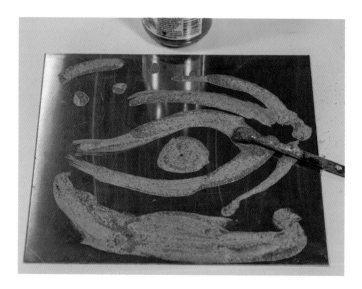

Paint your carborundum mix onto a degreased plate. Here the back of an old copper plate was used but aluminium will work just as well.

This carborundum plate has been printed as a backing plate. The print shows how different densities of carborundum grit provide a variety of intensities of colour.

Carborundum comes from a hard, synthetically made crystal, ground to a dust. It can be combined with a strong adhesive and diluted with water to create a paintable solution, which can be applied to a degreased plate, inked, wiped and printed in a similar way to an aquatint. It can provide dense areas of strong tone or painterly marks depending on how it is applied.

Materials and equipment

Metal plate the same thickness as your etching plate

Degreasing equipment

Carborundum dust (you can choose between grades)

Moulding paste (made by paint manufacturers Golden or Lascaux, for example)

Jam jar

Old spoon

Old paintbrush

Piece of card for applying ink

Old scrim

Damp paper and tissue for printing

An etching plate has been inked up to print over the carborundum. There are details on registering multi-plate prints in Chapter 7.

Method

Degrease your plate thoroughly and blot dry on clean newsprint. Mix some moulding paste with a little water in a jam jar until it reaches a paintable consistency. Spoon in a small amount of carborundum dust and mix thoroughly with the paste and water. Add a little more water if it gets too thick.

Paint areas of your degreased plate with the carborundum mix. Painted thinly it will retain the marks of a brushstroke. If applied more densely it will print with a uniquely earthy roughness. To create very strong tones allow the painted carborundum mix to dry, then apply another layer or two, allowing each application to dry before adding more.

Dry the plate with a fan heater or hair dryer and allow to cool. Alternatively, leave it overnight to dry and harden.

Ink up the plate with a piece of card and wipe with an old piece of scrim.

Print as for any other intaglio plate. When choosing inks for carborundum you could try a range of options, from very extended ink for painterly swathes of colour to opaque, dark ink for emphatic intensity.

Carborundum can be seen in the prints of Miro, Hodgkin, Jasper Johns and Hughie O'Donoghue.

Each area of carborundum on the plate was inked with a different 'dolly' and wiped with a separate scrim. The result is the clean colour print on the right. There are explanations about making and using dollies in Chapter 7.

Monotype

Monotype techniques can be used alone or in combination with etching in multi-plate prints. If two or more plates are overprinted it is easier if the plate used for monotype is the same thickness as the etching plate to make registration easier. One possibility is to cut a new plate of the same metal as your etching to use specifically for monoprint combinations, as this clear plate could always be processed subsequently as an etching should you want to use it in that way. Registration for multi-plate printing is described in Chapter 7.

Once you have decided on your plate there are many ways to start a monotype. You can mix relief ink with the same amount again of extender and apply thin layers of ink across the plate with a roller.

You could use the same mix for applying it with a brush or textured card or any other makeshift painting tool. You can remove ink by wiping areas with a dry brush or a rag or textured fabrics, a cotton bud or any size of stick.

You could try dipping a toothbrush in solvent and running a pencil through the bristles to spray the inked plate lightly. You can cut thin paper shapes to lay over the ink as a mask, then keep the same masks and flip them to apply ink in the next print.

Any of these could add a complementary or even completely different kind of visual language to your etched foreground plate, anything from a rich, painterly background to a clean graphic element in contrast with the etching.

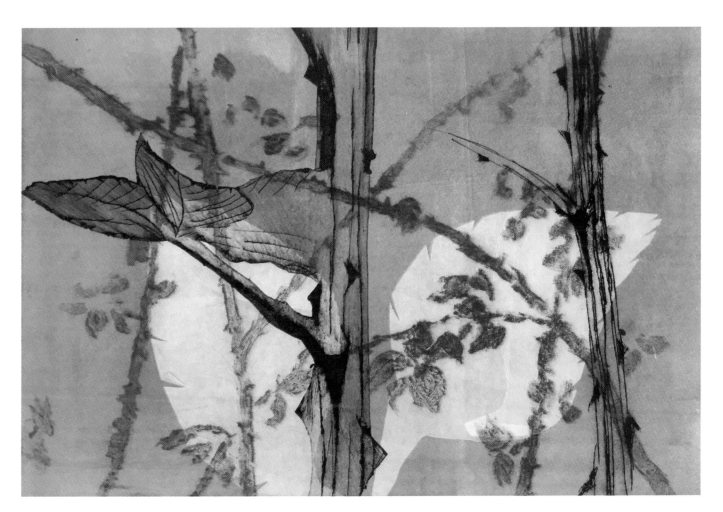

This three-plate print combines a masked and relief rolled backing plate in grey, a carborundum middle plate in magenta, and a drypoint card top plate in black. Ann Norfield, *Brambles*, 2011, 28 × 21cm on Somerset velvet 250gsm.

Approaches to etching: interviews with **Katherine Jones, Jason Hicklin** and **Hilary Powell**

I asked three artists who work in a variety of media about the ways in which they incorporate etching into their practice.

Katherine Jones is a printmaker and painter. Her *Looking In, Looking Out* project discussed here arose from a residency at Eton College.

Jason Hicklin is an artist who has an ongoing relationship with the British landscape and whose practice includes drawing and painting.

Hilary Powell's practice is wide ranging, from film and book production to performance and print. Her *Urban Alchemy* project involved salvaging metals from demolition sites and using them to etch large-scale portraits.

AN: To begin with, tell me how your individual projects started.

KJ: I was invited to do a residency at Eton College in the Autumn of 2015, which is where the first half of the project – a box set of sixteen etchings – was made. The second series of sixteen prints was made the following year at home in Southeast London.

The project was prompted by a conversation in which a description of my 'estate' was mistaken to mean 'country estate'. The disparity of the same vocabulary used in different contexts sparked the idea for *Looking In, Looking Out*.

Usually I read, draw and make watercolours before beginning a piece but I wanted these prints to be a simple and direct response to the place. They were made as observational drawings on small, postcard-sized pieces of zinc with sugar-lift.

JH: This set of etchings came about from walks I make in the British landscape. I have been making work in this manner for over 30 years. All of my etchings are informed by drawings I make in the sketchbooks I walk with.

HP: This project all began on a demolition site. I was interested in the material breakdown of the site – at that time I had made myself unofficial artist in residence on an East London redevelopment site on the edge of the Olympic Park. I mimicked how the demolition team sorted and salvaged, and I began to salvage roofing zinc and experiment with etching into this reclaimed and therefore unpredictable metal. I had never worked with print before but was attracted to etching due to the fact that the very making of the image entails a material corrosion and that working with found metal made it feel more like an alchemical experiment. Preparatory works included photography and drawing.

AN: Do you find you have a preferred sequence of techniques when starting something new?

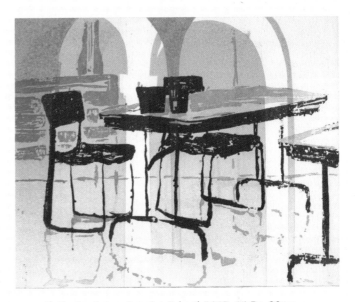

Katherine Jones, *Drawing School*, 2015, 14.5 × 20cm.

KJ: Each project follows a separate pattern. I drew the first plates as I walked around and discovered Eton College, the museum of Egyptology, libraries, swimming pools, golf course and so on. Photographs and supporting drawings of any significant details were also made in a sketchbook. The plates were then developed and printed in the Eton College print studio.

The next series followed the same pattern – discovering and recording the housing estate in the same way, drawing comparisons where I could, and printing the work in my own London studio.

JH: My initial marks on the plate are made relatively quickly and then etched and proofed. This then gives me an image to work with. I either etch the plates further or erase areas of etched metal.

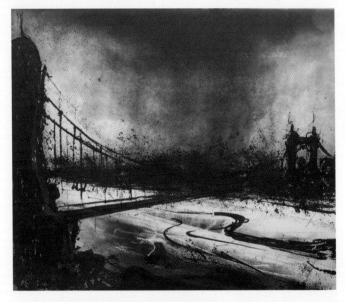

Jason Hicklin, *Hammersmith Bridge from Lower Mall*, 2005, 25 × 30cm.

These prints were made initially with soft ground etching followed by either sugar lift aquatints or spit biting. In a way I etch plates in a very similar way to the way I draw.

HP: I don't have a preferred sequence, though I often start with photography. In the case of the roofing zinc works, it is a case of trial and error and a collaboration with the material itself – allowing it to influence the final image.

Hillary Powell's long sheets of roofing zinc had to be etched outdoors in a bath made for the purpose.

I was lucky to become artist in residence with East London Printmakers at the same time as becoming 'alchemist in residence' in UCL's chemistry department. I worked with a material scientist who constantly questioned my processes and reasons for wanting to work with salvaged and reclaimed materials when I could just buy some print grade zinc. He became a great collaborator as we discussed surplus and creative reuse.

AN: Do you work one at a time or in series?

KJ: In this case the plates were etched in small batches. Some took far longer than others and several proofs were run before an image was resolved. In a purely practical sense, it's a good idea to have several plates on the go, as you are able to work on one while waiting for others to etch or dry.

My studio work tends to be large and cumbersome to print so, by contrast, this working on a small scale allowed the work to be more fluid and direct. It is important to be aware of how an image fits within a series. So although each piece was made individually, the others were visible during the process.

JH: Yes, I also work on several plates and enjoy the challenge of developing a series of etchings. That way I am able to be as productive as possible in the studio. When plates are in the acid or aquatint box I have other plates to work on which means I make the most of my time. As the work progresses, each print in a series relates to and feeds the next.

AN: Hilary, I imagine the logistics must have been a bit different for your series, given their scale?

HP: Well, my early etchings of buildings from the East London demolition site were small and worked as an index of ruination – printed onto index cards – and their scale allowed me to work on them all at the same time. When I moved to UCL and the demolition sites on campus in central London, I got an amazing zinc haul in the form of much of the roof of the architecture department, so I then worked much bigger and just one plate at a time. Getting to know this material sometimes meant days of absolutely no image emerging after a day of aquatint and nitric acid baths. I still have some extra large skyline etchings in this series to complete – I love working big but it requires a lot more logistical effort and collaboration. In this case, Simon Lawson at Huguenot Editions worked with me on printing first proofs of these on his giant etching press.

AN: How do you develop the work? Are some routes better for you than others?

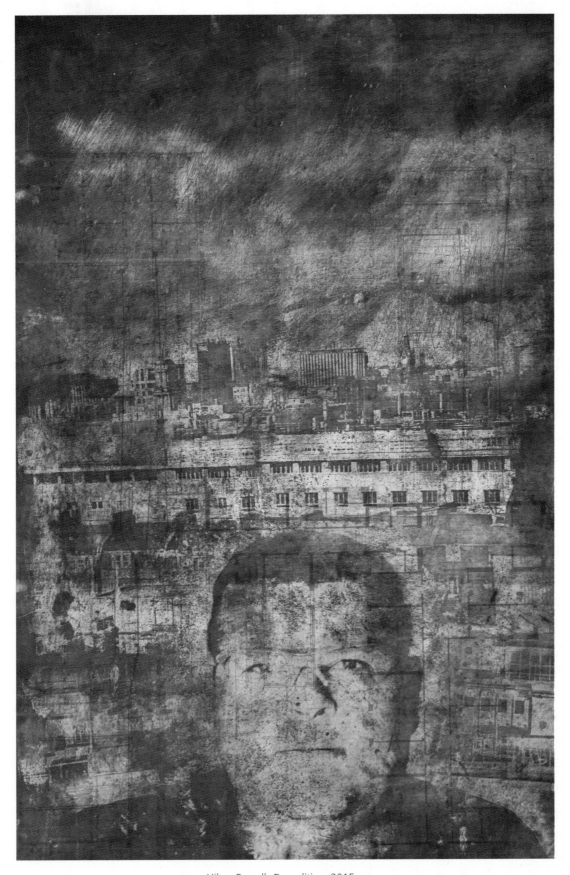

Hilary Powell, *Demolition*, 2015.

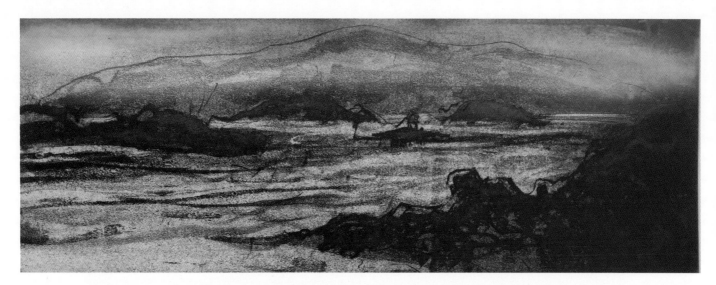

Jason Hicklin, *Aran Island from the Rosses, Co. Donegal*, 2006, 15 × 39.5cm.

JH: I begin with an image in mind and begin etching the plate and proof at each stage so I have time to consider my next move. For me, the developments of plates can only be made by etching and proofing.

KJ: I work slightly differently. My etchings don't get proofed until a plate looks like it might be resolved. I find if I take proofs at each stage of etching a plate, the image can become too precious. Occasionally they are re-grounded and adjusted, but most of the changes happen after etching by adding colour or block-print in the proofing stage. I find it useful to be open to anything that the process throws up during the making of an image and try not to predict its outcome. Occasionally a plate can take you in a new direction and open up unanticipated possibilities.

HP: I develop the plates through constant tests and experiments and I only keep going if I keep pushing what is possible with the material. I feel my urban alchemy is only just beginning and I am frustrated by the fact that other projects I love doing have taken over from this right now. For me this work requires time as well as collaboration and advice from other printmakers, scientists, demolition workers.

AN: How do you judge success and failure in the work?

JH: It isn't that they have 'failed'; it's just that a piece is not working at that stage of development. It has to be my own decision and judgement. But I see it as a challenge and make it my job to resolve the image. I often put the plate to one side and keep the proof pinned up until I can see my next move.

KJ: I know what Jason means; for me nothing goes out of the studio until I'm happy with it, but I rarely abandon a piece completely. There are stacks of plates and proofs which are unresolved and taken up again, sometimes years later. I am currently working on a set of plates that were started eight years ago. One has recently been resolved so I'm hopeful for the other two. Some plates get thrown away, but if an idea is still interesting after a year I see it as worth hanging onto.

AN: How do you know when you have finished?

HP: For me it's a feeling. I'm not sure….

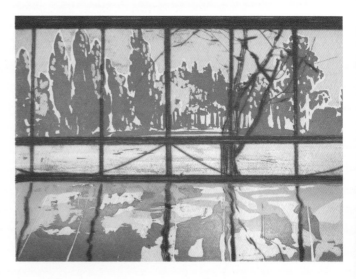

Katherine Jones, *Indoor Swimming Pool*, 2015, 14.5 × 20cm.

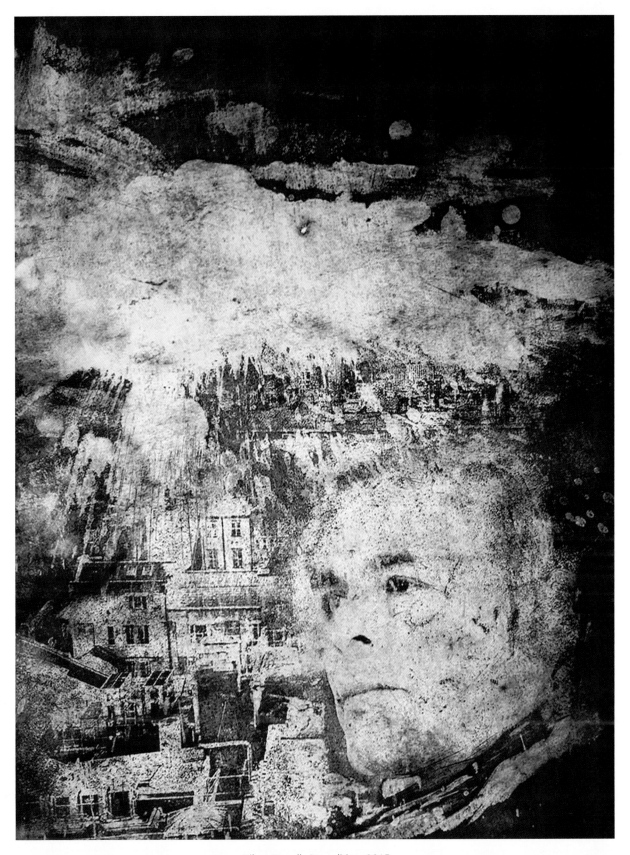

Hilary Powell, *Demolition*, 2015.

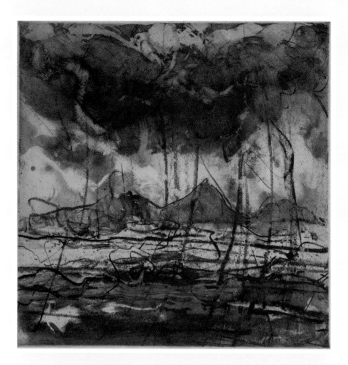

Jason Hicklin, *St David's Head*, 20 x 20 cm.

JH: Yes, it is a gut instinct and I know when they are right or not.

KJ: That's often the way. The composition seems to hang together and hopefully also communicates the thing you intended. Having said that, I often come back to the image the following day and realize that although one problem has been solved it still needs changing in another area and I am back to square one. Whether it's a painting, a drawing or a print, all media are equal in this respect.

AN: How would you characterize the relationship between your etching work and your practice overall?

HP: For me it's all about my relationship with the material and its possibilities. Etching is a chemical, unpredictable, physical process and needs an artistic and scientific treatment. I link it directly to the rooftop zinc I use and find a poetry and alchemy in it.

KJ: I agree that anybody who knows the rudiments of the etching process understands its alchemic quality. The embossed etched line and the flat tones achievable with aquatint, combined with the inverse of the plate's image on the paper, continually throw up new possibilities. The process almost encourages you to employ the etching medium in an irreverent way.

I really admire other artists who use these materials in non-conformist ways. Julian Trevelyan's take on colour and Prunella Clough's use of unusual materials in soft ground have both influenced my own approach to etching. There is an apparent honesty and independence of thought in their work that really appeals to me.

JH: To be honest, etching is absolutely fundamental to what I do. I find it addictive and all-consuming. Working with the etching process allows me to translate and re-interpret my drawings – made on walks – onto metal and then onto paper. The prints I make then feed the large drawings, the monotypes and paintings…. I have never struggled moving from one medium to another…. It always feels completely natural. Etching really drives my work and I am always learning from this corrosive process.

Using sugar lift aquatint and a la poupee colour printing, Jones uses both real and imagined elements in this 2013 print, *Mother*. With linear smudges and broad areas of tone and colour, she recontextualises the protective tissue of nets and shadows that surround a child's playhouse and climbing frame in a South London playground.

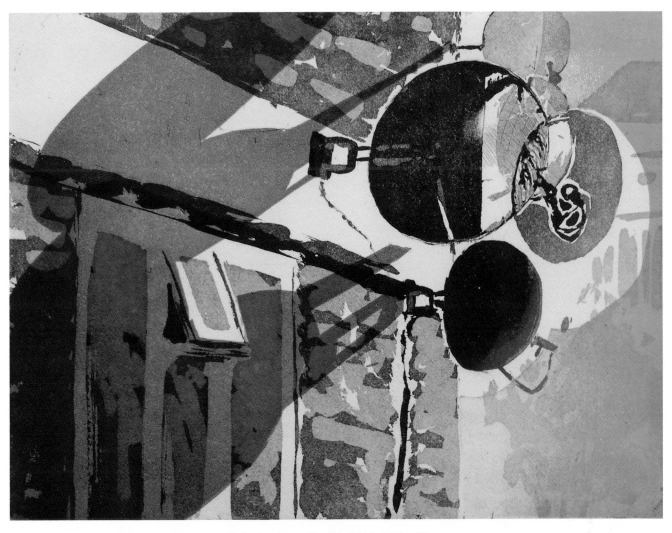

Katherine Jones, *Satellite*, 2016, 14.5 × 20cm.

Jason Hicklin, *Loch a Chuic Bhric from Islay*, 2009, 15 × 35cm.

Beyond the printed page:
Brian D. Hodgson

Through the course of this book we have seen that etching can move from a chosen starting point along any number of endless paths. Some of these routes will have been tried many times before, whereas others may be new and can take you and your audience somewhere else altogether.

Many prints are made with a purity of approach, a single technique developed to best express the artist's ideas. Most prints use at least two of the techniques in this book.

It is possible to use all of the techniques on a single image, work on it over years, scrape away whole areas, add new drawing, add colour and photographic elements. There are no hard and fast rules as to how to make a print, as there are no proscriptions about how we as artists decide to use print.

They may be made small, personal, domestic and intimate in nature. Others take on an almost architectural scale of production, shouting their message to as big an audience as possible. This journey is an individual one that each of us can engage with in our own personal way. The extraordinary number of variants and possibilities we try out and employ is what makes our work particular to each of us.

Etching is a fascinating twist on the process of corrosion, turning the potential for damage into a deliberately creative technique. For some artists, this journey is purely into the process itself. There is no real finished point envisaged and the idea of the print is seen simply as the resulting flotsam of that journey rather than its ultimate goal, and is therefore of less importance. Rather than the materials and techniques being a means to an end, they become the end in themselves.

One such artist is Brian D. Hodgson whose work for many years has explored the actions required to the making of an etching as of equal importance to the resulting art object.

Hodgson challenges not only the language of etching but also its very means of production. He carries out 'actions', turning the exhilarating physicality of etching into a significant event, akin to that of a performance. He says, 'What I am fascinated by is 'going back upstream' in the printmaking process of etching and focusing on its source – the way it bites in and around the etch-resist forming the image, the structure coming out of the fizzing and bubbling, the acid action itself.'

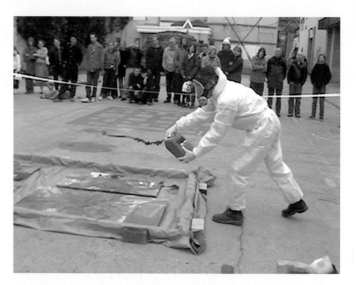

Brian D. Hodgson, still from *Attack*, 2003.

Brian D. Hodgson, still from *Attack*, 2003.

One such action, *Attack* took place in front of an audience on the weekend that the US and Britain invaded Iraq in 2003. He says, 'It was my personal reaction to and exorcism of the fear and collective paranoia pervading the public consciousness at the time.' For the project he spent several weeks taking photographs in public places in London, 'Imagining the camera shutter button to be the cause of a bomb detonation.'

The corrosive effects of acid were also used to memorable effect in Hodgson's recreation of Gustav Metzger's 1961 *Demonstration of Auto-Destructive Art*. Three large screens stretched with coloured nylon were erected on London's South Bank. Hodgson then sprayed acid onto the nylon as Metzger had done, as a protest against war, nuclear weapons and capitalism. Of this he says that, 'the procedure produced rapidly changing shapes before the nylon was consumed, so the work was simultaneously auto-creative and auto-destructive.'

Brian D. Hodgson, still from *Burning*, 2011.

Brian D. Hodgson, *Reconstruction of Metzler's 1961 Demonstration of Auto-Destructive Art*, 2006.

The photographed images were screenprinted onto sheet metal and displayed prior to the action. In front of his outdoor audience Brian removed the pieces from the wall, placed them in an etching area built on the yard floor and 'attacked' them with a powerful mordant known to be very reactive with the metal. The images on the metal were gradually bitten and dissolved over about twenty minutes, like an explosion in slow motion. The plates were redisplayed afterwards as partially destroyed artefacts bearing images of moments of detonation and bombed-out scenes.

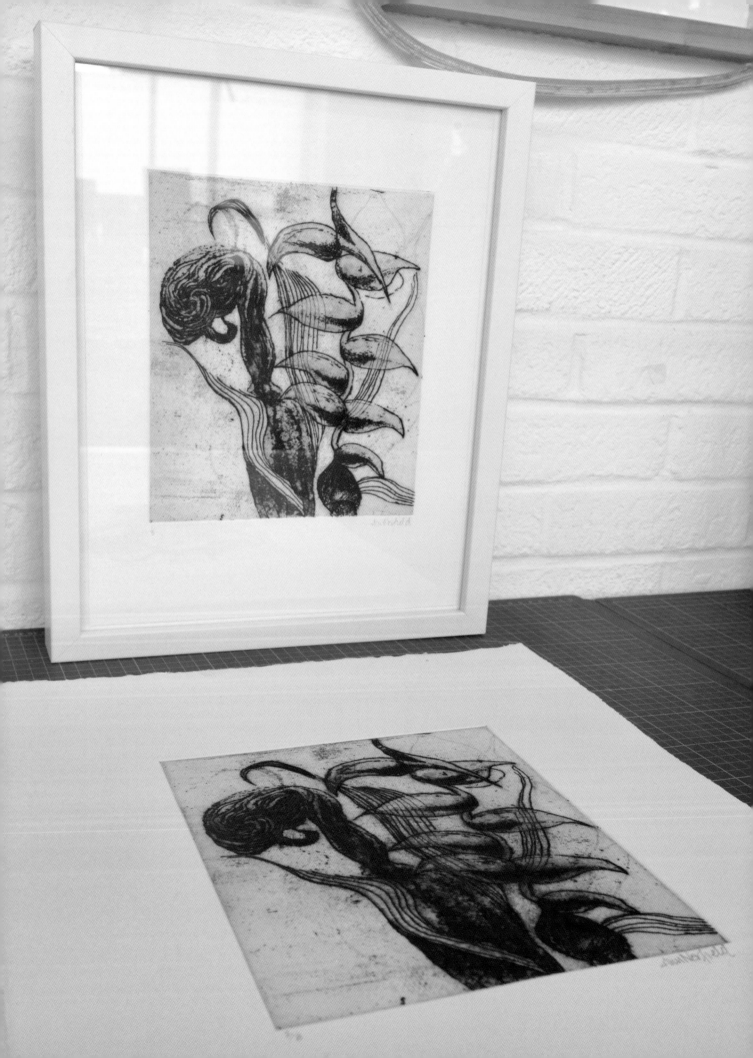

EDITIONING, FINISHING AND PRESENTATION

When you finally decide that the long and varied journey that your image and plate have been on is finally over, you arrive at the point of making a number of copies of the plate, all of which are essentially the same. This is called editioning and is one of the basic characteristics of all print processes.

You can decide to make an entire edition where each one is a different version, a variable edition. As long as the prints are indicated as being variable this need not be a problem. These are decisions for you to make and should not necessarily be dictated by history and convention. However, if you do decide to edition, in whatever way you imagine, some basic pointers are useful.

Editioning

Editioning is really about preparation and consistency. To get as much out of your plate as possible there are preparatory stages to follow, which will help you in the long run. Getting your paper and inks ready in advance, as well as your workspace, press and drying facilities, all helps to make the whole process more manageable.

In a nutshell

1. Prepare the edges of the plate.
2. Prepare the paper and inks.
3. Make a template for printing.

Materials and equipment

Metal files, one rough and one fine
Wet-and-dry sandpaper of different grades
Sanding block
Container of water
Burnisher
3-in-1 oil

Method

You will have filed and prepared the edges of you plate prior to starting the whole etching process. However, the etching process inevitably roughens the edges up, so they will need redoing. There are details on edge preparation in Chapter 2.

Tear and damp paper the evening before editioning if at all possible. It can be wrapped in polythene ready to use the following day.

File as before, aiming to get an even 45-degree angle around the plate. Then remove any sharp edges that may have been created at the back edge, under the plate.

After filing, firstly with a coarse file, then with a finer one, wrap some coarse wet-and-dry paper around a sanding block. Hold your plate down firmly on a solid surface and rub the covered block along each side of the plate, and around each corner to sand away any sharp or pitted marks. Repeat a few times, changing over to the finer wet-and-dry after a while. Be careful not to stray over into the image area.

Brush away any metal filings made and apply a little plate oil to the plate edge with a rag. Hold the plate still and run the burnisher firmly along each edge in turn, using a rolling action to cover the full bevel of the plate. You should eventually have a clear bevel on the plate that is smooth to the touch, no sharp edges and no rough surface that can hold any ink.

Paper

There are traditions associated with the way a print is positioned on paper. Although it is not essential to stick to these traditions it is useful to know them so you can use them if you want to.

Most prints tend to have paper around them on all four sides with the bottom edge approximately 2cm deeper to accommodate an edition number and a signature. This helps to visually centre the image on the sheet. Without it the signature can tend to look awkward, making the image appear too low on the sheet. The paper edges are usually torn to emulate the deckle edges of laid cotton printing paper.

When you have decided what size of paper to use and whether to tear or cut the pieces, prepare as many sheets as required and dampen according to your chosen method (*see* Chapter 4). If you are preparing to edition it is best to damp your paper the night before, wrap it and weight it in readiness for the next day.

If you are making a multi-plate print you will have to use a paper that is bigger than the intended final print. This is to accommodate the trapping (or pinching) of the paper under the etching press rollers so as to hold the paper in place while changing plates. This can then be cut down either at the end of the printing process, or after the prints are dry.

Editioning demands a particular skill and mind set. The idea is that each print should be identical to all others in that particular edition, whether it is number 1 or 100. This is obviously not so straightforward, as we are dealing with something that is handmade. There are innumerable essays on the relationship between the mechanical multiple and the handmade. For practical purposes though, we will approach this as an attempt to make an exactly repeatable image for an edition.

In the early stages of learning to edition it is advisable to keep the number small and the preparation simple. Small edition numbers are not only practical but keep costs down and save on storage space as you gradually acquire hundreds of prints.

One issue that has to be borne in mind and affects the number of prints produced, is the fact that the whole printing process can wear down the marks made on the plate, turning what was a rich and elegant etching in its early stages into a dull and lifeless ghost of its former self. Aluminium and zinc are soft metals and the image disappears quickly as the plate is run through the press. Copper is harder and retains the image for longer. However, fine areas of aquatint in particular are bound to change and start to break down after the first dozen or so prints. The small bumps of aquatinted metal wear away and these areas start to print lighter and more unevenly than originally intended.

The only solution, other than keeping numbers low, is to have the plate steel-faced. Steel is a harder metal and a coating over the surface applied electro magnetically will preserve the image for longer. You can pay a company such as those listed in the back of *Printmaking Today* to carry out this service, but it can be expensive. However, if you are confident that you can sell a reasonable number of any given print, the cost is small spread over the larger number.

By the time you come to edition a plate, you should have decided through the proofing process issues such as colour, order of printing and type of paper. Do not forget that even with black, there are many variables. There are different colours within black itself: some are blue, some red, some green or grey. Some are better for aquatint, some better for hard ground or drypoint. Use the proofing process to explore all the possible variables because by the time you come to edition a plate, the time and costs involved need to be focused solely on the editioning process.

If you are a contract printer, making work on behalf of another artist, the first important print you need is called the BAT (from French *bon à tirer,* 'good to pull'). This is the first print signed and marked BAT by the artist, where everything is correct. The BAT is used as the reference point from which the printer makes the edition. The reference is not just to the image on the plate but also to the colours and paper used, how light or dark certain areas are printed and even how the paper is torn to size.

Even for the artist who is printing their own work, it is advisable to have a single print marked as the BAT. There are bound to be gaps in time during the course of finishing the job and your reference will mean you can carry on with printing the edition knowing it will be the same throughout.

Set aside a day for your editioning. If possible, prepare the paper the evening before. Tear each sheet down to the required size, preparing spare sheets in case of mistakes. You can store the damp paper overnight by stacking it up on a sheet of glass and placing a second sheet of glass on top to weight it down. Alternatively, you can wrap the paper in polythene or opened, but clean, bin bags. Damp all the paper you need for your day's editioning, using a bucket of water and a clean sponge. Stack each wet sheet on top of the plastic, wrap it up and place boards on top to weight the stack flat. By morning

A template will help you print your edition more efficiently.

Make sure the press is at the right pressure to give you the best possible prints for an edition.

the paper should be evenly damped throughout the stack. Unless it is very wet there should be no need to blot each individual sheet during the editioning process. You can simply remove a sheet and rewrap the stack.

If best plans go awry and you cannot prepare paper the day before, soak a few sheets in the paper sink as soon as you arrive on the editioning day and blot as you go along. Try not to leave paper in the sink for more than 30 minutes, as over-wet paper can print slightly differently.

If your ink is mixed from different colours, mix more than enough to print the edition. Wrap it in foil or tissue paper and store it in an airtight container. A plastic take-away container will work well as temporary storage.

Ink up your plate as in your BAT version. Be systematic in the way you wipe the plate (for instance, scrim-wiping four times across the plate before turning it to wipe again from a different direction). Remember this detail to ensure every print is wiped essentially the same way.

As you print this and each print of the edition, lay it on a drying board, either cover it with clean tissue and place another drying board on top, or wrap it in clean polythene for putting into the drying system at the end of the day.

Print a few more copies than your intended edition, plus any artist's proofs, to make sure you have enough. Drying usually takes about four days within boards at room temperature. Alternatively you may use another drying system as outlined in Chapter 4.

Collating and cleaning your edition

As the idea behind an edition is that of consistency, there are clear recommendations about how to go about finishing off your prints and numbering them.

There is often an idea expressed about keeping your prints in the order that they were printed and that the numbering should be sequential based on their production. These ideas really relate to a pre-nineteenth-century period when the ability to maintain quality over an edition was compromised by the deterioration of the printing plate as the edition went on. It was not unusual to find prints noticeably lighter as the edition numbers got higher, so there was a premium based on early edition numbers.

This is not really the case any more. With steel facing, etched plates can last intact for longer, so far greater numbers of prints can be produced.

For most of us, large edition numbers are not necessary and the need to keep everything exactly the same throughout an edition is a restriction that works against the nature of anything handmade. Individual artists can decide for themselves how important this is to their work. If you decide that two slightly different versions of the same print are both acceptable, then sign both of them. Print publishers and galleries might find this difficult to deal with, as they like consistency, but this is a choice that an independent artist who self-publishes can make.

Using your BAT proof as a reference point, check through your prints carefully. The most obvious processes that deteriorate first are aquatints and drypoints. If you find the prints are too weak then they may not be good enough to show or sell anyway. Some prints may have met with accidents with registration or slippage and have to be rejected. Others may be well printed but are so different from the BAT proof that they cannot be included in an edition. Strictly speaking these misfits should be destroyed – and when you are an internationally known artist printing prized editions of etchings this is advisable. However, when first embarking on an edition there may be several prints that do not tally enough with the BAT. Although they may not be part of your numbered edition it can still be worth keeping some to experiment on with drawing and painting to help develop your next ideas.

Cleaning prints

It is quite normal to get grubby marks around the edges of prints when we are printing. Our hands are covered in ink and yet we are still trying to keep a damp piece of white paper spotlessly clean. Not so easy! As a result, the cleaning of prints is a normal part of the whole finishing process. Grubby fingerprints can be removed with an eraser and spots of ink removed with a scalpel. Little squirts of ink that can come out from the back of the plate when we are printing can be treated in the same way: scalpel first and then eraser. Some papers are easier to clean than others, and sometimes this can be a deciding factor in choosing which paper to print on over another.

Not everything has to be spotless; for instance, if we look through museum shows of some of the greatest artists' prints produced over the past 500 years there are spots of ink, grubby marks and creases. Not all of these are the product of a long life and bad handling. If we are making handmade prints, occasional 'mistakes' can actually add character and life to an image.

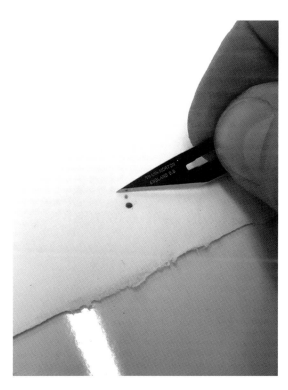

You can use a scalpel to remove ink spots around the paper margins of finished prints. An eraser should get rid of grubby fingerprints.

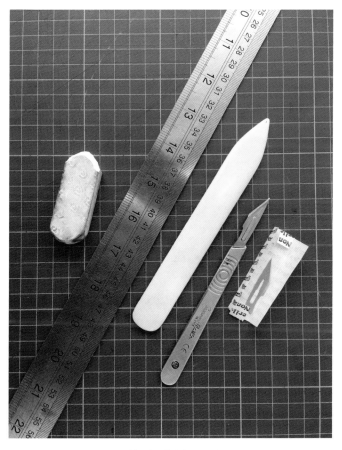

Tool kit for finishing prints.

Signing

Artworks made in print differ from most other kinds of artwork in that they are generally replicable. If a purchaser buys an etching it is expected that the extent of its uniqueness will be indicated by the way it is signed off.

The convention of signing prints is that they are signed immediately under the plate mark, the print number is in left-hand corner as 1/10, 2/10 etc. If there is a title, this is in the centre of the image and the signature itself is on the right-hand side. The date is usually after the signature.

However, this is just a convention, one we need not adhere to. Some artists find that numbers and a signature interfere with or detract from their image on the front, so they number and sign on the back of the sheet. Some sign the front and number the back; others sign on the bottom of the sheet, rather than immediately below the plate mark. All are perfectly acceptable.

When it comes to proofs and variations in the image, there are numerous ways of marking the prints. The signature, date and titling remain the same but the numbering can vary.

Here are some examples:

Bon à tirer – BAT
Artist's proofs – A/P 1/10 sometimes EA
Variable edition – V/E 1/10
Hors de commerce – HC or H/C 1/10
Roman numerals – i/v, ii/v, etc.
Unique prints – UP 1, UP 2
Printer's proof – PP1

There may be others around. The most important aspect of the whole numbering process is that you are indicating that there is a set, limited number of any print available of any particular type, whether it is the full edition or artist's proofs.

Hors de commerce prints are ones traditionally 'not for sale'. They were prints used to show clients, so they tended to get manhandled and grubby and were not deemed worthy of selling. However, market forces being as they are, even HC copies can find their way onto the market.

Roman numerals tend to be used when you want to extend an edition that has already been numbered.

Conventionally prints are numbered under the left-hand corner of the print and signed under the right.

Unique prints are one-off versions, maybe printed slightly differently, or altered in some way before, during or after the editioning process. The plates are the same but the printing has been changed in some ways.

Editioning printers have historically been paid solely by the print. As a result an editioning printer learns to be accurate and consistent in their printing. The printer's proof is a form of extra payment, a bonus at the end of the whole job.

Presentation

Once involved in a print studio, it is likely you will come across many conventions associated with the way a print should be displayed. Perhaps because etching has such a long and rich tradition it can appear that conventions relating to paper size, mounting and framing stem from ideas irrelevant to contemporary artists.

In reality many ideas on presentation are relatively modern in origin. Although particular kinds of display are common practice they are not all essential to good practice or well-presented artwork. This is not least because factors other than aesthetic considerations have affected how certain practices developed.

For instance, if you look at the traditional relationship between paper size and the image printed on it, there is a border of paper all around the print. This is usually equidistant on the top three edges with an extra 1–2cm underneath the image to accommodate a number and the artist's signature.

Prints can be torn down after printing to fit a particular frame. Mark the measurements in pencil.

Tear against a steel ruler.

Sometimes a ruler mark can be left along the torn paper edge.

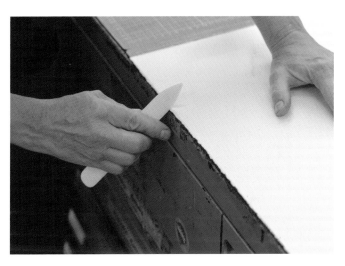

To get rid of the ruler mark, take the torn edge to the edge of a clean worktop and run a paper burnisher along it several times.

Alternatively you can tear paper from behind. If you mark the measurements with pin pricks instead of a pencil…

…then flip the paper over you can still see the pin marks and so can tear the paper from behind, leaving less of a ruler mark.

The practice of signing prints stems from the late nineteenth century when copyright law developed in regard to artworks. Unlike a painting, which could be signed and delivered by the artist directly to a gallery or buyer, an etching plate could be taken from the artist's hand and reproduced anywhere by anyone with editioning skills with complete anonymity. An artist's signature was therefore needed on the printed paper as evidence of provenance instead. Prior to that time it had been common practice for etchers to sign their plates directly; when this ceased more importance was attached to the signature on the paper.

The size of borders changes according to fashions in print. For instance, Rembrandt's etchings are often torn tight to the plate edge. This was possible in part because he signed many of his own plates so the signature was held within the image.

At the other end of the paper size spectrum, borders around prints made in the 1970s were often as wide and extravagant as the lapels and trousers fashionable at the time. Perhaps the signature was meant to be just as large and exaggerated.

Contemporary artists and publishers have moved towards using smaller borders. Fashions and habits vary over time. Meanwhile if there is a good aesthetic or conceptual reason for presenting work in a certain way this should take precedence over any desire to conform to perceived convention.

Other conventions involve torn versus cut edges. Torn edges mimic the deckle edges of handmade paper and the craft of printmaking. By contrast, cut edges imply a more commercial and conceptually modern approach by the artist.

Of course either can be considered valid. The deciding factor in all these considerations is always the work itself and the way you as artist want to present your piece to an audience.

Framing

Framing seems to provide almost as many choices as any other aspect of making artists' prints: what sort of frame is best, what alternatives to framing are there and even, do we need to frame at all?

Frames are a convenient and protective way of showing prints. Unlike most painting and sculpture, which are generally robust enough to survive unprotected, prints (along with drawings and photographs, of course) are easier to damage and more affected by the conditions in which they are kept. This is especially true in a domestic environment.

As a result a frame will always be the most obvious way of presenting prints. Nevertheless we still have to consider them as an ingredient in the overall aesthetic effect that we are after. Frames can be found in many materials and many styles and it is important that, cost notwithstanding, we select the right type of frame for each work.

Good quality, ready-made frames are available and may well suit your purpose. On the other hand, if you opt for bespoke framing you can be very specific about the details in presentation.

Whichever style or cost of frame you choose, bear in mind that if archival materials are not used, the prints will start to mark and deteriorate fairly quickly. Archival materials are acid free, and that includes the mounts, tape and backing boards used.

It is also not a good idea to have the print in direct contact with the glass, so either window mount or float mounting options should be used.

Window mounts are acid-free mountboards cut with a window so that only the image can be seen, not the edges of the paper. 'Float' mounting means the whole sheet is on view in a frame that has a 'fillet', a strip of wood that creates a space between the glass and the print.

Readymade frames of decent quality are available in local art suppliers. Habitat has affordable readymade frames and good discounts in sales, as do Ikea and bigger art shops. Wooden frames can be repainted or stained to refresh them over time. Secondhand frames with previous uses can give a different context for the work. Alternative framing options include Perspex box frames or a sandwich of Perspex sheets with prints held between them and fastened with small bolts or clips.

Some artists and some work require alternative approaches. I often prefer to show etchings bare-faced and raw, without the distancing factor of frames and glass so have tried the following: eyelets and nails/screws; screwheads and mini magnets; screws with mini bulldog clips (transparent ones from Muji are very popular); and dressmaker pins pushed directly into the wall.

How we present our work can often be the last thing on an artist's mind, but it sets the tone as to how we wish our work to be viewed. It is a part of the visual noise that surrounds our work, and so needs to be carefully considered. It frames our ideas, not just a piece of paper.

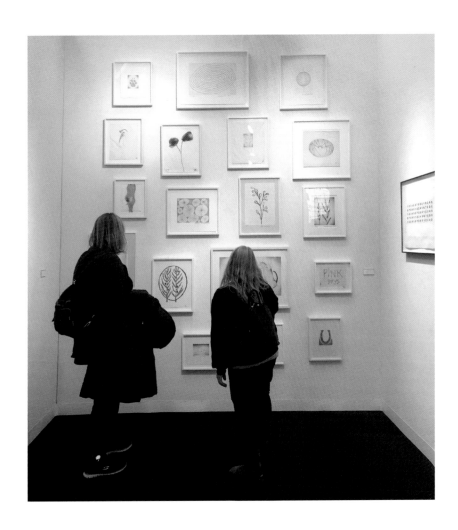

LIST OF OPEN ACCESS PRINT STUDIOS

Around the world there are studios where people can learn print techniques and go on to use the facilities independently. The studios listed here all accommodate intaglio printmaking in one form or another and all but a few provide plate-making facilities for etching.

The list is far from complete and is based on the shared knowledge of friends and colleagues. The studios vary enormously in scale and in the facilities available. Some may have bookable open-access sessions or involve a commitment to a membership scheme. Many offer residencies that are funded by the studio/workshop, while others have to be self-funded. I have listed the kinds of access available where known but the options may change over time, so each of these websites is worth checking for updates.

Australia

Australian Capital Territory

Megalo Print Studio
21 Wentworth Avenue
Kingston ACT
2604 Australia
www.megalo.org
Courses, studio access and residencies.

New South Wales

Centrehouse / Gallery Lane Cove
Lane Cove, New South Wales
www.centrehouse.org.au
Studio hire and residencies: intaglio, relief, monotype.

Newcastle Printmakers Workshop
Newcastle, NSW
www.newcastleprintmakersworkshop.org
Membership access for facilities in intaglio, relief, monotype,
photopolymer, screen.

Warringah Printmakers Studio
PO Box 216
Seaforth, New South Wales 2092
www.printstudio.org.au
Membership access and courses in intaglio, relief, monotype,
photopolymer.

Northern Territory

Tactile Arts Studio
Darwin, NT
www.tactilearts.org.au
Open access facilities and residencies: intaglio and relief
(printing only, not processing).

Queensland

Impress Printmakers Studio
Brisbane, QLD
www.impress.org.au
Membership and studio hire options, courses in intaglio, relief,
monotype, screenprinting, lithography, letterpress.

Inkmasters
Cairns, QLD
www.inkmasterscairns.com.au
Open access, residencies and courses in intaglio, relief, monotype,
lithography.

South Australia

Bittondi Printmakers
Adelaide, SA
www.bittondiprints.com.au
Community studio, membership access and courses.

Tasmania

Hunter Island Press
Hobart, TAS
www.hunterislandpress.org.au
Open access and membership options for intaglio
(printing, not processing), relief, monotype.

Moving Creature Printmaking and Artist Studio
Hobart, TAS
www.movingcreature.wordpress.com
Studio hire and membership options, residencies, courses in
intaglio, relief, lithography, letterpress.

Victoria

Agave Print Studio
Trentham, VIC
www.agaveprintstudio.com.au
Access to the studio, classes, residencies and accommodation.

The Art Vault
Mildura, VIC
www.theartvault.com.au
Residencies and facilities for intaglio, relief, monotype, lithography.

Australian Print Workshop
Melbourne, VIC
www.australianprintworkshop.com
Open access, residencies and courses.

Baldessin Press
St Andrews, VIC
www.baldessinpress.com.au
Open access, residencies, courses in intaglio, relief,
monotype, photopolymer.

Castlemaine Press
Castlemaine, VIC
www.castlemainepress.com.au
Community studio access, residencies, courses.

Firestation Print Studio
Melbourne, VIC
www.fps.org.au
Open access and membership options, courses.

Portland Bay Press
Portland, VIC
www.portlandcema.org.au
Access studio and residencies with accommodation.

Western Australia

Open Bite Australia
Edith Cowan University, Perth
www.ecu.edu.au
Open access and workshops in intaglio, relief, monotype.

Belgium

Frans Masereel Centrum
Masereeldijk 5
2460 Kasterlee
Belgium
www.fransmasereelcentrum.be
Range of print residencies.

Canada

Alberta Printmakers
4025 4th Street SE
Calgary
Alberta
Open membership and residencies.

China

CHAO Art Centre in Beijing
www.ilovechao.com/show/artcenter
Fully equipped printmaking workshop and print collection gallery
offering residencies by invitation.

Denmark

Fyns Grafiske Vaerksted
www.fynsgv.dk
Memberships and scholarships.

France

Atelier Bo Halbirk
80–82 rue du Chemin Vert
75011 Paris
www.bohalbirk.com
Courses and membership scheme.

Germany

BBK Berlin
Mariannenplatz 2
10997 Berlin
www.bbk-kulturwerk.de
Courses and appointment system for studio access.

Greece

Skopelos Foundation for the Arts
PO Box 56
Skopelos Island
Greece 37003
www.skopartfoundation.org
Residencies.

Iceland

Fish Factory
Sköpunarmiðstöð SVF.
Bankastræti 1
755 Stöðvarfjörður
Iceland
www.inhere.is
Print facilities for residencies.

Ireland

Black Church Print Studio
4 Temple Bar
Dublin 2, Ireland
www.blackchurchprint.ie
Residencies.

Cork Printmakers
Wandesford Quay
Clarke's Bridge
Cork, Ireland
www.corkprintmakers.ie
Open access, memberships and residencies.

Graphic Studio Dublin
Distillery Court
537 North Circular Road
Dublin 1
www.graphicstudiodublin.com
Courses, residencies and annual applications for open access and
full membership.

Italy

Fondazione Il Bisonte
Via San Niccolò 24/rosso
50125 Firenze
www.ilbisonte.it
Residencies and courses.

Opificio della Rosa
Rocca di Montefiore Conca
Via 2 giugno
47834 Montefiore Conca
www.opificiodellarosa.org
Workshops and residencies in a medieval castle.
Scuola Internazionale di Grafica
Calle Seconda del Cristo 1798
30121 Venezia
www.scuolagrafica.it
Workshops and residencies

India

Chhaap Baroda Printmaking Workshop
42 Nand Residency
B/h Reliance Mega Mall
Old Padra Road
Baroda-390 020
Gujarat
www.chhaap.com
Residency programme.

Netherlands

Grafische Werkplaats
Prinsegracht 16
2512 GA Den Haag
www.grafischewerkplaats.nl
Courses and open access options.

New Zealand

Wharepuke Print Studio
190 Kerikeri Road
Kerikeri
www.nontoxic-printmaking.co.nz
Courses, open access and residencies.

South Africa

Blue Door Print Studio
24 Chatou Road
Melville, Johannesburg
www.bluedoorprintstudio.co.za
Courses.

Spain

Artprint residence
Carrer Ramon Llull 1
08358 Arenys de Munt
Barcelona
www.artprintresidence.com
Residencies and courses.

Sweden

Grafikverkstan Godsmagasinet I Uttersberg
www.grafikverkstan.se
Residencies, courses and gallery in a forest studio.

United Kingdom

England

Art Academy
Mermaid Court
Borough High Street
London SE1
www.artacademy.org.uk
Open access and courses in etching with copper sulphate.

Art Hub Studios
Studios in Woolwich and Deptford
www.arthub.org.uk
Workshops and printmaking access.

Artichoke Print Studio
245a Coldharbour Lane
Second Floor Unit S1
Shakespeare Business Centre,
London SW9 8RR
www.artichokeprintworkshop.co.uk
Open access, courses, key-holder membership.

Badger Press
Unit 4
Claylands Road Industrial Estate
Bishops Waltham
Hampshire SO32 1BH
www.badgerpress.org
Courses and open access.

Bainbridge Print (studios in both Elephant and Castle SE17 and West Norwood SE27)
www.bainbridgeprint.com
Courses, open access and fellowships.

Bath Artist Printmakers
3 Upper Lambridge Street
Larkhall
Bath BA1 6RY
www.bathartistprintmakers.co.uk
Open access and courses.

Bip-Art
1A Arundel Mews
Arundel Place
Kemptown
Brighton BN2 1GG
www.bip-art.co.uk
Open access and courses.

Birmingham Printmakers
90 Floodgate Street
Birmingham B5 5SR
www.birminghamprintmakers.org
Courses and membership scheme.

Dundee Contemporary Arts
152 Nethergate
Dundee DD1 4DY
www.dca.org.uk
Open access.

East London Printmakers
42 Copperfield Road
London E3 4RR
www.eastlondonprintmakers.co.uk
Open access, residencies, key-holder membership.

Essex Print Studio
Dawes Farm
Ivy Barn Lane
Margaretting
Nr Chelmsford
Essex CM4 0PX
www.essexprintstudio.co.uk
Courses and open access including print facilities for etching in copper sulphate etc.

Folio Studio
5 High Street
Ilfracombe
EX34 9DF
www.foliostudio.co.uk
Courses and open access.

Hello Print Studio
Resort Studios
Pettman Building
50 Athelstan Road
Cliftonville
Margate CT9 2BH
www.helloprintstudio.com
Workshops, studio hire and residencies.

Hey Ho Print
17 Pearl Street
Saltburn by the Sea
Cleveland TS12 1DU
www.heyhoprint.co.uk
Open access.

Hot Bed Press
Casket works
Cow Lane
Salford
M5 4NB
www.hotbedpress.org
Open access, short and long courses and membership.

John Howard Print Studios
Unit 4 Jubilee Wharf
Penny
Cornwall
TR10 8FG
www.johnhowardprintstudios.com
Open access and courses.

Leicester Print Workshop
50 St George Street
Leicester LE1 1QG
www.leicesterprintworkshop.com
Open access membership and courses.

Linden Print Studio
Linden Farm House
Baldwinholme
Carlisle CA5 6LJ
www.lindenprintstudio.co.uk
Courses and open access.

London Print Studio
425 Harrow Road
London
W10 4RE
www.londonprintstudio.org.uk
Open access and courses.

Northern Print Studio
Stepney Bank
Newcastle upon Tyne
NE1 2NP
www.northernprint.org.uk
Courses and open access.

Ochre Print Studio
Lockwood Centre
Westfield Road
Slyfield Industrial Estate
Guildford
Surrey GU1 1RR
www.ochreprintstudio.co.uk
Open access, courses and residencies.

Print Room
Old Station
Station Road
Stow cum Quy
Cambridge CB25 9AJ
www.susieturner.com
Courses and facilities for photopolymer.

Print to the People
53–55 Pitt Street
Anglia Square
Norwich NR3 1DE
www.printtothepeople.com
Open access and courses.

Red Hot Press
The Corn Exchange
Old Cattle Market
Captains Place
Southampton
SO14 3FE
www.redhotpress.org.uk
Membership, courses and open access.

Slaughterhaus Print Studio
Vincent's Yard
23 Alphabet Mews
London SW9 0FN
www.slaughterhaus.net
Courses, day membership and key-holder scheme.

Spike Print Studio
133 Cumberland Road,
Bristol BS1 6UX
www.spikeprintstudio.org
Open access, courses and key-holder membership.

St Barnabas Press
Coldhams Road
Cambridge CB1 3EW
www.stbarnabaspress.co.uk
Open access printmaking.

Thames-Side Print Studio
Unit 4, Harrington Way
Warspite Road
Royal Borough of Greenwich
London SE18 5NR
www.thames-sideprintstudio.co.uk
Courses and membership.

Volcanic Editions
16 Rosehill Terrace
Brighton BN1 4JJ
www.volcaniceditions.com
Facilities bookable for drypoint, photopolymer, carborundum and monoprint.

West Yorkshire Print Workshop
75a Huddersfield Road
Mirfield
Huddersfield WF14 8AT
www.wypw.org
Open access membership scheme.

Northern Ireland

Belfast Print Workshop
Cotton Court
30–42 Waring Street
Belfast BT1 2ED
www.bpw.org.uk
Membership through application; courses and residencies.

Scotland

Edinburgh Printmakers
1 Dundee Street
Edinburgh EH3 9FP
www.edinburghprintmakers.co.uk
Open access and courses.

Highland Print Studio
20 Bank Street
Inverness
IV1 1QU
www.highlandprintstudio.co.uk
Open access and residencies.

Soulisquoy Printmakers
Wasps Stromness Studios
2 Hellihole Road
Stromness KW16 3DE
www.soulisquoyprintmakers.blogspot.com

Wales

41 Market Rd
Cardiff CF5 1QE
www.printmarketproject.com
Open access, workshops and technical support for print commissions.

The Regional Print Centre
Coleg Cambria
Grove Park Rd
Wrexham LL12 7AB
Open access facilities.

Seacourt Print Workshop
Unit 20 Dunlop Industrial Units
8 Balloo Drive
Bangor (Down) BT19 7QY
www.seacourt-ni.org.uk
Membership scheme and self-arranged residencies.

United States of America

California

Crown Point Press
20 Hawthorne Street
San Francisco, CA 94105
www.crownpoint.com
Illustrious print publisher and gallery with summer workshop
programme.

Kala Art Insitute
1060 Heinz Avenue
Berkeley, CA 94710
www.kala.org
Residencies.

Myrtle Press
Verge Center for the Arts
625 S Street
Sacramento, CA 95811
www.myrtlepress.com
Workshops and accessible facilities.

Massachusetts

Zea Mays Printmaking
320 Riverside Drive
Florence, MA 01062
www.zeamaysprintmaking.com
Workshops and residencies.

New York

Ink Shop Printmaking Centre
Ithaca
NY 14850
www.ink-shop.org
Workshops and residencies.

Lower East Side Print Shop
306 West 37th Street
New York City, NY 10018
www.printshop.org
Residencies and rentals.

Ohio

Zygote Press
1410 East 30th Street
Cleveland, Ohio 44114
www.zygotepress.com
Classes and residencies.

Oregon

Atelier Meridian
820 N River Street
Studio B-1
Portland, OR 97227
www.ateliermeridian.com
Membership schemes and residencies.

Sitka Center for Art and Ecology
56605 Sitka Drive
Otis, OR 97368
www.sitkacenter.org/residencies
Ongoing residency programme with simple studio facilities in
National Scenic Research Area.

Washington State

Seattle Print Arts
1329 North 47th Street
PO Box 31148
Seattle, WA 98103
www.seattleprintarts.org
Programme of fellowships and scholarships.

Links to other open access studios may be found on
https://printmaker.com/links.html

STOCKISTS AND SUPPLIERS

Etching materials and equipment

Art Equipment Ltd
Victoria Rd
Rushden
Northamptonshire NN10 0AS
www.art-equipment.co.uk
Press manufacture and material suppliers.

Harry F. Rochat Ltd
15a Moxon St
High Barnet
Hertfordshire EN5 5TS
www.harryrochat.com
Press manufacture and material suppliers.

Hawthorn Printmaker Supplies
Web-only address, based near York.
www.hawthornprintmaker.com
Press manufacture and material suppliers.

Intaglio Printmaker
9 Playhouse Court
62 Southwark Bridge Road
London SE1 0AT
www.intaglioprintmaker.com
Unique shop selling all etching supplies.

Lawrence Art Supplies
208–212 Portland Road
Hove
East Sussex BN3 5QT
www.lawrence.co.uk
General art suppliers selling many etching materials.

L. Cornelissen & Son
105 Great Russell St
London WC1B 3RY
www.cornelissen.com
Inks and tools.

Polymetaal
Web-only address, based in Netherlands.
www.polymetaal.nl
Press manufactures and material suppliers.

General art suppliers that stock some etching materials

Atlantis
www.atlantisart.co.uk
Good range of printmaking papers.

Great Art
49 Kingsland Road
London E2 8AG
www.greatart.co.uk
Etching sundries and Charbonnel inks.

Jackson's Art Supplies
Store branches and online.
www.jacksonsart.com
Good range of etching inks and some sundries.

Papers

John Purcell Paper
London SW9
www.johnpurcell.net
Excellent range of printmaking papers.

RK Burt and Company
London SE1
www.rkburt.com
Importer and distributer of wide range of papers, including those used for etching.

Shepherds Falkiners
London SW1
www.store.bookbinding.co.uk
Fantastic paper shop selling papers of many kinds.

BIBLIOGRAPHY AND FURTHER READING

Boegh, H. *Handbook of Non-Toxic Intaglio*. Grafisk Eksperimentarium, 2007.

Chamberain, W. *The Thames and Hudson Manual of Etching and Engraving*. Thames & Hudson, 1973.

Coppel, S. and Daunt, C. *The American Dream: Pop to the Present (British Museum)*. Thames & Hudson, 2017.

Gilmour, P. *The Mechanised Image: An Historical Perspective on 20th Century Prints*. Arts Council of Great Britain, 1978.

Leaf, R. *Etching, Engraving and Other Intaglio Printmaking Techniques*. Watson-Guptil, 1976.

Lumsden, E.S. *The Art of Etching*. Dover, 1998 edition.

Oxley, N. *Colour Etching* (from *Printmaking Handbook* series). A & C Black, 2007.

Ross, J., Romano, C., Ross R. *The Complete Printmaker: Techniques, Traditions, Innovations*. Roundtable, 1990.

Saff, D. and Sacilotto, D. *Printmaking: History and Process*. Holt, Rinehart and Winston, 1978.

Smith, A. *Etching: A Guide to Traditional Techniques*. Crowood, 2003.

Tallman, S. *The Contemporary Print, from Pre-Pop to Postmodern*. Thames & Hudson, 1996.

Taylor, M. ed. *The Mechanical Hand: Artists' Projects at the Pauper's Press*. Black Dog, 2012.

Other sources of information and publications

Printmaking Today
www.cellopress.co.uk
Journal of the Royal Society of Painter-Printmakers.

Printmakers Council
www.printmakerscouncil.com
Information, membership and exhibiting opportunities.

Art in Print
www.artinprint.org
American print and online magazine.

INDEX

OTHER ART TITLES FROM CROWOOD

Linocut for Artists and Designers
978 1 78500 145 1

Wood Engraving and Linocutting
978 1 86126 998 0

Making Woodblock Prints
978 1 84797 903 2

Fine Art Screenprinting
978 1 84797 981 0

Making Collagraph Prints
978 1 78500 581 7

Making Japanese Woodblock Prints
978 1 78500 655 5

Etching
978 1 86126 597 5

Figurative Painting with Collage
978 1 78500 074 1

Expressive Painting in Mixed Media
978 1 84797 798 4